**W9-DCW-741**

# TIEPOLO PINK

# TIEPOLO PINK

## ROBERTO CALASSO

TRANSLATED FROM THE ITALIAN
BY ALASTAIR MCEWEN

*Alfred A. Knopf* NEW YORK 2009

THIS IS A BORZOI BOOK
PUBLISHED BY ALFRED A. KNOPF

*www.aaknopf.com*

Originally published in Italy as Il Rosa Tiepolo by Adelphi Edizioni, Milan, in 2006.
Copyright © 2006 by Adelphi Edizioni S.P.A., Milano.

Library of Congress Cataloging-in-Publication

Calasso, Roberto.
[Rosa Tiepolo. English]
Tiepolo pink / by Roberto Calasso ; translated from the Italian by Alastair McEwen.
p. cm.
"Originally published in Italy by Adelphi Edizioni, Milan, in 2006."
Includes index.
ISBN 978-0-307-26766-5
1. Tiepolo, Giovanni Battista, 1696–1770—Criticism and interpretation.
2. Tiepolo, Giovanni Battista, 1696–1770. Scherzi. I. Title.
ND623.T5C3513 2009
769.92—dc22
2009020011

Manufactured in Singapore

FIRST AMERICAN EDITION

TO ENZO TUROLLA

The outcome of these little perceptions is therefore more efficacious than one would think. They form that *je ne sais quoi,* those inclinations, those images of the qualities of the senses, clear as a whole, but confused in their parts; those impressions that surrounding bodies make on us, and that embody infinity; the bond that every living being has with the rest of the universe. One may even say that as a consequence of these little perceptions the present is pregnant with the future and laden with the past, which plots all (*sýmpnoia pánta,* as Hippocrates put it), and that in the smallest of substances penetrating eyes like those of God might read all the concatenation of the things of the universe.

G.W. LEIBNIZ
*New Essays on Human Understanding*

# CONTENTS

I

"A
PLEASURE
ACCOMPANIED
BY
LIGHT"

What happened with Tiepolo was the same thing that was to happen with certain imposing and mysterious ancient objects like the Shang bronzes: those aspects that resisted interpretation were considered *decorative,* while those too charged with meaning were labeled *ornamental.* The twenty-three *Scherzi,* which are a kind of *Art of the Fugue* in Tiepolo's work—variations built on an established repertoire of characters, accessories, talismans, and gestures—were seen with some condescension as bizarre entertainments with a hint of the disquieting about them. Many took pains to repeat something that is obvious, but perhaps true: Tiepolo marks the definitive end of an epoch. But they failed to notice the unprecedented accumulation of venom and sweetness contained in that *motus in fine velocior.*

Tiepolo: the last breath of happiness in Europe. And, like all true happiness, it was full of dark sides destined not to fade away, but to get the upper hand. Recognizable by its effortless, unfettered air, doomed to disappear afterward. Compared with Tiepolo's happiness, that of Fragonard is based on tacit exclusions. But Tiepolo excludes nothing. Not even Death, who joins the number of his characters without drawing too much attention to himself. The happiness that Tiepolo emanates did not

necessarily spring from within. Perhaps there were many occasions when he told it to come back later, because right now he had a job to finish and he was behind schedule.

The ultimate peculiarity of Italian culture, the quality it could be proudest of, also because over the centuries it has proved untranslatable into other languages (whereas by contrast the meaning of the word has become obscure and remote for the majority of Italians), is what is known as *sprezzatura*. Baldesar Castiglione defined it as follows, in complete contrast with the thing he advised people to "steer clear of as far as possible, as if from the sharpest and most dangerous rocks," in other words "affectation." According to Castiglione, the remedy for the "bane of affectation" consisted in "using in all things a certain nonchalance [*sprezzatura*] that may conceal art and demonstrate that what one does and says is done without effort and almost without thinking." A gloss followed: "From this, I believe, does much grace derive." And a decisive consequence: "It can be said that true art is that which does not seem to be art; nor should a man study anything more than the concealment of it."

For those looking for an example of *sprezzatura,* no one is likely to be more convincing than Tiepolo, who for a lifetime did his utmost to conceal, behind his blinding speed of execution, the subtly aberrant nature of his subjects to the point that he succeeded in having his most daring and enigmatic works, the *Scherzi,* passed off as facile amusements. If no one ever took Tiepolo completely seriously, we might almost say that this was what he wanted. He never had symbols and meanings assume a *pose,* with the result that those symbols and meanings were generally overlooked. In the *Scherzi* too, although no fewer than eleven of the twenty-three plates are steeped in an almost

unbearable tension bound up with the act of looking at some-
thing unknown, others are imbued with a sort of torpor, as in
the two portrayals of family groups at rest, one group of Satyrs
and another of humans. The *Scherzi* have no obligatory meaning
(as was the case later with Goya's *The Disasters of War*), but a
physiological rhythm, an alternation of psychic atmospheres in
which no single element prevails over the others. Even when
meanings gather densely in his images with brazen insolence,
Tiepolo never abandons the air of one who does things "without
effort and almost without thinking." He does this so well that
some are led to believe he didn't think at all. And in this way he
protected his thinking from intruders.

"Tiepolo was a happy painter by nature," wrote his contempo-
rary Anton Maria Zanetti, son of Alessandro—and he was not
forgiven for that happiness. Zanetti added: "But this didn't stop
him from assiduously cultivating his fertile spirit." This pleased
some even less: the idea that Tiepolo possessed more erudition
than he admitted to. In 1868 Charles Blanc outlined a judgment
of Tiepolo that was to be picked up on and elaborated by many
critics for decades: "His fire is mere artifice, a firework display;
his abundance has more to do with temperament than with
spirit." It was therefore necessary to deny Tiepolo access to the
area reserved for the spirit. But for what original sin, if not the
"happiness" that seemed to deprive his work of a certain praise-
worthy decorum? Tiepolo always had "stern critics" against him.
This was so already during his lifetime, as Zanetti himself tells us
when he mentions that Tiepolo had reawakened "the dormant,
happy, most graceful ideas of Paolo Caliari." The idea that
Tiepolo was a sort of born-again Veronese was deeply disturb-
ing. Hence the observation that "the forms of the heads are no

less graceful and beautiful; but the stern critics will let no one say that they have life and soul like those of the old Master."

After having a go in various directions (toward Piazzetta, toward Bencovich), with the frescoes in the Palazzo Patriarcale in Udine the young Tiepolo shows his hand: to bathe the world in an all-embracing light that would never be drab. And, as Giuseppe Fiocco wrote, "he breaks out like a fanfare." The supremely frivolous angel that tells Sarah of the imminent birth of Isaac is also the herald of an entire tribe—Tiepolo's tribe—that for the next few decades was to spread out on the ceilings of churches and palaces, as well as on canvas and copper plates. Apparently Tiepolo was not remotely interested in subduing the totality of appearance. Right from the start he wanted to take appearance and, using invisible shears, cut out from it a segment of related and secret correspondences: between ferns and the faces of young boys, lopsided tree trunks and halberds, drapes and the busts of Nymphs and courtesans, greyhounds and ominous Orientals. Tiepolo's patrons committed themselves, together with him, to welcoming his entire tribe, which moved from one neighborhood to another, from villa to villa, as far as Würzburg and Madrid. It was "the prophetic tribe with blazing eyes" that Baudelaire was later to call up, an unstoppable motley caravan that dragged along with them all their assorted trappings, the flotsam and jetsam of history. They could always serve, from time to time, as scenic accessories. Without declaring or stressing this (since he never declared or stressed anything), Tiepolo allowed something to happen that would soon become an insuppressible component of all experience: the transformation of history—and of all the past—into phantasmagoria, material suited equally to providing the scenery for a fairground sideshow or to becoming a haunting image, pure power of the mind.

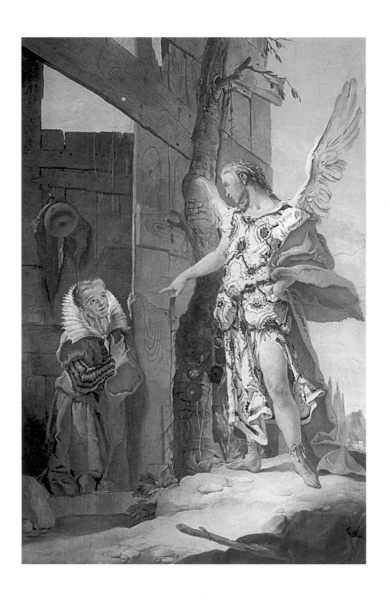

Why an angel was needed—that angel in Udine in particular—to herald the unfolding of Tiepolo's painting was illustrated with eloquent ease by Giorgio Manganelli: "Tiepolo is not only a painter of angels, but one has the impression that he had a superstitious fancy, ready to run riot at the first beam of light to catch his eye. It could be Jupiter, or a harbinger of fertility to the pensive Sarah: it was always a mantled light, a cloud with precious sandals, a miraculously stable and elegant glow." A description that introduced a definitive judgment: "He is an idolater of light disguised as a human being." These few words provide the indispensable elements that allow us to get closer to Tiepolo: light, theater (the mask, disguise). And above all idolatry, a natural reverence for the image.

Baudelaire made his debut with a *Salon* review and, a few years later, on finding himself obliged to write another, he spoke of "that kind of tedious article known as the *Salon*." Working one's way through the vast bituminous expanses that opened up every spring in the rooms of the Louvre or, later, in the Palais des Beaux-Arts, must have been fairly depressing. "No explosions; no undiscovered geniuses," but above all a succession of characters in vacuous or mawkish poses, often portrayed in period costume. *All the names of history* were mobilized, without ever granting the past its salutary foreignness, but reducing all things to a modest range of perfunctory expressions. What was missing, what air was lacking in that oppressive art to make Baudelaire feel the need to escape it? He felt at home only among Boudin's clouds, "those clouds with fantastic, luminous forms, those chaotic shadows, those green and pink immensities, suspended and superimposed one over the other, those gaping furnaces, those firmaments of black or violet satin, creased, rolled-up, or

torn, those horizons in mourning, glittering with molten metal."
Here, in a kind of theurgical process, Baudelaire ventured far
beyond the admittedly delightful Boudin, who acted solely as a
fortuitous device for evocation (this is how magic works). What
Baudelaire was calling up was that all-embracing air no longer
present in painting after the French Revolution. And that air had
a name: Tiepolo. The entire nineteenth century was branded, like
a herd of cattle, by that absence. One day, without realizing it, it
had forever lost the sovereign sense of *sprezzatura,* of facility and
fluidity of movement. That grand air, on a measure with the
skies, which for the last time had been perceived with Tiepolo
and his family. Of whom Baudelaire knew nothing, because he
had not come across their works (no other country had been as
reluctant to welcome them as France, a jealous guardian of its
affectations and feeling of sovereignty). But with visionary preci-
sion he called up that negative silhouette, based on what was
lacking, of an air no longer breathed in the overloaded Paris of
the Second Empire.

We know very little about Tiepolo's life and that little is exclu-
sively concerned with his work as a painter. Of his personal life
we know almost nothing. Yet right from his youth Tiepolo was
famous. But his life was as transparent as glass: no one noticed it.
They were all looking at the landscape that opened up in the
background. This too was why Tiepolo was the right person to
impersonate painting's epilogue, just as in a theater performance
there is an actor whose function is solely to appear at the end and
make an imperfectible bow to the audience. And so painting
took its leave of us—at least in the particular, singular, irretriev-
able sense it had acquired over roughly five centuries in Europe,
where countless painters had all conformed to a single notion of

painting and moved as a unified whole of immaculate grace and lightness, like certain extremely fat actors such as Sydney Greenstreet. During those centuries, painting was primarily a task assigned by the world, through various, fundamentally indifferent procedures. The only essential thing was that a commission arrived from the outside, in the same way as a courier received the order to set off. Perhaps Tiepolo never painted if not on commission—and where one suspects there was no commission (as in the case of the *Scherzi* or the last small canvases portraying the flight into Egypt), the work gives off an irresistible scent of secrecy and the forbidden.

After, we were left with artists. Of course, there were still patrons, both public and private, but something had gone irremediably wrong. Painting steadily became a monologizing activity, a calm delirium that started and stopped every day, with the hours of daylight, behind the windows of a studio. Artists remained, brimming with moods, whims, caprices, and idiosyncrasies. And in the end even they risked disappearing.

Among the old masters, no one lends himself less than Tiepolo to psychological and dramatic reconstructions. There is no trace of any "struggle with the demon." Contemporaries have left no key with which to unlock his psyche and moods. But neither can we say that he is elusive because of a dearth of documentary evidence. On the contrary, as soon as the talk got around to contemporary painting, people often wrote about Tiepolo. But without fail they did so to refer to his renown and his virtuosity. No aspect of him as a person attracted any attention whatsoever. Nor has anyone handed down any anecdotes or significant episodes that might have occurred in his life. Everything seemed to run smoothly, in a series of commissions, always accompanied by worries about finishing in time or at least not too late.

Likewise, with regard to his works—except for the constant references to Veronese—the comments were never any more than succinct. Tiepolo's fame was described in functional terms: the diarist Gradenigo defined him as a matchless specialist, "the most acclaimed, for his historical paintings of ceilings of salons, rooms, and churches in fresco and in oils." And, even though the greats of the world vied for his works, from the "Court of Muscovy" to that of Madrid, Tiepolo received only sparing, occasionally graceless recognition. He was over sixty when the recently established Accademia di Parma proposed to accept him as an "*amatore*" (connoisseur). And only thanks to the intervention of Anton Maria Zanetti, who pointed out this faux pas, did the Academy decide to nominate him "Honorary Academician." It was as if the people around him had trouble admiring him without taking precautionary measures. And his death was followed by a prolonged spell of obscurity.

From his heavenly ceiling, Tiepolo must have sketched a slight, satisfied smile when the two most knowledgeable scholars to deal with him in recent years—Svetlana Alpers and Richard Baxandall—found themselves obliged to state with one voice that "the man's personality" had "totally eluded" them. But he didn't elude only them. When historians want to say the last word on Tiepolo, in general we are not granted more than a few remarks on the last blaze of Venetian glory and on the vanity of his patrons, with the occasional addition of an evident non sequitur: since his patrons were vain, then Tiepolo must have been vain too. A thinly veiled assumption even in the greatest and most unjust of his critics: Roberto Longhi, who did not go so far as to treat him with the extreme iniquity he reserved for Canova ("the sculptor born dead, whose heart lies in the Frari, whose hand is in the Accademia and the rest I don't know

where"). In any event he made Tiepolo the Bad Guy to set in opposition to the Good Guy par excellence, who was unfailingly Caravaggio, to the point that Longhi felt the need to have them meet and converse in heaven, as if there too Tiepolo had to be persecuted by someone ready to lecture him, despite all the well-founded doubts we might have regarding Caravaggio's suitability for the role of a moralizing tutor. Yet this otherworldly dialogue composed by Longhi shortly after his *Viatico per cinque secoli di pittura veneziana,* in which he penned his irrevocable condemnation of Tiepolo, sounds like a surreptitious palinode. Even though Caravaggio lashes out at Tiepolo from start to finish, accusing him first and foremost of not sharing his "craving for truth," even though he has him understand that, instead of his tawny-haired and rosy-skinned Armidas, he would have done better to paint a "brawl among swarthy gondoliers on the tremulous water," it is Tiepolo who makes the "lethal thrust"—a far more effective blow than the summary drubbing he has been subjected to until that moment. The opportunity presents itself when Caravaggio reminds Tiepolo, in indignant tones, how widespread the custom of wearing masks was in Venice. But Tiepolo counters this by remarking that in Venice even beggars wear masks. Few words, but enough to dismantle and foil his adversary's heated arguments as well as those of all future authors of proclamations in favor of a reality that is then unfailingly revealed to be so parochial as to be unable to accept even the mask. Hence a world of beggars in masks becomes an unpardonable provocation—and there's no wonder that Tiepolo continues to appear elusive.

Roberto Longhi's rant against Tiepolo, not entirely unlike an altercation between neighbors in a condo, albeit one conducted

in a high-flown style, received a detailed, definitive reply, twenty-five years later, from another great virtuoso of Italian prose, Giorgio Manganelli. The reference to Longhi was implicit: "Tiepolo was frequently the target of honest rebuke for the facility with which he staged triumphs in honor of worldly potentates. And there is no doubt that his theatrical streak led to his love of triumphs: because they are extravagant, luminous, absurd, mendacious. He is indifferent to power, if not as a supreme, excessive occasion to lie. Any aristocrat, not only mortal but ephemeral, is dressed up like Jupiter; he is set among a crowd of allegorical figures; he is surrounded by light that no human being could bear; these glorious and vainglorious images thrust upward toward the ceiling: the whole thing is no more than a further show of virtuosity, a loveless theatrical enterprise, astute, skillful, but basically cold and mocking. Not ironic: the intellectualist game, dialectic shrewdness, the dry and cultivated cunning of irony were foreign to Tiepolo: he is no Enlightenment artist; but his technical subtlety takes him beyond, conferring upon him the appeal of an imaginative wisdom, a vision that has no fear of the gods and converses with the angels. To take the heavens, the world, the eternal, and holy images and make of them a scene, a Triumph, a land inhabited impartially by divinities and allegories, a harmonious chorus in which Peace rubs shoulders with Venus, and this last with Hagar, and Hagar with Campaspe and Alexander, and to add to these legitimately non-existent forms the Prince-Bishop of Würzburg—a being who thinks he exists, as happens with mortals—well, it's hard to believe that a more complete travesty was ever planned and put into effect, a fake that is heroic, epic, dramatic, even theological—Tiepolo is not just a liar, he is a forger, the inventor of a consistent and habitable world, seductive and inaccessible." Having read Manganelli's words, any-

one arriving in Würzburg can do little else but bow before that marvelous fresco while at the same time feeling a certain gratitude for Prince-Bishop von Greiffenklau, the man who wanted it to exist and believed that he existed as well.

Longhi's manifesto (because that's what we're dealing with, as if it were the program of a political party) is encapsulated in his vindication of Caravaggio, which runs through his entire life and culminates in the exhibition of 1951, followed by the monograph *Il Caravaggio* (1952), a (temporarily) definitive stance, forty-one years after his degree thesis. This text he then returned to and expanded, with numerous variations, in the 1968 edition. It is also a text where the argument hinges on a rudimentary sophism, from which one can be distracted only by the dazzling *poikilía* of his prose. It is one thing to say that Caravaggio advocated a painting aimed "at all of life and without classes, at simple sentiments and even the everyday aspect of objects"—an assertion that makes one wonder whether it grates more for its call for painting "without classes" or the no less incongruous one for "simple sentiments." It's another thing altogether for Longhi to say that Caravaggio establishes a kind of faultless, sovereign parity between beings and things: "Even if Bacchus is no longer reflected in the mirror, the bowl of fruit, the forgotten ribbon are still there; were the musician or the diner to withdraw from the table, there would still remain the instrument of undeciphered beauty or the remains of the meal: the half-full carafe, the slices of melon or watermelon, the whole pear and the half apple, the flies hopping about on their own shadows. Thus reality continues in the life of these silent, motionless things under the waxing or waning of light and shade; a form of quasi autonomous enchantment that seems brought about by things

left to themselves, but still reflect the sidelong gaze of man and, *in primis,* of the man who produced that enchantment." *Things left to themselves:* here it is surely impossible not to sense the nearness of Caravaggio, more than ever before. But why weigh down this painting with the pointless repetition of "revolutionary impetus," complete with its Trotskyite variant "permanent revolution"? And why conclude by conferring upon it connotations of "human more than humanist; in a word, popular," a statement that is even more inappropriate than the previous ones? A few decades later, those passages sound like fragments of a message in support of the Partisans of Peace. And they reveal that Longhi shrewdly avoided any clear expression of certain ideological assumptions, which would have obliged him to brandish, like some offensive weapon, the momentous word *reality.* He was too good a stylist to give it house room, but he could not avoid its filtering through some chink, as his tribute to the times.

What is the background to Roberto Longhi's condemnation of Tiepolo? Longhi had doggedly engaged in a partisan poetics, right from the start. At twenty-four he had the effrontery to write: "I deeply despised northern painting even before 1914." Then he was more specific, making things worse: "In a mind that wishes to maintain the habit of even the coarsest consistency Masaccio and Van Eyck, Titian and Holbein, Bouts and Pollaiolo, Altdorfer and Lotto cannot coexist: in all cases you have to take sides as soon as possible for either one or the other." The conceit of this sentence might lead one to suppose some mental confusion, were it not penned by the man who, a mere six months previously, had written the *Breve ma veridica storia della pittura italiana,* a work of formidable intensity and sharpness.

Rightly, Cesare Garboli felt a certain embarrassment when

deciding whether to include "Keine Malerei"—the 1914 essay, where the invective against any kind of "boreal" painting was white hot—in a collection of Longhi's unpublished works. And, rightly, in the end he included this text of "acute and waspish phobia," insofar as it was a psychodrama in which Longhi had staged his "perverse and providential Italianness," which provided him with a barricade against any intrusion on the part of foreigners but at the same time allowed him to winnow every possible gilded straw on Italian soil, right down to its most neglected corners, with an exclusive and possessive avidity that remains unparalleled. This was a deeply pathological operation, to which we owe some great discoveries and many lamentable misunderstandings, which Longhi luckily kept to himself once the phase of his youthful passions had passed.

Tiepolo was a final change of heart, a relapse into old vices. His painting irritated Longhi because, even though Tiepolo was more Venetian than anyone, he went beyond the bounds of any obligation to comply with the local tradition. And he appeared as the manifest negation of the central dogma that Longhi had faithfully observed. On one occasion, Longhi formulated this in a memorably grotesque manner, denouncing "the most intelligent critics" whom he thought guilty of enthusing about Rembrandt and Velázquez, "a really odd thing when one did not *first* wish to kneel before Caravaggio and his greatest successors, the true creators of the great modern pictorial culture; the only [culture] from whose taste . . . one may move smoothly on to an understanding of the only modern painting worthy of the name— from Courbet to Degas." It is obvious what a deluge of inanities, the work of other writers, would spring from these words, especially regarding the claim that painting followed a sole legitimate line and hence one must scornfully discard any spurious com-

pany, which from time to time might have been represented by
Fuseli or Ingres or Friedrich. And then: why perforce ascribe the
unfathomable and refractory Degas to the manly stock of Cara-
vaggio, to whom Longhi attributes a monopoly in the correct
understanding of history? Longhi did not know that Degas, in a
letter to his friend Rouart in Venice, had begged him as follows:
"Do me the favor of abandoning your two lady friends for a
moment and go to Palazzo Labia to see, half on your part and
half on mine, Tiepolo's frescoes." With his poor eyesight, Degas
would never manage to see them himself.

Longhi's acrimonious judgment of Tiepolo in his otherwise
dazzling *Viatico per cinque secoli di pittura veneziana* was not there-
fore an infelicitous fit of ill humor, but a final declaration of war.
In that apotropaic sequence that constitutes the history of paint-
ing (right from the start Longhi had written that "artists . . . all
hold one another by the hand to form the chain of historical tra-
dition") Tiepolo came to represent the weak link; he was the
reprobate whose aberrant style heralded the lamentable end of a
superb history. Nothing testifies to Longhi's embarrassment in
effecting this political liquidation (analogous to one of those
"show trials" that were already being planned in Eastern Euro-
pean satellite states) as eloquently as the coarseness of his accu-
sations. Tiepolo was compared to De Mille, exactly as if some
arrogant Florentine, convinced that he was still at the center of
the world, had decreed that the Würzburg frescoes were all pure
Hollywood, a crude verdict, which Longhi had to force himself
to hand down because—as soon as he had a breathing space—
he showed he was able to grasp the essence of Tiepolo with
his usual perspicacity: "Tiepolo's genius lies precisely in his
'arrangement' in open, scalene, asymmetrical order; for new
layouts or constellations of figures to be set in the corners of the

sloping surfaces of his skies, subsequently snipped off, below, by the broken up, fanciful, fake structures of his trusty co-worker Mengozzi-Colonna." These few words would suffice to make it clear that there certainly was no lack of congeniality between Longhi and Tiepolo. The obstacles were different: the ideology of *realismo all'italiana* and (no less impelling in Longhi's psyche) his irritation with official scholars of Tiepolo, especially Antonio Morassi.

But for Tiepolo the word *reality* could not be used as a vaguely military password. And his "haughty skepticism" would hardly have won him a welcome among militant subversives. If anything, he could have become the Talleyrand of painting—and Longhi did not falter before the task of providing a delirious account of how Tiepolo might have behaved during the years of revolutionary tumult: "No effort [was required], for such an eloquent propagandist, to exit the 'Concilium in Arena' and blithely enter the 'Jeu de paume'; get by for a few years; then, especially after the 18th of Brumaire, to support Napoleon and hang on until the end. Finally, he would even have tried to stay afloat, and he would have succeeded, with the Restoration. And the gates of the villas on the Brenta would have been closed again." With no other painter did Longhi indulge in such a lengthy and vehement political digression. Which culminated in the middle of modernism—a glamorous and often shallow category of which only one trait can be affirmed with certainty: that, under its sway, the acme of praise was to be defined as *modern*. The direct consequence of this was an enormous profusion of tautologies when that modernism was already under way and a great accumulation of pathos when it came to identifying its earliest stages. Hence Longhi, having reached the end of his peroration of Caravaggio, and having to award the supreme accolade, wrote pithily

(but with the peremptory tone of a popular textbook): "Instead of being the last painter of the Renaissance, Caravaggio is rather the first of the modern age." (Elsewhere, and far more elegantly, he had denied that Caravaggio could be "a kind of 'night porter' of the Renaissance.") How many times, since then, have we heard similar words, applicable to Caravaggio but also to others (the first among the candidates would be Goya), and always with the idea that modernism must be, by vocation, something grim and "workaday." But can we be so sure of this? If we go back to Baudelaire's definition of the "painter of modern life," the image that emerges is entirely different. Whereas Guys did not have the stuff to keep up that difficult role (which ought to have been Manet's, but mischievously Baudelaire did not want that), in retrospect the only painter who could have had a claim to be the first of the forefathers of "modern life" was none other than Tiepolo. Hence the suspicion that Longhi had reached the acme of exasperation not only for regrettable political reasons, but— more secretly—because he glimpsed in Tiepolo an alternative to that modernism of which he had named Caravaggio the father. And this must have gnawed away at him on a far deeper level, because Longhi was a monomaniac of painting, while it is doubtful that the cause of the proletariat was dear to his heart. Perhaps modernism was not so simple—and above all not necessarily suited solely to those "simple sentiments" that Longhi had surreptitiously attributed to Caravaggio.

If we look at the dates, the "Dialogo fra il Caravaggio e il Tiepolo"—a whimsy without precedent or further development in Longhi's work—comes at the zenith of Longhi's eulogy of Caravaggio. In March 1951 the magazine *Paragone* ran the essay "Il Caravaggio e la sua cerchia a Milano," an introduction to the cat-

alog of the historic Mostra del Caravaggio e dei Caravaggeschi, which opened in Milan's Palazzo Reale in April 1951. In the fall of that same year Longhi published in *Paragone* the "Dialogo fra il Caravaggio e il Tiepolo." An unexpected guest. Was it a way of flogging a dead horse, after the ferocious pages of the *Viatico per cinque secoli di pittura veneziana?* Was it a change of heart? Or was Longhi simply talking to himself (and few people seem to have noticed this)?

The scene takes place in heaven, in those Elysian Fields against which Caravaggio instantly inveighs: "Fields without light and without shadow, which I detest." This is already a declaration of supramundane hostility (one is reminded of how Longhi had defined Caravaggio's original revelation: "What was flashing through his mind by then was not so much the 'outline of bodies' as the form of the shadows that interrupt them").

Caravaggio wants Tiepolo to bring him up to date about how things are going on earth, and it doesn't take him long to realize how much his discoveries have been ignored. Starting from the ceiling in the Palazzo Farnese—Tiepolo informs him—the world has been submerged by a "flux of mythologies," a "majestic mirage that has spread almost throughout Europe in erudite fables, fantasies never seen before, gigantic allegories" (and already here we observe a subtle historical falsification, because that "flux of mythologies" had begun years before, at least in the Florence of Marsilio Ficino and Botticelli). Bad news for Caravaggio, who in Longhi's mise-en-scène behaves like a dour, intemperate teacher. He cannot open his mouth without mentioning the *truth,* which would perhaps prefer not to be brandished at every step. He talks of painting that leaves a "trace of truth," he talks of a "moment of truth," and of "everyday truth." There is something inquisitorial in his tone. Tiepolo, on the

other hand, is urbane, indulgent. But his inquisitor tries to out-
flank him: "What do you do? Painting or stage sets?" A decisive
question, which Tiepolo does not avoid: "Was I wrong if, on
watching festive plays, the parades of my noble patrons, I con-
cluded that it was best to indulge them and paint the world as if
it were all a theater?" Concealed beneath this worldly tone,
Tiepolo's reply is metaphysical. And from this moment on the
debate ought to welcome, as spiritual patrons, precisely those
thinkers whom Longhi wished to ignore at all costs: Plato and
Nietzsche. For "paint[ing] the world as if it were all a theater" is
certainly not a simple norm of polite society. If anything, it is a
royal road of thought.

Among Tiepolo scholars it has become traditional to talk of his
"traveling company," with the slightly knowing air of one who
knows the secrets of the game. The point is undeniable, because
it alludes to the theatrical nature of all that happens in Tiepolo.
But it also conceals something misleading: that company of play-
ers who went from square to square, prepared to stage sacred or
profane shows, depending on the audience, is at the same time a
tribe, ethnically distinct from that which surrounds it. Tiepolo's
characters form a parallel world, with its own customs and con-
ventions. Decorations, colors, and headgear do not correspond
only to the history of previous painting (epitomized in Veronese)
and to the expectations of patrons, but to an internal code, as at
the court of Heian Japan or among the Kwakiutl of the American
Northwest. If one does not see that code, Tiepolo's painting is
unjustly confused with the air of his day. If one does see it, it is
the chronicle of the eighteenth century that is absorbed and
vaporized in the air of Tiepolo.

   But, with regard to Tiepolo, it is true that everything gets

more complicated as soon as the word *theater* is uttered. It is a sign that one is setting foot in an obscure area, getting closer to the peculiar enigma that is Tiepolo: why, as soon as he puts his hand to his figures, do they take on this *theatrical* character? And what, in itself, does *being theatrical* mean? Even before Tiepolo begins to paint, it seems as if, through a peculiar process, all living beings have been made equivalent—be they allegories or historical characters, anonymous extras or divinities—and the result is their immediate transference into a scene that is never defined or declared, but that the onlooker instantly perceives. In the ceilings of Würzburg or Palazzo Clerici, the churches of the Gesuati or the Carmini, but also in the frescoes of Palazzo Labia or in the canvases inspired by Torquato Tasso's *Jerusalem Delivered,* everything appears as an element of a mise-en-scène removed from its accidental and occasional existence and transposed to another place, where the same events and movements proceed without any changes, but in another light. It is the binding character of reality or beliefs (since reality itself is only the first of all beliefs) that is here called into question, and in fact dissolved. Although Tiepolo probably didn't know the word and in any case—we may surmise—he would have found it indifferent and extraneous, an *epistemological* change seems to underpin his painting. It is as if the Vedantic *māyā* had clandestinely seeped into the pigments and enveloped every figure, but without changing in any way the ceremonial of commissions, subjects, and techniques. But could this be a misrepresentation, an unjust attribution of significance to a style of painting that contemporaries did not even consider particularly new and admired above all for its skilled execution? There is no way of ascertaining this. But neither can we exclude it in principle: certain boundaries are stepped over unnoticed, without this being perceived by the

one taking the step or being recognized by others. If we wished, we could propose a proof by contradiction, a kind of ordeal: in the absence of that all-embracing *māyā,* Tiepolo's world ought to be understandable in another way, in terms better suited to his times and milieu. But that's not how it is. Tiepolo goes beyond the entire framework of eighteenth-century painting and becomes completely obscure if interpreted within a historical process. Was he merely a late offshoot of Veronese? Was he merely a great virtuoso, prepared to celebrate triumphs that were secular and ecclesiastical, pagan and Christian, mythological and dynastic? Was he faithful to the intentions of his patrons, contenting himself with adding a dash of talent to them? If understood according to this model, Tiepolo's entire oeuvre is flattened like a house of cards struck by an impatient hand. But anyone who has long familiarity with his painting cannot shake off the suspicion that Tiepolo did not use his triumphs in relation to the individual characters portrayed; he used those same characters in relation to the triumph itself, which, in its turn, could be none other than a Western and ostentatious name for what, on a different continent, was called *māyā:* not only "illusion" and "appearance," but also "the magic that measures," the fabric of which the world is made, according to the meaning of the word in the Vedic texts, before the meaning it took on in the Vedantic tradition.

Perhaps the most congenial and equable end for an artist is that of being transformed into a color, like Daphne into laurel: this is what happened to Tiepolo in Proust. In the entire *À la recherche du Temps Perdu,* which teems with references to painting, there is never any mention of a work by Tiepolo. But the artist's name rings out three times—and each time in relation to a different

woman: Odette, the Duchess of Guermantes, and Albertine. The three women about whom Marcel fantasized the most, the ones who made him suffer most (even when he took on the character of Swann)—the women who accompanied his life like a long, glittering tripartite wake.

For Proust, Tiepolo was first and foremost Odette's robes. In the eyes of this very young and stubborn worshipper, none of the outfits with which Madame Swann appeared in society were remotely comparable to the "marvelous robe in crêpe de Chine or silk, old rose, cherry, Tiepolo pink, white, mauve, green, red, yellow, plain or patterned, with which Madame Swann had eaten breakfast and was about to take off." Like a faithful fanatic, Marcel deplored the fact that she did not go out dressed that way—and remembered that then Odette "would laugh, to make fun of his ignorance or with pleasure for the compliment." Perhaps between Odette and Marcel there would never more be a moment of such intimacy, protected by the color that stood out in her collection of robes: "Tiepolo pink."

With the Duchess of Guermantes, years later, another Tiepolesque epiphany was to occur. This time it was public and illuminating, when the duchess presented herself with "her evening mantle, in a magnificent Tiepolo red." And so the duchess could remain petrified in a *tableau vivant* where Marcel himself offered to serve as her ensign—and that one day would expand to include all the vast population of the *Recherche:* "Erect, isolated, with her husband and me at her side, the duchess was on the left hand side of the stairway, already wrapped in her mantle à la Tiepolo, a ruby-studded clasp around her neck, devoured by the eyes of women and men trying to guess the secret of her elegance and beauty."

Finally there was the Tiepolo of Albertine, brought back to

life—this time—in the lining of a robe, as if in some Buddhist metempsychosis, and once more permeated by the aura of the artist's birthplace, Venice, but no longer flaunted as an emblem of sovereignty. Now it would live in semiclandestinity, concealed beneath the blue and gold of the Fortuny robe that Albertine loved. As Marcel's gaze gradually penetrated that deep blue, the color "changed into malleable gold, those same transmutations that, ahead of the gondola moving forward, change the light blue of the Canal Grande into glittering metal," until the metamorphosis subsided in the "sleeves lined with a cherry pink so peculiarly Venetian as to be called Tiepolo pink." Perhaps, by virtue of a magic not unknown to the Orientals of the *Scherzi,* the pink clouds over the Four Continents of Würzburg had agreed to seep into that lining, close to the warmth of a woman's arm, as if in anticipation of a long spell of concealment and cosmic cold.

Today, if you go to an artists' supply store or a drapery store and ask for Tiepolo pink or Tiepolo red you are not likely to find them. And probably in Proust's day not all stores would have stocked them. They are striking colors, but then easily lost. In Proust's case this must have touched a very sensitive point, if he mentions it only to call up Odette, Oriane de Guermantes, and Albertine. Perhaps the thing that kept such divergent, contrasting, and haunting beings together was that color. It appeared like some fleeting and definitive flash of light.

Something similar happened with Tiepolo: like a probe in the brain, his painting touched a point that produced an extremely acute, piercing reaction. But barely a few millimeters away there was no longer any reaction. Among the old masters, very few had such a modest influence on the painting that came after them. Only Canova, his successor and antagonist in the tastes of

the majority, lovingly carried on collecting Tiepolo (he owned about five hundred of his drawings and all the etchings). Stendhal worshipped Canova, but in his *Histoire de la peinture en Italie* Tiepolo's name does not appear. The curtain had come down on his stage. Tiepolo's gestural expressiveness fell out of favor like an archaic relic. But it was precisely this that helped to keep its intensity and supreme lightness intact, so that it was immune to the rust of history.

Tiepolo was still seldom consorted with—and always with caution and various reservations—when the young Maurice Barrès claimed to identify with him (in 1899). Veronese intimidated Barrès, but with regard to Tiepolo—whom Roberto Longhi, when he was not blinded by acrimony, had the magnificent bravado to define as "a Veronese after a downpour"—the French artist instantly dared to say: "My companion, my true self, is Tiepolo." No one, until then, had attributed a self to Tiepolo, who was probably devoid of one—far less had anyone thought of identifying with him. But with Barrès we witness a first attempt at cornering an area of the sensibilities that had remained vacant and anonymous. Barrès needed Tiepolo to reveal something that decadence—obviously through himself—could offer, something hitherto unheard of: to be "an analyst who plays with the treasure of virtues inherited from his forefathers." It was a new way of *playing*—an irreplaceable word—with all of the past, as if it were a repertoire of available stock characters. Yet by adding a heady element—the light (and this was the "downpour" to which Roberto Longhi was alluding)—"[Tiepolo takes] all the people of the creators of bygone days and repeats them to satiety, jumbles them up, inoculates them with a fever and pulls them apart by dint of their shivering! But he floods them with

light." For the moderns of the decadent movement Tiepolo could be a model, a banner, a force still to be unleashed. This was not the path that either Barrès or the twentieth century was to take. But like a promise still redolent of and subtly suited to the sensibilities of one who lived two and a half centuries after Tiepolo, there remains suspended that "oeuvre brimming with fragmentary memories, with a hotchpotch of all the schools, sudden, with no restraint or respect for the proprieties, you will say, but where harmony springs from an incredibly vibrant light."

There were years in which English-speaking travelers visited Venice and did not see Tiepolo. The 1860 Murray's Guide observes that the Palazzo Labia was in poor condition, but does not mention the frescoes. Ruskin ignored Tiepolo. If he mentions him, it is only to criticize him. On seeing *The Flagellation* and *The Crowning with Thorns* in Sant'Alvise, he decreed: Tiepolo is "virtually the beginner of Modernism: these two pictures of his are exactly like what a first-rate Parisian Academy student would do, setting himself to conceive the sentiment of Christ's flagellation, after having read unlimited quantities of George Sand and Dumas." A profound irony of the times: the word *modernism,* which throughout the twentieth century would become the emblem of all avant-garde movements, is here applied to the most hackneyed academic painting, which in its turn could allegedly be traced back to Tiepolo. Yet now that the clamor of the avant-garde has passed, saying that Tiepolo had something to do with modernism makes sense once more, at least in the sense that Baudelaire attached to the term.

Henry James wrote that he began writing *A London Life* "in one of the wonderful faded back rooms of an old Venetian palace [Palazzo Barbaro], a room with a pompous Tiepolo ceiling [one

of the rare cases in which the word means both "stately" and "pretentious"] and walls of ancient pale green damask." In reality it was a copy: the original of *The Glorification of the Barbaro Family* had already been removed years before. Yet James did not miss the chance to let fly the adjective—pompous—which in English implies an irreparable intellectual disdain. His friend Edith Wharton was far more enlightened. James longed to travel with her, in her "chariot of fire" (her automobile). But he was tormented by the fear of having to write a review in exchange. Wharton admired Tiepolo without moral reservations, with upper-class confidence. And in this she found an unexpected ally in Mark Twain, who had noted in his diary, back in 1878: "But Tiepolo is *my* artist."

Tiepolo's patrons—be they the Pisani or the Clerici families or the prince-bishop of Würzburg or the king of Spain—required him to illustrate their glory, in other words the glory of persons and noble houses. Tiepolo agreed and worked with prodigious speed, painting glory in itself. The glory of the visible, which the most ancient Greeks called *dóxa,* before the word was distorted to stand for the vast pastures of opinion. The glory that Helen—according to Coluthus—called *aglaía,* when she said: "I have loved splendor and splendor follows me." Tiepolo might have said this too.

It is inevitable—and right—to see his frescoes as a novel in installments, where the same characters meet up, from one end of Europe to the other, changing—sometimes only minimally—costume and pose. They are a crowded caravan, swaying, more gypsylike than courtly. They emerge from and plunge into tents like the one with blue and white stripes—long, low, and mysterious—painted on the ceiling above the grand staircase in Würzburg.

Tiepolo based his life on this ambiguity, to his own satisfaction and to that of his patrons. He shared the secret with two sons—Giandomenico and Lorenzo—both of whom were gifted with fragments of his genius, ready to bring his characters into play once more, on other registers, lower, anonymous, and ironical, like a family recipe. Nor did Giandomenico ever forget to summon to his scenes, wherever he had the chance, a group of old Orientals, solemn and disquieting.

For several centuries it was customary for painters to isolate from humankind—and from the animal and vegetable kingdoms—a certain number of forms, profiles, expressions, perhaps vast in number but clearly limited, withdraw them from all the rest, and then play with them, complying strictly with that register, as if it exhausted the list of possibilities. As if all the remainder were of scant importance or had not attained fullness.

Tiepolo was one of those artists. In fact, perhaps he was the last of them. Paradoxically, in his work the result of that drastic process of reduction by exclusion, which affected a large part of existence, was destined to arouse a converse impression: that the horizon of the figures had expanded, that their breath had become easier and unopposed, and that a new fluidity had enveloped all that moves between heaven and earth.

Tiepolo chose his forms—human, animal, vegetable—like an impresario selecting the company with which he would have to travel on an endless tour. With them he would have to stage, in principle forever, a repertoire that was extremely varied albeit not devoid of exclusions. It was a company that certainly knew and wanted to meet with the tastes of the audience, but above all it wanted to satisfy itself and its own criteria of judgment.

Who to start with? With the leading lady, of course. She would have to lend herself to various roles, lowly or celestial, but in all of them she would have to show the same characteristic: sovereignty. She would have to play a Nymph or an angel with a trumpet, an Oriental queen or a sorceress, a goddess or an anonymous maiden. She would have to dress up, from one season to the next, as Cleopatra, Zenobia, Armida, Angelica, Beatrice of Burgundy, Flora, Venus, Saint Lucy (but not as the Virgin, which required another typology, closer to Piazzetta, even though this meant "hilarizing" him, to use Luigi Lanzi's felicitous coinage). And at times she would have to play the role of certain allegorical virtues (but those, as Manganelli was to warn, "will never end up on an educational stamp"). But she would always have to offer the same physiognomic requisites: a round face rather than an oval one; blond or tawny hair; round breasts set far apart; eyes lengthened toward the temples and slightly bulging; pinkish complexion; a narrow, rounded brow; a strong, supple torso; calm, confident, fearless gestures. This woman of Tiepolo's had never existed before. Even in the closest precedents—inevitably to be found in Venice, between Titian and Veronese—the detachment and lightness of sovereignty are not yet perfected. Something holds those figures to the ground, or to white beds, whereas with Tiepolo all now occurs between the sky and the stage. The theatricality serves to lighten appearance. Besides, it only accentuates a fiction already present in the fabric of the world—and in Venice this is merely a little more conspicuous than elsewhere, if only because it is the only place where reflections are more numerous than things themselves.

"There is no concealing the fact, in following the method of learning to paint as discussed so far, that one may run certain

risks, and precisely, if one looks too much at sculpture, the risk is that of adopting a spare, statuary style. Poussin has occasionally been criticized for such reasons." This shrewd point was made by Algarotti, the only writer with whom Tiepolo was on friendly terms, and the only one with whom he liked to discuss painting.

But there was certainly no danger of that observation fitting Tiepolo, who never ran the risk of adopting a "spare, statuary style": his figures always have something delicate and moist about them, and a vaporous warmth envelops them, even when they are depicted in canonical poses. The suppleness of Tiepolo's hand, which afforded him a legendary speed of execution, was also the suppleness of his figures, their ability to avoid encountering obstacles, and not to become rigid in movement. You can understand why Tiepolo immediately got along with Algarotti, who had struck Voltaire as a "young man who knows languages, writes verse like Ariosto and knows his Locke and Newton." What appeared in Algarotti as a refined Italian self-assurance, a quality that was soon to vanish, in Tiepolo was rather a kind of transcendental fluidity in occupying space. Neither before nor after would such a convergence of virtues be possible, yet then it seemed entirely normal, like the meeting of the ways between a polymath and connoisseur wandering around Europe and a painter who managed to satisfy a throng of patrons.

Between the limpness of Greuze and the rigidity of Mengs, which correspond punctually with the blunt and fatal course of history, Tiepolo is a hindrance and a slight aberration (as we say of the course of a planet). He does not serve either to throw light on the past or to be projected into the future. He is not a modern before the moderns, according to the formula that was to be applied—banally—to Goya. And he is not archaizing (how

could he be, since he emanates so much insolence and *sprez-zatura?*). Tiepolo is an extreme example of Taoist suppleness in art, a quality inconceivable before him, and never attained after him. If he was shelved for a century, if certain canvases of his lay rolled up in storehouses, it was only because history rightly perceived him as an intruder, while it stubbornly worked to make sensibilities denser, more unsophisticated.

The "assurance of brushstroke" that Algarotti found amazing was accompanied in Tiepolo by an assurance of conception that could even become brazenness. But you had to see it—and many of the first viewers must have got lost in the play of secret correspondences between the pagan and the Christian, the sacred and the profane. A process that sometimes went very far. If we look through the abundant gallery devoted to the Loves of the Gods, we notice that few pictures dare to push the grotesque to the point of Tiepolo's *Danae and Jupiter,* where a lethargic Danae flaunting one side of her massive, cumbersome, and soft buttocks corresponds to a grasping and rapacious *dueña,* intent solely on collecting in her tray all the coins raining down from the sky, without missing a single one, while a fleshy, aged Jupiter impatiently rides a cloud as he waits to get into Danae's unmade bed. But the most provocative point is revealed when we realize that this indecorous Jupiter, even though girt with the crown of sovereignty, resembles no one more than another of Tiepolo's old men: God the Father in his *Pope Saint Clement Adoring the Trinity* (painted immediately after the *Danae*). Is this doubly irreverent? Or merely a natural familiarity with divine figures, as if they were experienced actors who have been alternating roles on stage for years—or centuries?

Tiepolo clearly loved the overlapping and ambivalence of meanings. Otherwise we cannot explain why his charming por-

trait of a young woman in a cloak whose hood is ruffled by the wind and who seems to have been pictured as she sets off in romantic trepidation and a hint of anxiety to a clandestine love tryst is then revealed to be—but only when we read the words on the back of the canvas—the Beata Laduina, or Lydwine of Schiedam, who lived in Holland between 1380 and 1433 and has been renowned since then for the strength of her faith, which permitted her to bear with abnegation terrible sufferings, following an accident that occurred while she was ice skating. At her death, her body was deformed. But miraculously her original beauty returned, as is shown in the portrait. If Tiepolo was the herald of decadence before decadence had a name, it may

only be considered as a heavenly confirmation (or an *intersigne,* as Louis Massignon would have put it) that the very saint to whom he dedicated this highly anomalous painting (there is no iconographic tradition regarding Lydwine in Italy, nor do we have any idea who may have commissioned the work) would become the main character of an impassioned and devout book (*Saint Lydwine of Schiedam,* 1901) by Joris-Karl Huysmans (who, moreover, was unaware of Tiepolo's portrait).

More than Guys, fascinating but technically not up to the task, the *peintre de la vie moderne* whom Baudelaire prefigured was Tiepolo. But isn't the leap between epochs too brusque? And will it be possible to rediscover, in Tiepolo's women, "the variegated image of equivocal beauty" (an indispensable requisite— almost the acid test—for anyone wishing to be elected the *painter of modern life*)? By way of an unexpected witness in favor, we may call Pompeo Molmenti, despite his slightly late-nineteenth-century air. His description of the female figure between Veronese and Tiepolo sounds like he is paving the way for those figures to escape the streets and masks of Venice to find themselves, with nonchalance, in some carriage on its way to the Bois de Boulogne: "In Veronese's women the beauty of the face unfolds in magnificent purity, but without ardor and depth of sentiment, without any hint of the passionate and seductive expression of modern woman. Nor does Tiepolo generally seek thought in the female brow, attending only to plastic beauty, opulent and often vulgar. Many of the female faces painted by him are of the Satyr type: almond eyes; long, oval faces; low brow; full, prominent lips; nostrils flaring as in a thrill of emotion. Nonetheless, in some types he portrays with great clarity Venetian woman in the twilight of her anemic exhaustion, in her

acute and expressive sensitivity, in her refined and highly strung beauty. These female types, whose faces reveal the restless sentiment of the spirit, were seen by the painter in the streets of his city. He copied them and, with happy unawareness, he conveyed their passionate expression, out of the profound correspondence that exists between the forms of art and those of surrounding nature." Previously, Camillo Boito had noted the scant respectability of Tiepolo's women: "His Venuses, and his Divinities in general recall certain stage parodies; the Goddesses often have the face of strumpets and show off their legs, admiring their own plump charms; the Gods look and act like bit-part players in the Roman theater." The word *strumpet* was heavy and strident, but the observation was well founded. Tiepolo's goddesses belong to the demimonde of the heavens—and this takes away none of their splendor. Their frivolity is a benevolent measure of courtesy, to avoid their appearing pointlessly solemn. And above all, this is an ancient tradition: Praxiteles' renowned work, the *Aphrodite of Cnidos,* was said to have been modeled "*ad formam Cratinae meretricis, quam infelix perdite diligebat*" (on the figure of the prostitute Cratina, with whom the unhappy [Praxiteles] was madly in love).

Baudelaire suggested an experiment: if you wish to recognize the modern, ask any "patient and meticulous" painter to try his hand at a portrait of a "courtesan of the present day." If he is not able to capture "the pose, the gaze, the smile, the vital appearance of one of these creatures who the dictionary of fashion has successfully classified with the coarse or malicious label of lewd woman or kept woman or cocotte or biche," then it may be said that that artist has not captured the fleeting essence of the modern. No one could have, no one would have been capable of tackling such a test with the overwhelming assurance of Tiepolo.

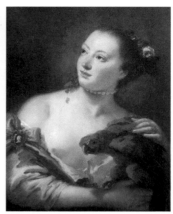

And not only in the three magnificent portraits considered (per-
haps wrongly) to represent three courtesans of his day (two of
these paintings, it has been suggested, were bought by the cza-
rina Elizabeth), but in the unstoppable procession of sorcer-
esses, queens, goddesses, princesses, Nymphs, and allegorical
figures depicted unhesitatingly for years by his vigorous, felici-
tous hand.

Judging by the documents and other testimony, Tiepolo may
never have read a book in all his life. He frequented Algarotti not
because he was a brilliant polymath, but because he procured
works of art for the court of Saxony. But Tiepolo did illustrate
some books. He drew some Roman busts for Scipione Maffei's
*Verona illustrata,* and the celebrated scholar was extremely pleased
with them. Then there was a vignette for Battista Guarini's *Il pas-
tor fido,* published by Alberto Tumermani, in which Tiepolo vied
with Piazzetta's enchanting illustrations for *Jerusalem Delivered.*
Finally, he produced a vignette for *Paradise Lost,* again published by
Tumermani: *Sin and Death,* a work in that allegorical form favored
by Baudelaire, who vainly tried to have it imitated by his friend

Felix Bracquemond and by Rops. In this image Tiepolo and Baudelaire seem almost to meet; indeed, the one seems to correspond to some unfulfilled mental image of the other.

These are the elements: in the vignette for *Paradise Lost* Death is a nimble and elegant skeleton, partly covered by one of those sumptuous fabrics that Tiepolo would use for Cleopatra and the pharaoh's daughter. But here Death wears this carefully closed at the neck. His scythe towers before an altar with the remains of a sacrifice, not unlike the altars in the *Scherzi*. Death is wearing a mask, but one that lets us glimpse the grinning skull. With his right hand, like an expert seducer, Death clutches the shoulder of an entirely naked young woman. Serpents cling to her hair and belly. We come across Death and the maiden again in two sculptures by Ernest Christophe, a friend of Baudelaire's. To both of these Baudelaire dedicated a lyric in *Les Fleurs du mal*. Both sculptures feature a mask; in one it is held by a skeleton, and in the other it is in the hands of a scantily dressed young woman, a marble version of which can be seen to this day in the Tuileries. Apart from the mask, the essential thing for Baudelaire, as it was for Tiepolo, was the elegance of the skeleton,

"*l'élégance sans nom de l'humaine armature.*" But, even more than in the verses of *Danse macabre,* Baudelaire outlines the situation in prose: "Imagine a tall female skeleton ready to go to a party. With her flat, negress's face, her smile without lips or gums, and her gaze merely a hollow full of shadows, the horrid thing that was once a beautiful woman looks as if she is seeking vaguely in space for the delightful hour of the appointment or the solemn hour of the sabbat inscribed on the invisible clock-face of the centuries. Her corset, dissected by time, projects frivolously from her bodice, like a withered posy from its wrapping, and this funereal thought stands atop the pedestal of a sumptuous crinoline."

Only one element is missing, if we compare the two statues by Christophe and Tiepolo's vignette: the snakes. But not in Baudelaire. In *Danse macabre,* which amounts to a faithful ekphrasis in verse of one of Christophe's two sculptures, Baudelaire manages to see a snake *that is not there,* a snake that corresponds perfectly, in position, to the one that in Tiepolo is about to bite the maiden on her left breast: "*À travers le treillis recourbé de tes côtes / Je vois, errant encore, l'insatiable aspic.*" (Over the curved trellis of your sides / I see the asp, insatiable, still wandering.) Between Tiepolo and Baudelaire, with a perpendicular movement, the body of the maiden and the elegant skeleton overlap and separate, united by the incessant swaying of the asp, which—even when it is absent—Baudelaire's fancy imagines as present. Elsewhere he would compare his "*chère indolente*" to "a serpent dancing around a stick." But wasn't this also an image that recurred for no reason we can be sure of in Tiepolo's *Scherzi?*

The consistency—and the boldness—with which Tiepolo re-introduced certain of his figures (the stern Orientals, the owls

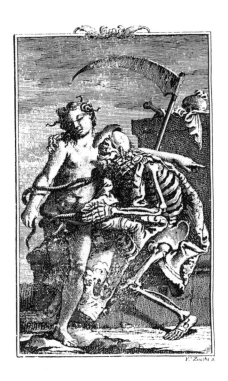

and bats in dazzling light, the hearty and possessive old men clinging on to Nymphs or goddesses, the snakes coiled around poles) applied to all forms and dimensions: canvases, etchings, and frescoed ceilings alike. Such was the intrusiveness and the regularity with which such figures appeared that one may suspect that they derived from an assumption: the conviction that, in all probability, they would pass unnoticed. Proof of this would also lie in the fact that for two and a half centuries details of this kind were all but ignored. It is unlikely that on the vast surfaces of Palazzo Clerici someone might recognize the Orientals glowering from behind a drape, or the delightful bat alongside Proserpine. Otherwise one might think that a highly restricted circle

of people—a kind of pictorial sect—would instantly spot these characters and take pleasure in them, as if recognizing a coded sign. But sometimes you get the impression that Tiepolo enjoyed defying the requirements of the places where he found himself painting. On the ceiling of the Scuola dei Carmini (one of his most strictly devotional compositions, dedicated to the scapulary of Saint Simon Stock) he painted one of his most attractive angels—and, in general, seldom in painting have there been angels as attractive as Tiepolo's. This angel has his arms raised and in the hollow of his armpits we see a soft down. This was not customary with angels. Not even in Guercino or Guy François or Caravaggio. And obviously there is no need to attribute to Tiepolo any intention of emphasizing a certain earthly nature in the figure. Nothing was more alien to Tiepolo than the animus of Caravaggio. And nothing is as calmly celestial as this angel, despite that unusual physiological characteristic.

Tiepolo is a biographer's nightmare. He moves among villas, palazzi, and churches, in compliance with the wishes of his patrons. On no occasion does he show any sign of the artist's syndrome. We know nothing of his ill humors, or of his gloomy or euphoric moments. His life appears like that of a lawyer who, as his curriculum vitae, can only list a series of cases won or lost. Tiepolo is the opposite of a painter like Goya, who provides all kinds of satisfactions: love affairs, political clashes, illness, melancholy. But the course of Tiepolo's doings is inescapably monotonous. The only variants are the dimensions of the canvases or the ceilings to be painted. To state, as we read in Molmenti, that Tiepolo "lived his life like a calm lake, healthy and happy amid domestic bliss, with no obstacles, without bitterness, without struggle" is obviously wholly arbitrary. But at the

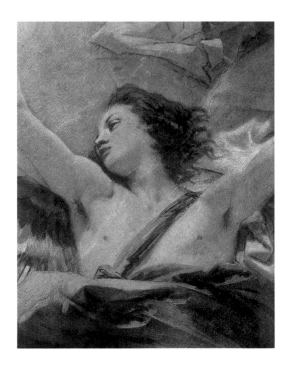

same time it is very significant: if such statements were guess-work, it was also because there are no episodes that might clearly contradict them.

Only when he found himself invited to foreign courts was Tiepolo obliged to make decisions that would change the order of his life. And here too his criterion was sober and pragmatic. He refused an invitation from the king of Sweden because the fee struck him as inadequate. But when the Venetian authorities had him understand, also through the intervention of the supreme inquisitor, that it would have been inopportune to refuse the king of Spain's invitation to fresco the royal palace, he obeyed. "Unexpectedly summoned by one empowered to command, I

was enjoined to make ready to leave immediately, exemption from this being impossible, in order to comply with the urgings of H.C.M. [His Catholic Majesty]," he recounts in a letter. But, from a report written by the Duke of Montealegre about his meeting with Tiepolo regarding the commission for the frescoes in the royal palace, it emerges that Tiepolo did his utmost to resist. Falling back on a wide variety of arguments, listed by the duke as follows, Tiepolo apparently said that "he was not a robust man, nor one accustomed to long and difficult journeys"; that he had to "marry off his numerous family, who would remain in Venice, and he found himself on the point of arranging the marriage of one of his daughters." Finally he suffered from "panic terrors, both regarding the Alps and the sea." Soon Tiepolo was to leave for Madrid. A one-way trip.

Carl Gustaf, Count Tessin, a gentleman of the Swedish court, the son of the architect of the royal palace in Stockholm and an enthusiastic art lover, arrived in Venice in May 1736, hoping to find there the right painter to decorate his king's palace. For some time, Tessin had been purchasing works of art for the king on his various travels, especially in France. In Venice he bought, among other things, a Canaletto, six drawings by Piazzetta, and two small canvases by Tiepolo: one mythological and the other Christian. Instantly he saw in Tiepolo the right artist for the works in Stockholm. He dashed off his first impressions in a letter: "In his pictures all are richly dressed, even beggars. Is this not all the rage? Apart from that, he is full of spirit, indulgent as any Taraval; he has a boundless fire, splendid colors, and is prodigiously swift." Noted almost in shorthand, these are still the liveliest and most penetrating words that any contemporary wrote about Tiepolo. You can sense the congeniality, the thrill of

excitement the painter conveyed to his patron. Yet Tiepolo and Tessin did not come to an agreement. Tiepolo thought the fee offered by the king of Sweden was too low. Tessin was offended. But ten months later he spoke wistfully of Tiepolo in a letter to Anton Maria Zanetti: "I pray you news of Signor Tiepolo, I still hold him dear, and I should really like to know, it is merely the price that still keeps us apart. . . . I am convinced that Tiepolo would not regret [this], and I would give him, as I offered, board and lodging in my house, as well as the king's pension."

Tessin had grasped an essential point: in Tiepolo the poor do not appear to be any less rich than the rich. In the anonymous crowd prostrating themselves before Saint Dominic on the ceiling of the Gesuati, there is a powerfully built young man, lost in devotion, who is pressing one cheek to the ground as if he wished to plunge even lower, while in his right hand he is clutching a rosary. If we look at his clothes, we note the bright pink of his shirt, sublimely delicate and elegant, in contrast with his knotted muscles and unkempt hair. Above the prostrate man, a magnificent lower-class woman—perhaps his wife—has arranged with the skill and meticulous care of a lady-in-waiting her various garments and the striped cloth in which she has wrapped her little boy. These two figures stand next to the doge, who is holding out his hand to receive the rosary from Saint Dominic. But certainly the doge has no more majesty or presence than they. Indeed the roles could be reversed: the doge might be the postulant and the supporting player were he not betrayed by his doge's hat, while the lower-class couple might aspire to the rank of the main figures. In this way Tiepolo invented something one might dream about to this day: a democracy leveled off toward the top, where aesthetic quality makes it possible to eliminate any divergence in status. It is the boldest

and most plausible political program, still not invalidated. And still waiting to be put into practice.

Like Shakespeare's Antony, Tiepolo could have said: "I' the east my pleasure lies." There is no scene, coincidental or solemn, that he does not have guarded by his Orientals, as if only they could guarantee the pleasure of painting. This most Western of painters, as was Chopin of musicians, darted away from his immediate surroundings: they had to be either the Venice of Veronese, two hundred years before, or an unspecified Orient. With these elements he had to compose every scene. Yet no one had such a swift, sure hand when it came to capturing on paper the outlines of the everyday life that he was familiar with, as can be seen in the sketches, whether they are isolated characters or a farmhouse or a roof. But Giambattista decided to conceal this prodigious talent in his sketchbooks. Sharing out the powers, the father delegated to his son Giandomenico that part of life he was in contact with on the streets every day. And the result was often superb. If you wish to grasp the epoch and the places in an instant, nothing is more effective than Giandomenico's frescoes at Zianigo. But at times all you need is a drawing, like his *A Stroll in the Rain*. A minimum deployment of forces, an immense resonance.

Giandomenico's *Stroll* is a suspended, light chord, yet it conceals a sharp, wounding point. Seven characters, seen from behind, are walking tranquilly in rainfall that cannot be seen. But is it really raining? There are three umbrellas and one of the characters has covered her head with a cloth, but at the same time the figures cast distinct shadows. So the sun is out. Are the umbrellas to provide protection from the rain or the sun? We cannot say for sure. What strikes one is the silence, the solitude of the strollers. They are close, they are going in the same direc-

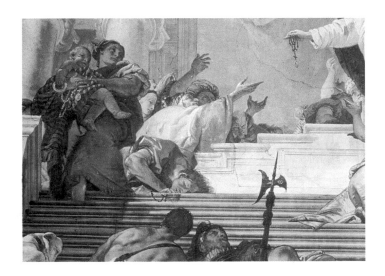

tion—and they ignore one another. Movement is slow, almost unnoticeable. The two characters on the far sides are almost motionless. Where are they going? In the background we catch a glimpse of a gentle slope and a hint of trees. Birds roam across the sky, as in some of Giambattista's *Scherzi*. The figures are dressed in city clothes, immaculate. There is also a dignified Punchinello. The figure on the far left with the cloth over her head is vaguely odd. But there is nothing picturesque about the composition as a whole. The total extraneousness of the characters is ruled by a tacit accord between them, as if a single reason had caused them to converge in that point in space, at that moment. The perfect opposite of their image is that of the Great March, mocked by Milan Kundera. Promoted by the Messieurs Homais of the nineteenth century, it continued to proceed throughout the twentieth, its ranks growing denser. But here each character exists for himself, even the family group in the center, with the man giving the woman his arm and his hand to

the little boy. No one is in a hurry—and all are heading toward the same destination, which perhaps is death.

Tiepolo did not want to be original in any way. The dogs (greyhounds or lapdogs) that dot his paintings derive from Veronese. And so do the slanting tree trunks. Even in imitating, Tiepolo did not want to be original. Sebastiano Ricci had already imitated Veronese when Tiepolo was a young man. At that time Ricci was the dominant painter in Venice. Imitating Veronese implied a certain way of looking at the city's past, which had to be sumptuous, nobly decorated, and devoid of any obvious tensions. Tiepolo happily adapted to a trail already blazed. As a result Tessin described him as a "follower of Paolo Veronese," and Algarotti immediately saw him as one who could carry on painting in the "manner of Veronese." But was not Veronese already a superlative painter? To what extent could this revival of his style and scene setting, two centuries later, have added something to painting? With Sebastiano Ricci, in fact, Veronese's gold was devalued. Refinement plunged toward affectation. What would happen with the next step?

It was around 1740, when the artist had only just turned forty, perfectly mature, that Tiepolo found himself painting a subject that Veronese and his studio had worked on several times (four versions have survived): *The Finding of Moses.* He decided to copy, as much as he could, the elements used by Veronese in the most imposing version, which at that time could be seen in the Palazzo Grimani. Starting with the format, a long horizontal rectangle (178 × 277 centimeters for Veronese, 200 × 339 for Tiepolo, but you would have to add the figure of the halberdier with the greyhound, excised from the picture by an unknown hand: today that halberdier is part of a collection in Turin). The

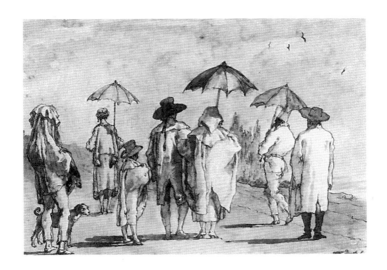

correspondences are precise: two halberdiers in Veronese, three in Tiepolo; two greyhounds in Veronese, two in Tiepolo; one lap-dog in Veronese, one in Tiepolo; various slanting tree trunks in Veronese, various trunks in Tiepolo; a female dwarf in Veronese, a male dwarf in Tiepolo. It is as if Tiepolo had made a crafty bet with himself: could he compose a variation that repeated the highest possible number of elements in a picture, while distancing it as far as possible from the original? An objective ahead of the times, and one that would be easier to attribute to Stravinsky than to an eighteenth-century painter. But Tiepolo kept faith with his bet and won it in the manner most congenial to him: by making sure that no one noticed.

In the two horizontal versions of *The Finding of Moses*—the Veronese in Dresden and the Tiepolo—you can try to enter, and stroll around, as Denis Diderot had done with Joseph Vernet's *Sites*. In Veronese, the pharaoh's daughter has left the palace to go to bathe in the Nile, with a train of handmaidens and equerries.

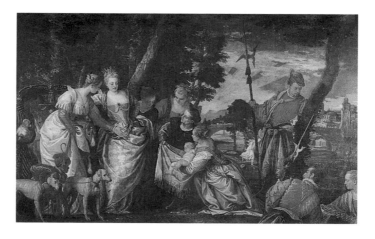

She is dressed like a Venetian lady of rank at the height of the six-
teenth century. Opulent, benevolent. She has not taken off her
crown. Slightly plump, but less than the other princess—
Europa—whom Veronese painted as she was being seated on the
back of a meek bull who is intent on licking her left foot.

In Veronese, the pharaoh's daughter has tawny blond hair. She
has not come out on foot; behind her we can see two ponies
and the outline of a black carriage with gilt relief work. And she
hasn't gone very far: on the other side of the wood with the
slanting tree trunks there is the arch of a bridge, absolutely Ital-
ian, which leads to the city. A city with porticoes and columns.
In the vertical versions of *The Finding of Moses,* now in the Prado
and the National Gallery in Washington, Veronese did not refrain
from showing, with a profusion of details, the bridge and the city
in the background. And in all of the pictures we can glimpse on
the riverbank a young girl running, draped in a white dress. In
fact in the vertical versions there are two girls. Who are they?
In their white dresses, ruffled by the wind, they represent the
only element in the picture that cannot be dated. They might be

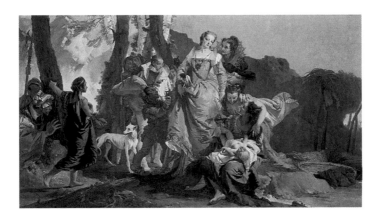

another appearance of the handmaidens, on their way to bathe and play, already scantily dressed. Or Nymphs, always near water, with the breeze ruffling their clothes. Although each of the figures gathered around the pharaoh's daughter is involved in some activity, the picture freezes them in impervious fixity. But Veronese concentrates all the potential disorder on the movement of the little white figure visible in the background, the torso cut in two by the shaft of a halberd in the foreground. Something similar happens in the vertical versions, with the other girl in motion, who is bringing one hand to her ankle, as if to adjust her sandal, and with this he injects a minimal factor of imbalance into that world where all is in balance—and where it seems hard to conceive of anything being otherwise.

The overall impression is of a perfect continuity between the artificial place of men, on the far side of the bridge, and nature, with its dense wood. It is almost as if the scene had taken place inside the pharaoh's palace. Only the darkening of the color, in the depths of the wood, indicates that in that place there is something called nature. With one hand resting on the back of the

handmaiden who is showing her baby Moses, and the other arm arched at her own side, the princess acknowledges the surprise of the little creature saved from the waters. The slightly oblique lines of the pharaoh's daughter's sides suffice to decide the quality of the painting, far superior to the vertical versions, where the princess's pose is matronly and commonsensical. With these minimal shifts Veronese succeeded in composing a scene protected from all possible intrusions from the outside, a scene suspended in a calm perpetuity, yet moved by a distant tremor, like a throb.

About two centuries later, frequenting the same places and breathing in the same light, Tiepolo appears. Alpers and Baxandall are right when they write that, for Tiepolo, "Veronese was Painting"; in fact Veronese *is* painting, for anyone. He is the distant, luxuriant, and gilded source from which images overflow, without the burden of meaning. He is the pure unfolding of figures on the surface, like so many unrolled carpets. For Tiepolo too this was the only admissible implication in his art.

But in painting there also circulates something unseen that informs every particle of matter: time. Tiepolo wanted to reproduce Veronese, but in a looser fashion, as a tribute to the passage of time. He took from him a great number of elements and left them to drift where their nature took them. In the end, there is nothing as similar as these two pictures, but neither is there anything as divergent.

In Tiepolo first and foremost the background with the bridge and the city has disappeared. This time we are going to witness the encounter between the supreme artifice and an untamed, indifferent nature. Tall, slender, provided with an invisible support beneath her abundant clothing, the pharaoh's daughter is the very glory of artifice. Without a crown, but studded with pearls: in her hair, around her neck, at her wrists, hanging from

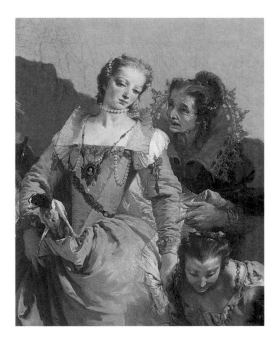

her bodice. The pearls cling to her as if to flypaper. But the most eccentric feature is a belt of buckles and dark precious stones slung diagonally across her torso, like a bandolier of cartridges. Starting from the tight-fitting, V-shaped bodice, the fabric swells into folds and waves, copious enough to hold safely a lapdog, strongly attracted to the doughnut that the princess's dwarf is showing it, teasingly. This too happened in the moment that was to decide Moses's fate.

With the pharaoh's daughter Tiepolo already introduces some decisive changes. The imperturbable placidity of Veronese's princess has been replaced with a restrained, codified nervousness. Although Michael Levey claimed to know that "dress, it seems will always take precedence in her thoughts over any

emotion," all that can be said with certainty about Tiepolo's princess is that she is not wearing a stock expression—whereas by then painting was tending, fatefully, to be populated by stock expressions. What many critics have defined as inexpressiveness in Tiepolo's faces is the sign of their disengagement from set meanings. The realm of expression is far larger and more elusive than the basically modest range still current in those years for great biblical projects, oscillating between horror, scorn, surprise, tenderness, emotion, and measured eloquence. The world was made of other things too—and Tiepolo was a tireless explorer of those intermediate areas, nameless and for the most part off the beaten track. The pharaoh's daughter inhabits one of those areas. From her liquid gaze—perhaps indifferent, perhaps melancholy—and from her features, which still possess a few childish traces, especially in the lips and chin, we may presume nothing with certainty. If not this: the princess is listening to something that is being whispered in her ear by the Elegant Old Lady standing behind her—a lady of rank, as is proved by her jewels (she too wears numerous pearls in her hair) and her extremely fine white ruff. She certainly does have an unambiguous, rapacious expression: she wants her message to reach the princess, as she talks she is pointing at the baby with her index finger. She is a variant of the *dueña:* a woman who was once beautiful, who has lived a great deal, too much, and is now in the young woman's service. Her eye is perceptive, her wrinkles many, her expression tense. But here there comes into play a mechanism that countless other times acts on those who move within Tiepolo's painting: that Elegant Old Lady is a character we already know. In the frescoes in the Palazzo Patriarcale in Udine she is Sarah greeting the Angel. And in Tiepolo's most caustic work *Danae and Jupiter,* she is Danae's *dueña,* intent on

collecting on a tray the few coins that Jupiter has let fall. This is already disconcerting: the same character, recognizable by her physiognomic traits, from her hair parted in the middle and her clothes (still black and still worn together with an exquisite ruff), is also used for the wife of the patriarch Abraham, when she receives an unhoped-for heavenly gift; for the procuress of an indolent and chubby courtesan, when she collects cash from a rich divine client; and for the adviser to the pharaoh's daughter, when she is suggesting something to her. But these are not the only appearances of the Elegant Old Lady. In Verolanuova, in the large canvas *The Gathering of Manna,* if we look closely at the crowd of Jews as they collect the fruits of the miracle, the Elegant Old Lady appears again. She is still dressed in the same way, her head encircled by the white ruff, although perhaps the sojourn in the desert has somewhat spoiled her clothes and her hairdo, and beside her there is an Oriental.

It may be that the pharaoh's daughter painted by Tiepolo is a fatuous young girl, worn out by the long hours devoted to her toilette. But there is no doubt that her figure changes and becomes notably more complex if we consider it together with the two characters at her side: the Elegant Old Lady on her left, the page on her right. The old lady in black, the page in white silk. While the Elegant Old Lady is one of Tiepolo's serial characters, good for the most diverse uses and occasions, the page represents the boldest Tiepolo, the one aiming for uniqueness. Many critics have neglected the page, but not Levey, who wrote of him: "[He] might be modelled in Meissen or Dresden china, it has come from Tiepolo's imagination as a fresh touch of fantasy, not found in Veronese or Ricci."

But why should this page, a generic element par excellence, be unique? Overshadowed by the slender figure of the princess,

who is standing on a piece of raised ground (but the whole pic-
ture plays on the disproportion between the figures), dressed
right down to his feet in white silk with a broad, flowing pink
collar (and maybe this is the original *Tiepolo pink*), the page is
holding a golden cushion with tassels. More than a follower of
the princess, he looks like her younger brother, with finer, more
singular features. His tawny blond hair is barely less tawny than
that of the princess, but it belongs to the same family. Worn
drawn backward, it reveals a rounded brow, slightly concave at
the temples. The page is not effeminate, but hermaphroditic. His
gaze is very serious, penetrating. He is not looking at the
foundling baby, or at the princess, or at anyone else. If he is star-
ing at something, it is the medallion on the pharaoh's daughter's

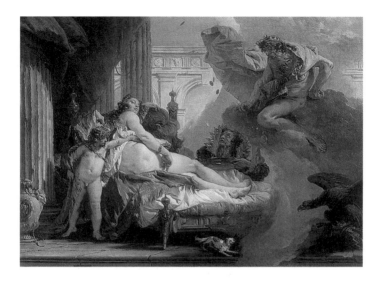

bosom, maybe a cameo, one of her numerous jewels. But we notice that his gaze is suspended in emptiness. By virtue of his style, and his pose, the page seems separated from all the other figures by a sort of anthropological caesura. It is as if his lineaments required much more time to produce than those of the other characters, so worldly, their functions so well defined, from the Elegant Old Lady to the halberdiers, and to the omnipresent Oriental who is looking on. If we were to say which period the page belongs to, it would not come naturally to think of sixteenth-century Venice, to which the cut of his clothes would seem to assign him, but to a word that only in Nietzsche has attained its definitive sound: *décadence*. The page belongs to that which, by its essence, comes *after,* which combines within itself all saps and all humors, which it transforms and exists in the midst of the rest of the world like a shard of another origin, like the word *décadence* in Nietzsche's German

prose. But merely wanting to be a *décadent* does not make you such. It requires a long labor of time, a slow alchemical ripening. This happened with Tiepolo's page. By now it would be impossible to confuse him with all the rest, as he appears in the midground, behind a dwarf and a greyhound.

The only character who never came off for Tiepolo was Jesus. The process of turning him into a little holy image had been going on for too long by then, as can be seen in the various versions of Jesus by Sebastiano Ricci, Tiepolo's predecessor. And Tiepolo was no man to go against the flow. He never opposed anything; on the contrary he flowed along too, but just a little faster than the current. In the paintings in which he appears, Jesus is always the weakest point of the picture, other areas of which may well be magnificent. Drama, pure suffering, salvation—all elements far from Tiepolo, who was devoted only to

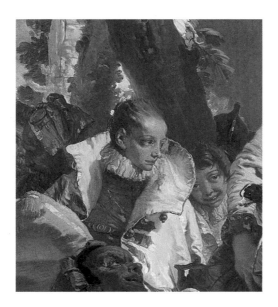

the epiphany—and hence to angels, Cupids, Nymphs, Satyrs, Satyresses—all those intermediate and mediating creatures entrusted with the psychic circulation between heaven and earth. As he followed in the wake of this vast population, mostly ignored by common humanity, Tiepolo felt at ease. Indeed, perhaps only among them.

Proof of this can be seen in one of Tiepolo's drawings in the Uffizi, *Satyr and Satyress with Cornucopia:* a flash of pagan vivacity, like nothing ever seen during the Renaissance, and like nothing ever seen after it. The two figures stand out from the paper, almost scorching it. At the same time they possess the lightness of a darting movement, which might dissolve—together with them—a moment later. The female Satyr's animal nature is not edulcorated; in fact it is emphasized: from her hooves to the top of her thighs her legs are covered with goat's fleece and they are

shown apart, which painters were not allowed to do when depicting a nude woman. Instead her torso and face are wholly feminine; they seem to belong to an extremely beautiful girl who for a whim has decided to adorn herself with a goat's ears. The cornucopia is solemn and sinuous, like a serpent or a lightning bolt falling from the sky. The Satyr has only one leg, which becomes a kind of tail, as in the primordial Fohi of Chinese origins. From the tip of the Satyr's single leg to the tip of the female Satyr's splayed right leg all is constant, swaying movement. These are not characters, but clots of energy, which thanks to a felicitous play of appearances also possess a body and a face. But you cannot be sure that they will still be there a moment later.

Tiepolo painted the legs of a female Satyr with a sure and sober hand, but he occasionally yielded (to sentimentalism, to emphasis, to stock expressions, to eloquence) when painting the gestures of a female saint. Drama was alien to him, if not in the form of the kind of psychic turmoil that in the *Scherzi* hovers above a sacrificial altar. Whether in *The Death of Hyacinth* or in *The Ascent to Calvary* or *Christ in the Garden of Gethsemane,* pictorially speaking the most unconvincing figure is always the one who is suffering (be it Jesus or Apollo's young lover), while the intensity is concentrated in the Orientals who look on, their faces often masklike.

An epoch incapable of understanding, or even of conceiving the tragic, the eighteenth century surrounded itself—in music, in the theater, and in painting—with portrayals of that which lies at the roots of tragedy: sacrifice. With the air of a perplexed chronicler, Michael Levey noted: "at no other time was the sacrifice of Isaac, for example, so popular a subject for painting." Tiepolo also conformed. He devoted two frescoes to *The Sacrifice of Iphi-*

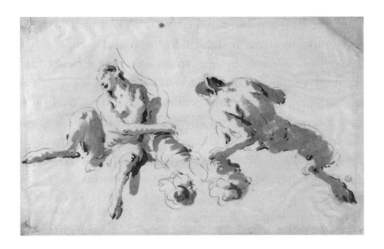

*genia,* one in Villa Valmarana and the other in Villa Corner in Merlengo. This last was destroyed because, when the villa changed hands, "the figure of Iphigenia, whose bosom was bared and nude, struck Bishop Soldati as too licentious"—and his nephews were even more zealous than he: they had the frescoes obliterated, including the chinoiseries, certainly delightful. This is what the sacrifice of Iphigenia had become: a chance for an aria by the primadonna and a parade of men-at-arms, for some maudlin sentiment and the odd bared breast. No one seemed to remember what the situation implied: in the space of a few hours, the daughter of the "lord of men," *ánax andrôn,* a venerated and untouchable young woman, became a beast whose throat was to be slit, in accordance with standard procedures.

In Villa Valmarana, Tiepolo did not distance himself very much from the stock manner. His Calchas and his Iphigenia are not memorable, whereas a certain terror may be inspired by the place in which they find themselves: surrounded by marbles and columns, all spic-and-span like some future Californian portico,

outstanding elements include the long blade in Calchas's fist, an ax leaning against the steps of the altar, and the silver tray that a young man is solicitously holding out to receive the blood. Neatness and butchery. There where the tragedy was looming, Tiepolo seemed to grow impatient, as if he wished to let himself be temporarily replaced by some expert in the required poses and expressions. But he then reappears at the height of his powers to paint the marginal figures: the Orientals, clearly observing the scene, indefatigable supervisors—and their gaze is already trained on the doe that is about to take Iphigenia's place.

But everything changes, turned inside out like a sock, when it is the Orientals who act, in the *Capricci* and the *Scherzi*. In those works we feel as if we have been hurled out of the century to return to life in some remote epoch, where a sacrifice was not one of those things one watched at the opera, but the source of all actions. And the archaic significance of sacrifice resurfaced. Hence, even though their clothing was different, the Orientals remind us of the Vedic *adhvaryu* and *hotr* bustling around the oblatory pyre.

The Tiepolos were one of the great Venetian families. In the thirteenth century the doge Jacopo Tiepolo had gifted the Dominican order with the land where the basilica of Saints John and Paul was later to rise. But Giambattista Tiepolo was not his descendant. His father was a "parcenevole," a stock owner in the boats that unloaded cargo in the port of Venice. Giambattista was born in the working-class district of Castello and his father died when he was one year old. For his entire lifetime people called him Tiepoletto ("little Tiepolo"). Perhaps to distinguish him from the great Tiepolos, perhaps to hint at the fact that he was known to all, like a mask or a demon of the place.

When Tiepolo wanted to play the obsequious Venetian—

especially obsequious toward those powerful men who were also his patrons—he became embarrassing, indulging in excesses worthy of a Chinese tightrope walker who takes your breath away with his acrobatic feats and the constant pretense that he is about to plunge to the ground. A letter to Algarotti, among the few that have survived, leaves one with a feeling of comic giddiness:

"My Most Excellent and Revered Lord Count, Such and so great has always been my confidence, Illustrious My Lord Count, that in your heart there still lingers the long-standing regard for my person that, despite the time elapsed, I was fully persuaded that in you there had been absolutely no diminution of the memory of he who remains your good and sincere servitor. A goodly proof that I did not deceive myself lies in your note, Esteemed My Lord Count, which confirms me in my persuasion and at the same time consoles me with the kind expressions that I read in the aforesaid note. I cannot and I know not how to offer aught in exchange for this, if not by attesting my respect and by proffering you my sincerest thanks, adding moreover that there has been no diminution in me of the memory of my infinite obligation, nor of the love I have always borne for your most worthy Person, and so I once more and with the greatest pleasure welcome the honor of serving you in all that might be of service to you with that same solicitousness of which I have at all times essayed to give proof, and hence I cannot better employ the time in those few days that I shall be [there] in order to carry out your most esteemed commands. I add solely for your information that without fail at the end of the present month personal business obliges me to repair for some days to Milan, where I shall remain for no more than ten or twelve days, and upon my

return home I shall leave no more in the certainty that I might serve you."

This wild, uncontainable exterior monologue is dated March 16, 1761, therefore eight years after the completion of the Würzburg frescoes and a year before Tiepolo's departure for Madrid. A glorious, sought-after painter, but by now elderly, Tiepolo nonetheless felt duty-bound to write in those terms to Algarotti, who was not even a vain aristocrat but the connoisseur who had sponsored his painting for years and years. The customs of the day are not enough to explain Tiepolo's behavior, just as the elaborate coiffures of George III's time are not enough to explain those flaunted by Fuseli's women. Moreover, on occasion Tiepolo was capable of using a completely different tone, casual and familiar, with the same Algarotti, as in a letter written almost twenty years previously, when Tiepolo was busy frescoing Villa Cordellina. This is what he wrote to his friend: "Here I am and I can't get anything done because there's too many foreigners here. I swear I would get far more pleasure out of one day in your company talking about painting than all the amusements in this villa, and believe me there are more than a few of those." This time the tone is engaging—and we know that the connoisseur Algarotti would also have been very glad to talk about painting with Tiepolo. Once, with regard to two paintings by Lodovico Carracci that differed notably in manner, Algarotti had written that one would have needed "all the sagacity of Tiepoletto, great judge of manner that he is, to recognize that those two paintings were by the same hand."

Perhaps, as with Mozart, it is not advisable to probe Tiepolo's psyche. It would have been in vain. The man who could not write a letter without a profusion of bowing and scraping,

apologies, declarations of loyalty, gratitude, obsequiousness, deference, far beyond the requirements of courtesy, and forever getting entangled with grammar and syntax, was the same man who—with a sovereign sense of impunity and tranquil insolence—had strewn the plates of the *Scherzi* and the skies and continents of Würzburg with mocking and caustic details.

What are the implications of the theatricalization of the world in Tiepolo? Veronese had already set this process in motion, as if it were obvious. His canvases lead one to believe that the world existed first and foremost to be painted, whereas with Tiepolo we go beyond this: the doors of existence were hoisted off their hinges and what was thrown open on the other side rested on a cloud, as with the Virgin or Venus. This could hardly fail to have consequences on the stability and consistency of the whole.

Historical and thematic affinities can conceal profound incompatibilities, rooted in physiology, as among hostile theologians. This was the case between François Boucher and Tiepolo, who lived parallel lives and died within a few weeks of each other. It is revealing to compare one of Boucher's two pictures of *Vulcan Presenting Venus with Arms for Aeneas* and Tiepolo's version of the same subject. Boucher set the scene in a soft, fluffy sky, teeming with a "fricassee of children" (the description comes from Madame Geoffrin and was first applied to a Greuze), where a Venus who looks slightly hyperthyroidal but with impeccable breasts waits idly for Vulcan to hand her the sword already forged for her protégé. As for Vulcan, the only signs of his craft are an anvil and a vise.

Those skies spread out by Boucher seem cloying when compared with Tiepolo's version, where in the middle of the gloomy, claustrophobic forge of the divine smith, Venus is portrayed

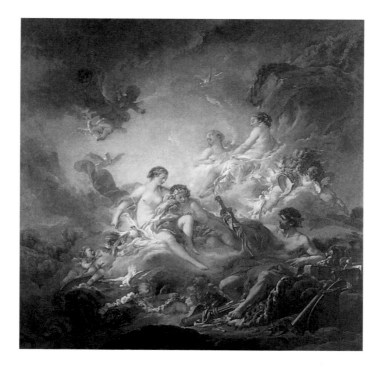

lying on a cloud that is also congealed foam or a vast bed. The
face does not attain the imperious enchantment of other blondes
by Tiepolo, but the pose reveals the goddess by its sovereign
ease. For Venus it is not a matter of asking, but of showing her-
self. Floating on her pure white mount, and without even notic-
ing it, Venus has slipped through the prison bars that separate the
artificer's scorching workshop from the world. And now her
cloud has landed on the ground, occupying the smithy with the
naturalness of a rock that has been growing together with the
floor forever. But two columns—one of which is broken—
suffice to offer the equivalent of the tree trunks dear to Tiepolo
and to remind us that, after all, this singular scene takes place on
Olympus.

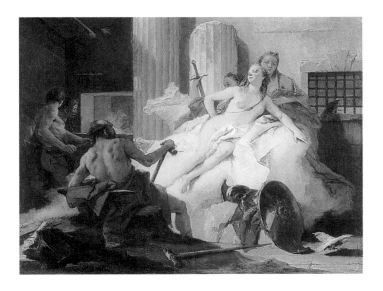

The distinction between Boucher and Tiepolo is clear: in his unabashed frivolity, Tiepolo succeeds in preserving the sense of what an epiphany really is; Boucher is unsure about the matter. But how would that Tiepolo have been judged had it been shown at the Salon? Certainly badly. It could not be considered a *grande machine* and not even a *scène galante*. And the word *epiphany* had no place in the lexicon of the Enlightenment, even though it was a modality of light. The fact that Tiepolo did not find favor helps us to understand a certain barren, jaded character, a certain meanness of soul that was to be long perpetuated in the Salons. Nor was Tiepolo's influence on a fine draftsman like Dandré-Bardon, as claimed by Pierre Rosenberg, sufficient to mitigate the *fin de non recevoir,* based on incomprehension and no longer on ignorance, which France reserved for Tiepolo. There was a fundamental incompatibility, which shows through even in Charles-Nicolas Cochin's praise of Tiepolo, generous but restrictive and paternalistic, in his letter to the Comte de Caylus

("Tiepolo has a wealth of talent above all for ceilings, in which he successfully risks the boldest foreshortenings; there is something parochial and a little barren about his style, above all because of the excessive luminosity he favors in his paintings").

Algarotti's first biographer, Michelessi, credited the count with having a beneficial influence on Tiepolo: "Even the illustrious Tiepoletto is indebted to [Algarotti's] frequent amicable counsels because they partly tempered that impassioned poetic imagination of his." Tiepolo's excesses—extremely numerous, right from the first works—did not therefore escape his contemporaries and, even if they ended up being put down to his "impassioned poetic imagination," this did not lead to their being considered favorably. Evidently in Italy too there was a tendency toward those *grandes machines* that turned up every year at the Salon and before which Diderot struggled not to yawn. To his good fortune, Tiepolo was happily alien to the intellectual trends that surrounded him—although he had nothing against going along with whoever paid him enough. Transposed into the Romantic period, his "impassioned poetic imagination" would have been irksome because it was wholly devoid of flabby sentimentalism. In the Enlightenment period (but the Enlightenment in Venice was, as children say, "pretend"), he was up against a certain aridity of the spirit that at the time seemed *comme il faut*.

There is something petty about the acrimony with which Roberto Longhi lashed out against the fatuousness of Tiepolo's patrons and the artist's malleability in conforming with their desires. Instead, he might have admired as a rare example of preestablished harmony the fact that on a good four occasions in the space of a few years various noble families of the Veneto asked Tiepolo to paint Time revealing Truth, in the sense of

unveiling her. Tiepolo's patrons' aim was to contemplate on the ceilings of their palazzi and villas a subject that was absolutely moral but one that also featured a beautiful naked woman, or at least a scantily dressed one. But Tiepolo wanted to paint a certain old man, potent and absorbed in his thoughts, wrapped in an intimate embrace with a certain voluptuous blonde. Both held a strong physical attraction for Tiepolo. And for him they were the ideal couple, far more than legendary lovers such as Rinaldo and Armida or Medoro and Angelica. He painted those figures with élan, but they always had to keep up a sentimental and at times a rather vacuous air, as if reciting a compulsory script. Time and Truth, instead, do not even need to look at each other. They have known each other so well, since time immemorial in fact, that each one can afford to remain sunk for a long time—for as long as the painting endured—in their own thoughts, without the other taking umbrage. In the meantime Truth is aware of Time's light yet firm grasp on her hip. This reassures her.

The young blond woman and the old, fearsome man with the beard: this is the polarity that Tiepolo relied upon, as soon as he had a pretext for doing so. Whether they are Truth and Time or Cleopatra and the two Orientals at her side (to protect her or to keep watch on her?), everywhere beauty is presented as sovereign: it demands this combination, which is also a dissonance of elements. The Orientals would be nothing on their own—but even Cleopatra needs them, far more than the occasional captain just off a ship. Other ships may arrive: every time the proud and unwitting lover is left amazed and humiliated before the sight of Cleopatra dissolving her most precious pearl in vinegar—and then *drinking* it. Whereas the Orientals, who observe the scene from the shadows, are not amazed. They know the scene, they know that it may be repeated every time a ship docks in the port

of Alexandria to land a foreigner swollen with power but not yet accustomed to the meanders of Oriental wisdom, which is also worldly wisdom and can make use of a pearl and a goblet full of vinegar.

Doubts of all kinds may creep in regarding the relationship between Truth and Time. But between Venus and Time? According to all punitive and moralizing tenets, they ought to be antagonistic powers. Beauty fears nothing more than the scythe wielded by that winged old man. Not so for Tiepolo. Towering in the sky of Palazzo Clerici, Venus and Time are presented as a harmonious, serene couple who let nothing upset them. Venus is not the most irresistible of Tiepolo's tawny blondes, but she oozes eros. A round face, almost in the manner of Piazzetta, far from any concern for expressivity. A plump knee, a strong leg. Time is shown from the back. Tiepolo always had a preference for the sturdy male back, slightly curved. He seized every opportunity to paint it. Even when Saint Dominic is distributing the rosary, on the ceiling of the church of the Gesuati, an anonymous young man with a powerful back is watching him. But Time's back is something more: a prodigious concentration of strength, it is turned to us, ignoring us. It is already beyond, with respect to anyone looking at it. Two soft locks of white hair are parted at the nape of his neck: this is all we are permitted to see of his head.

But in the heavens the accessories count for more than the characters. And among these we should consider clouds. Venus and Time are resting on a fluffy turquoise mountain, from which hangs an indigo-colored cloth, with no purpose whatsoever. The gods are above all an opportunity for the epiphany of fabrics. Because people—strictly speaking—no longer exist, a bit like René Guénon, who used to say: "René Guénon does not exist."

Venus is holding a white rose—and its leaves are the only touch of green in the sky. They remind us that down there, very far away, there is the earth—and something called Nature. Venus's right arm brushes one of those superb flowered fabrics that were *always* a part of the last queen of Egypt's wardrobe. At the banquet with Antony, Cleopatra wears just such a fabric in a mauvish hue, while on receiving him at the port she prefers one with a honey-colored background (but also the Angel who appears to Sarah—in the Palazzo Patriarcale in Udine—had hastily dressed in another of these flowered fabrics, with a black motif on a sand-colored ground). Between Venus and Time, a kind of pink vortex whirls in the air: another fabric, which does not seem to belong to anyone and serves for nothing else than to manifest its existence. But the most amazing thing is the color of Time's huge wings. A slightly lighter turquoise than the cloud beneath. And the great scythe is tinged by the color of the supremely soft feathers. Its metallic gray benevolently welcomes light blue and silver reflections as far as the sharp point, which is a shard of orangey light. This family group (there is also a little Eros already blindfolded, clutching fast at his quiver, waiting to go back into action) brings together a sense of supreme indolence, concealed concord, and terror, all stacked up like a pile of laundry.

While the sturdy old man no longer has wings, his expression is dour and grim, his hand rapacious, and while the girl is more attractive than the vaguely dumpy Venus in Palazzo Clerici, the old man and the blooming young girl become another couple, that of Hades and Kore, or Pluto and Proserpine, in the sky of Palazzo Labia. In the realm of the dead, fabrics can only be more discreet, but a touch of indigo lingers on. And a little Eros does not forgo waving a golden fabric. The thing that remains identical is the wheel, even the workmanship of the spokes: the inex-

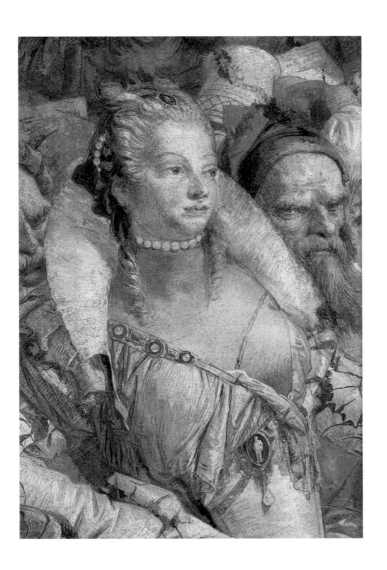

orable wheel of time, which if necessary can become a wheel on
Hades's chariot. Kore is no longer holding a white rose, but a
wreath made of the flowers she was picking when Hades carried
her off. Her face betrays neither surprise, nor fear, nor vexation.
Perfectly calm, she observes the observer and she allows Hades's
long and possessive fingers to clutch at her waist. The balance
between the figures is perfect, even in the relation between
Hades's knobbly, bronzed leg and Kore's soft white one. If some-
thing dramatic has happened it no longer seems to perturb
Kore's thoughts. And one cannot expect Hades to be too affable.

In Tiepolo's studio the drawings were collected in albums,
divided into categories. Each album covered a segment of his
repertoire. The compositions that appeared in these collections
were examples of things that one day might find a place in his
painting. Although they were very rarely transposed outright
(one example is to be seen in *The Sacrifice of Iphigenia,* in Villa Val-
marana ai Nani, where Calchas is taken from a drawing in which
the scene is focused on a subsequent moment: now the seer is
showing the blade of the knife and his gaze is fixed heavenward).
But in any event those figures came from the ranks of Tiepolo's
tribe, from which the characters of the frescoes and the canvases
would emerge from time to time.

Most of these albums have been dismembered by merchants
and collectors. But some—for example, the two in the Victoria
and Albert Museum—have remained complete. The second is
titled *Single Clothed Figures* and contains eighty-six characters
dressed in various styles. Another, no longer possible to recon-
struct, was titled *Single Figures for Ceilings.* The *Single Clothed
Figures* album offers a sequence of isolated characters, each cap-
tured in unmistakable gestures or postures.

Not that we need proof of this, but the album shows that Tiepolo's humanity was largely made up of Orientals: about two-thirds of the whole. Old, intimidating men, with marked features and expressions that are often grim, often rapacious. Alongside them, adolescents and blond women in full bloom with rounded faces and eyes flush with the skin. On the other hand a whole population of active adults with practical functions, men between thirty and fifty, all struggled to become figures. The premise of his painting, both sacred and secular, was a rigorous selection of human types, a physiognomic decimation, which permitted the survival of a highly restricted number of possibilities. Instead, the variety of appearances was enormous,

among groups of all types and provenance. The formidable homogeneity of Tiepolo's painting, despite its boundless compass, is above all a question of temperament and genetics, as if Tiepolo had identified only individuals with certain star signs, discarding without hesitation all the others. And this selection was also applied to clothing, poses, and makeup. For some centuries, every painter—you might say—had done something similar. But in Tiepolo, the more discordant the circumstances in which his characters appear, the bolder this procedure becomes. Nothing reveals the specific difference, or rather the uniqueness of Tiepolo, better than the comparison with Veronese, hailed as his immediate predecessor. In Veronese's wedding at Cana or his

version of the feast in the house of Levi the samples of humanity
are ecumenical. The important thing is a certain movement of
the figures and a certain chromatic fluctuation. As for the rest,
each character is replaceable. This is not the case in Tiepolo: his
choice of figures, down to the least of his supporting characters,
is partisan, oriented in a single direction. Tiepolo does not want
his company to be infiltrated by elements from the outside. And
he left out a considerable part of human physiognomic types. But
such is his ability in creating a play of contrasts within the circle
of his chosen characters that one's first impression is that of wan-
dering around a port in the Levant, where you come across
everything—and the colors of the animals, the fabrics, and the
people run more easily into one another than they do elsewhere.

The stage was boundless, the company not too numerous. But
it was made up of actors highly skilled in shifting register and
taking on disparate roles. That sturdy and sinewy old man who,
in the guise of Neptune, offers his tribute to the blond personifi-
cation of Venice is the same man who, on another day and
another canvas, now in Boston, was Time revealing Truth, who is
Venice herself, or a close relative. Like a couple of ballet
dancers, their gestures suggest long familiarity. Time lifts Truth
effortlessly in his bronzed arms, and Truth's hand, absent and
trusting, rests on his back. The allegories too are connected by
families and kinship, only a little more enduring than the human
sort. In terms of the way he appears, the most consistent figure
is Time, whom we find physiognomically identical, and still in
the act of unveiling Truth, on the ceiling of Villa Cordellina.
Now his hand is resting with intimate affection on the hip of his
companion, whom we recognize as a relative of the other Truth
identifiable more by the form of her bosom and her knee than by
her face, framed this time—a rare case—by darker, chestnut

hair. Time is an old man who emanates power but, if necessary (as in the oval for Palazzo Contarini, now in the National Gallery of London), is also capable of intense, silent devotion, as he holds in his arms the son whom Venus has just placed in his charge and whose head the mother is fondling, while she flaunts her bosom, one of the most enchanting in the history of painting. Not just because it is her right, for she is Venus, but because eroticism is perhaps the first of the distinctive and omnipresent qualities of Tiepolo. Eroticism: a quality of matter, like acidity, liquidity, and so on. Arrigo Cajumi once talked of the "freemasonry of pleasure," which he defined as "the religion of the eighteenth century." Tiepolo was not a member of that sect, but his work implied it. Every fiber of his painting is erotic. Not only in the bodies and poses but in the *ductus,* which washes over his figures like a wave of light. Yet Tiepolo is never gallant, also because the *scène galante* was alien to Venetian painting. But eros emanates from his every gesture—especially when he employs techniques that do not allow for any retouching: fresco and engraving. Through a kind of tacit agreement, the requirements of his patrons—ecclesiastics and nobles—came to coincide, for some decades, with the vocation of his art. Only fresco could allow Tiepolo's painting to aim at becoming the pure modulation of light, whereas light was otherwise conquered with difficulty through the many layers of oil painting. This contrast is noticeable throughout Tiepolo's lifetime, down to the last period in Madrid. And it is resolved perhaps only in the small-format canvases in which his work culminated, the equivalent for him of the "*petit pan de mur jaune*" for Vermeer.

Over the years, Tiepolo recomposed the world in a sequence of figures, gestures, and perspectives. An immense sequence, but a clearly circumscribed one: roughly four thousand drawings

in part systematically divided up, like soldiers ready to be sent into battle. By combining those figures, those gestures, and those perspectives, he knew he could fulfill any new commission, sacred or secular. Whether the patron was a religious brotherhood, a noble family, the king of Spain, or the czarina, it made little difference. Tiepolo was protected and separated from all thanks to the teeming caravanserai that invisibly surrounded him. The *ars combinatoria* proposed by Leibniz found its application not so much in the logic as in the figures. Tiepolo had set up a theatrical storehouse with which he could reproduce the continuity of the world by breaking it up into series of figural modules through which, once reshuffled, he rediscovered a continuity, often on the ceilings of churches and palazzi—or on the walls of villas. Certainly, the secret of this repertoire remained a family affair, restricted to the father and two of his sons. But among them it worked without hindrance. Not only did the sons succeed in following their father in every variant (Giandomenico used Orientals and greyhounds no less than Giambattista), but even where the sons seemed to be searching to make their own way (Giandomenico in the chronicles of everyday life, as in the frescoes of Villa Valmarana and Zianigo) their father accompanied them every time with drawings brimming with comedy and irony, portraying with a few indelible strokes the actors in an eternal play. Or, if he wished to fix a corner of the countryside or the flaking walls of a farmhouse, in his images there lay concealed the impalpable breath of life, even more so than in those of his brother-in-law Guardi. But in those drawings Giambattista always left out the human figure, as if it were a nuisance. As a rule, Giambattista could do anything Giandomenico and Lorenzo could do; and Giandomenico and Lorenzo could do a good part of what Giambattista could do, albeit with slightly less

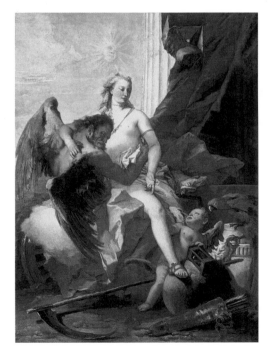

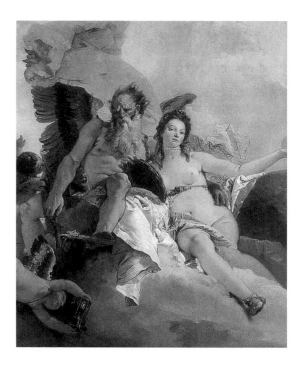

intensity and elegance, not only as a mark of their inadequacy but as a discreet act of homage to their father. It does not seem as if many have taken the trouble to probe the hidden biological and mental workings of the Tiepolo family. Right from Giambattista's day, there circulated the commonly accepted idea of the great decorator gifted with exceptional facility, the swiftest of painters. Afterward, he went abruptly out of fashion. Something similar was also said of Giandomenico. Then he too went abruptly out of fashion.

Tiepolo corresponded to a physiognomic schema, to a tone that Europe had come to emanate of its own, almost without notic-

ing, after centuries of obscure elaboration. And it was the sky of Europe—the only sky capable of embracing, with impartial benevolence, all images, of gods and men, saints and Nymphs, Olympus and Bethlehem. Scepsis and mysticism: Tiepolo welcomed all, but always reducing the dependence of the figures on gravity. Their gait became ever so slightly lighter, more fluid. But nothing was forgotten, from dwarfs and Punchinellos to angels and dragons. Because he was born in a city where women were in the habit of wearing masks and hence could afford "to do absolutely what they wish" (as a traveler put it), his metamorphic inclinations do not seem unnatural. Renowned above all for his speed and sureness of touch, he was in demand even outside the boundaries of La Serenissima, although the kingdoms of France and England remained closed to him. But nowhere was he recognized for what he was, nor did anyone grasp the peculiarity of the spell cast by his hand. Just as he had arrived without meeting any resistance, so he departed without arousing any regret, losing himself among the names of those of whom there is a confused, shadowy memory. No one suspected that with him vanished the last point of equilibrium in the visible. Elusive, precarious, and bewitching. Yet such was the case. Thereafter, even the possibility that that point existed was forgotten.

II

MERIDIAN
THEURGY

Tiepolo's oeuvre might be presented as a succession of more or less vast ceilings, more or less imposing altarpieces, more or less allusive mythological scenes and more or less official portraits, if it did not also contain, hidden in its heart, a rather inconspicuous cupboard full of spices and poisons marked by two labels intended to be reassuring: *Capricci* and *Scherzi di fantasia*. These are thirty-three etchings. Ten *Capricci,* twenty-three *Scherzi:* the *Capricci* are horizontal, while the *Scherzi* are prevalently (twenty-one out of twenty-three) vertical and larger in format. Together, they amount to almost all of Tiepolo's etchings, thirty-five in all. A limited oeuvre in terms of numbers—if we compare it to Stefano della Bella's output or even that of Tiepolo's son Giandomenico (more than 175 plates), or that of Rembrandt. But inexhaustible in its implications. With regard to the dating of these etchings there was a long-drawn-out and often futile debate, but one that reached two fixed points. In 1972 Maria Santifaller found in the Dresden Print Cabinet a copy of Anton Maria Zanetti's print collection, which includes Tiepolo's ten *Capricci,* dated 1743. (And Bettagno was later to find the date 1742 in the dedication of the Zanetti collection in Castle Howard.) In 1971 Lina Christina Frerichs published some doc-

uments connected to the Tiepolo Album in the Bibliothèque Nationale, an album containing all of Tiepolo's etchings from the Pierre-Jean Mariette collection, which was moved to the Cabinet du Roi in 1775. These documents revealed incontrovertibly that twenty out of the twenty-three *Scherzi* were already finished by 1757, while a note accompanying a bill from Giandomenico Tiepolo to Mariette tells us that the collector would soon receive in Paris another four as yet unfinished etchings by his father, including the title page. In 1775, following his father's death, Giandomenico was to add the title *Scherzi di fantasia* to that same title page, for the second edition of the complete etchings of Giambattista Tiepolo. In that edition the plates of the *Scherzi* were numbered for the first time, again the work of Giandomenico. This numbering, since every subsequent attempt to establish a reasoned sequence of the *Scherzi* proved groundless, remains the only one to which we may refer.

Finally, since the other etchings sold by Giandomenico to Mariette in 1757 all date from the period before the departure for Würzburg in 1750, Dario Succi has argued that at least twenty of the twenty-three *Scherzi* must have been completed by that date. But, according to Lina Christina Frerichs, "the last three etchings of the *Scherzi di fantasia* were begun by Giambattista in the year 1757 and did not come into Mariette's possession until the spring of 1762." Tiepolo's work as an etcher would therefore be mostly encompassed in the fourth decade of the century, with a coda in the fifth, the period of Tiepolo's full maturity, during which he allows his secret to emerge.

Punctilious and patient when tackling questions of dating or etching technique, almost all Tiepolo scholars begin to champ at the bit when it comes to the point of answering the most imme-

diate question: what is going on in the *Capricci* and the *Scherzi*? After some obligatory acknowledgment of the mysterious, enigmatic, obscure nature of the scenes, after references—always vague, devoid of substantiation, and hurried as if dealing with a matter already too well known—to esoteric atmospheres and influences at work in Venice in those years, the discourse hastens, with obvious relief, in another direction. The general tendency is to interpret the title *Scherzi* in a literal sense. Hence they are seen as an area of Tiepolo's work devoted to play, amusement, and escapism. The wording varies, but there is basic agreement. Terisio Pignatti talks of "the artist's *sentimental escapism*"; Anna Pallucchini of "the escapism of a roving imagination"; Diane Russell notes soberly, with regard to the *Capricci* and the *Scherzi,* that various experts "have considered them subjects devoid of specific significance—fantasies put together by Tiepolo for his own amusement." *Amusement:* this seems to be, after all, the most reassuring term, the most suitable counterweight to the troubled gravity that insinuates itself into the *Scherzi,* as if Tiepolo had acted, in that enclave of his oeuvre, in the spirit of a typically Italian attitude: "Let me have some fun." But, if the *Scherzi* were first and foremost, as Bruno Passamani opined, an "amusement for the quiet hours," one does not see why they were so repetitive and obsessive. Here imagination was certainly unbridled, but intensified and concentrated. If this were a question of amusement, it was a maniacal amusement, and one can understand the impatience with which the most diverse critics wished to exempt themselves from any study of what the *Scherzi* portray. Even the wise Henri Focillon, in a pioneering article, contented himself with observing that "in that witty, licentious, and languid Venice whose image was made to glitter by the poets, the strangest inventions, the most daring

fantasies and caprices become plausible," an observation that is perhaps incontrovertible, but remarkably generic. The air of Venice could very well be conducive to *capricci*—and it is also true that in those days Venice was "Europe's print warehouse." But these particular *Capricci* and *Scherzi* were solely by Tiepolo, solitary and proudly unrelated not only to any local precursor, but to the epoch as a whole. The only real affinity was with a younger Venetian, Piranesi, who first set foot in Tiepolo's studio in that very period. And, four years after the *Capricci,* Piranesi was to etch his grotesques, which are an extended, denser version of the *Capricci* with an Amazonian luxuriance of vegetation and ancient ruins.

Even more suspicious is the hastiness with which, immediately after calling up an occult background, people take pains to liquidate its relevance. Hence, for example, Diane Russell: "Tiepolo's etchings, however, have nothing in common with the complicated and specific occult practices of the time." This apodictic statement would lead us to suppose that the scholar has a deep knowledge of such "occult practices," but it is a knowledge of which she has left no trace in her essay, except in a fatuous second-hand quotation from Voltaire on the progress of superstition. Leaving aside the epochs, the schools, and the methods, the common denominator of criticism of the *Capricci* and the *Scherzi,* with regard to a pure description of what is happening in them, is embarrassment.

The dominant attitude toward Tiepolo's etchings within the confraternity of art historians is summed up incisively in the words Arthur Hind uses to describe them in his *A Short History of Engraving & Etching:* "These medleys of Satyrs and nymphs, gipsies and goats, philosophers and cavaliers, snakes and owls, trophies and tombs, are meaningless enough to us in subject, but

their balanced composition of triangular build, the lightness of touch and fancy, give a true idea of Tiepolo's genius for decorative combination." Two traits are immediately noticeable in these words: above all the "gipsies" who insinuate themselves between philosophers and Nymphs, even though nothing openly makes it possible to recognize them. A sign of deep, ineradicable puzzlement. In the second place, the rapid shifting of the irritating obscurity (and presumed irrelevance) of the subject to the reassuring and pleasing area of decoration is a device that corresponds to a lengthy, subterranean historical process, already under way at the height of the Middle Ages, by virtue of which monsters were relegated to the corners of ceilings and on the edges of cornices—because they too were *pure decoration.*

In Tiepolo's lifetime, the *Scherzi* circulated only among a few connoisseurs. The most illustrious of their number, Pierre-Jean Mariette, who never met Tiepolo, noted down these words in the volume in which he collected the etchings: "Twenty-one *Capricci* (dreams that passed through his head)." This was the collection, as yet incomplete, of the *Scherzi,* and no one else, in those years, was to define them so aptly.

You can roam right through the eighteenth century without finding anything that resembles the *Capricci* and the *Scherzi.* This epiphanic story in thirty-three episodes is as esoteric as anything to be found in an epoch that—more than any other—was an enemy of secrecy. By making confidential use of the means then used most of all for the diffusion of images (during the author's lifetime it would seem that some plates of the *Scherzi* circulated only among Anton Maria Zanetti di Girolamo, Pierre-Jean Mariette, and the Dresden Print Cabinet), Tiepolo condensed all that was present in his painting, but as an allusion and a marginal

variation. Now instead it became the radiating center. There were the Orientals, the snakes, the young boys, the Satyresses, the owls, a world that was a blend of the divine, the animal, and the human, where these elements would never have agreed to split up—much less to vanish. It is the ancient alliance between invisible powers and visible talismans, between demons of the air and creatures of flesh, that reasserts itself in the silence of the figures, often surprised in a moment of amazement or dismay, as if they were faced with the revelation of themselves. Far from the high ground that was the place of their encounters, in the towns and cities of the plains, life continued in a completely different form, among gallants and ladies, merchants and pettifoggers, curates and tax collectors, commoners and patricians. None of them would have ventured onto the high ground, which perhaps they knew only by reputation, as vaguely sinister. Yet there, unbeknownst to all and fixed only by a vibrant and febrile metallic point, an ancient pact would continue to be renewed, tightening into a knot that was the "*nodus et copula mundi,*" as Ficino put it. A knot assimilable to that formed by the snakes coiled around wooden staves, loyal guardians of the place.

The *Capricci* can be considered as a kind of prelude to the *Scherzi.* Their serial nature is less evident, as if the game were just about to get under way. But, one after another, we are introduced to the various characters that recur in the *Scherzi*—and already we can say of them, as Max Kozloff remarked, that "they are among each other because of an opaque necessity which we cannot grasp." The owls, impenetrable witnesses, are not yet there to welcome us, but there is an extremely lively snake, coiled around a long staff resting on the ground, and the faces—turned to the viewer—of young boys of flaunted, fragrant beauty, with the faintest of shadow on cheeks like peach fuzz.

Their priority having now been definitively ascertained, everything conspires to make one think that the *Capricci* were the experiments wherein for the first time there appears, takes shape, and is set out the locus (in the mnemotechnical sense) of the *Scherzi*. The characters, the animals, the half-buried stones, the altars, and even the truncated pyramid of the *Scherzi* are already present in the *Capricci*. But with the *Scherzi* the mesh of the narrative sequence seems to have tightened. Something is going on, something is constantly going on, but no one has been able to pinpoint what it is. The definitions that have been resorted to (necromancy, pyromancy, sacrifices, magi, astrologers, witchcraft) are generic and almost comical in their indifference to establishing what is happening in detail. And nothing enables us to specify unequivocally the relationship between the characters that come and go on the stage. Yet the aura that envelops these images is highly novelistic. If we observe them in sequence, we end up by recognizing in them the *demonic novel* that the eighteenth century did not manage to produce. It would have been the darkest, most enigmatic novel of the century, and probably the most memorable one too. In comparison, the Gothic novels that were about to invade Europe look like nursery school material.

But the *Scherzi* will remain a silent novel. Like all esoteric beings, Tiepolo said nothing about his secret. He merely displayed it. He knew that in all probability it would not have been recognized, and it wasn't. Tiepolo was the saturnine painter of radiant light. With the excess of light he covered and protected that obvious discrepancy. The *Scherzi* are also the place where a dazzling light erupts, and something that the literature of the time would have taken every care to avoid: a highly pronounced, silent, psychic density, an irrevocable union with the most ominous images and gestures of the pagan past, which not only come

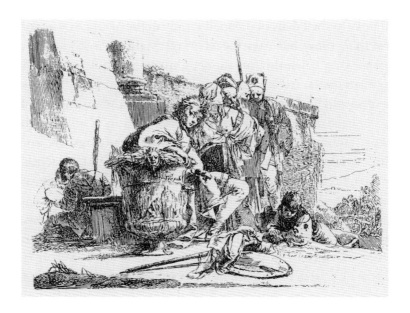

back to life but imperiously dominate the stage, self-sufficient and sovereign. Behind the *sprezzatura,* the facility, and the magnanimity of the gesture, Tiepolo guarded the treasure of his "strangeness of thoughts," already remarked by his contemporaries and ever more elusive for posterity. This man who spent his life responding swiftly to religious and secular patrons, nobles and parvenus, monarchs and princes, on only one occasion permitted himself to compose a body of work without a patron and without a buyer (or at least with extremely rare buyers), a body of work in which there reappear figures we have already encountered in paintings and frescoes, but that are now finally on their own, without any ceremonial function or apparatus: this is how the *Scherzi* came into being. In all his painting, Tiepolo had himself escorted by that extra-temporal, Oriental company, ready to take on all roles, from biblical and Roman

antiquity to the fables of Tasso, but only in the *Scherzi* is that company free. Only here do the characters allow us a glimpse of what they do when they are alone. Only here can we understand why their faces are so severe and so seductive. Only here is it revealed why Tiepolo's Orientals have those solemn and terrifying countenances, archaic and cryptic, so much so that they make Rembrandt's Orientals look almost innocuous. By a sardonic paradox, the sole convincing expression of utter depth in the Enlightenment period is to be attributed to a painter who was identified with the dazzling quality of his surface.

From Renaissance days in which the *prisca Aegyptiorum sapientia* (ancient Egyptian wisdom) had once more begun to hover over Europe like a virulent plot, for the first time there is a chance to see some of the actors in the plot assembled in daytime—but for this very reason perhaps more disturbing—surrounded by noble and sophisticated young boys, who resemble nothing more than the angels Giambattista painted for his ecclesiastical patrons. And now they are depicted beside erotic, affectionate Satyresses, as if that were their place of origin. But there is also Punchinello, who sometimes appears, and Death (perhaps they belonged to the same family?), and there are bucrania, skulls, and scattered bones. Many in-folios, carefully perused and creased. Abandoned scrolls. Ancient stones with reliefs in which we can recognize the faces of the people who found themselves nearby. Soldiers in shining armor. Meek sheep listening, awaiting the butcher. Horses, monkeys on chains. But above all snakes, always snakes, often coiled around a piece of wood. The mystery lies in them. Then trumpets, axes, and halberds. Owls forever on the spot, almost as if they were the hosts. Flames and ashes. And there is something that appears, something that various characters—in turn—point at, or which they are looking at, with grave, perhaps

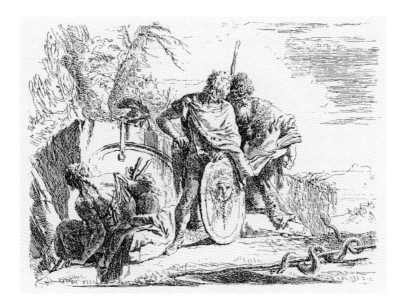

frightened expressions. What is it? Various forms of the invisible, which have not been etched into the plate. This is the reason why this motley company has come together. They are devotees of the invisible. And the man who devoted his work to the glory of the visible accompanies them, blends in with them, becomes one of them—and now he etches them with a few strokes, as if drawing them, on a copper plate. For, as one of his first commentators wrote: "he could say: conceiving and drawing and etching take me but an instant."

Just as a "Caprice" in Bernardo Bellotto's sense is not a place but an assembly of places, so a *Capriccio* in Tiepolo's sense is an assembly of characters, each the bearer of a totally distinct essence, which is combined and varied in exemplary poses and scenes. The game is closed and isolated right from the start.

What appears in a *Capriccio* was never to be a random view but one of an innumerable sequence, like that offered by a deck of cards. The more precisely a character (or a place) is identified, the more we can be sure that it can exist only inside the game. Each of Tiepolo's twenty-three *Scherzi* is a configuration of the game. We do not know how many others would have to be added in order to go back to the first, yet there is a distinct feeling of the periodicity and circularity of the sequence. The snakes shift to the left, above, to the ground, coiled around a staff, but we know that the snakes must be there. Likewise with the Orientals: they pop up from behind a sarcophagus, observe an altar, leaf through a book. And if we don't see them yet, it means they are about to arrive.

In parallel with the architectural *Capricci*, Tiepolo's variant of the *Capricci* and *Scherzi* offer first and foremost a certain incongruity *in time*. Satyrs and Satyresses encounter soldiers kitted out for some dynastic war. The Orientals—the maximum approximation of uninterrupted continuity in terms of aspect, because they have not changed since the days of the Magi—find themselves together with Punchinello, a more modern character, but also with Death, the oldest of all. And the epochs overlap in the rites they celebrate: pagan rites in Christian times. A family of Satyrs rest in the afternoon heat and it is hard to distinguish them from the Holy Family resting during the flight into Egypt. The characters seem to have known one another forever, as if they grew up together and had always been accustomed to meet on the high ground that is perhaps a closed world parallel to that of the cities we sometimes glimpse in the distance, on the plain. Whereas Goya's *Caprichos* are visions that belong to one time alone, that of the painter, Tiepolo's *Capricci* and *Scherzi* assume that the progress of time has been momentarily dissolved in the

coexistence of simultaneity. Even the half-buried bas-reliefs could not have belonged to such a remote epoch if in some of them we recognize the physiognomies of the very characters who meet on the high ground. Perhaps they were no more than family portraits.

With greater fairness than modern critics, who often pretend to know what Tiepolo was depicting in his *Scherzi* or otherwise avoid the argument (hence their pretensions to deal with only *formal values*), Charles Blanc declared that "this series of *Capricci* is incomprehensible and consequently impossible to describe." It was not easy to admit, at the height of the nineteenth century, that a master of the recent past had produced something impenetrable, both in the form of "obscure allegories that cannot be explained even through the symbols that the artist has liberally included in them," and in the form of "inventions of the kind dreamed of by the bizarre and somber genius of Salvator Rosa." All the more so if one recognizes the novelty and high quality of Tiepolo's etchings, something that Blanc grasped clear-sightedly, also explaining why they were the opposite of Rembrandt's etchings, to the point that he came to a paradox, thus expressed: "What an odd thing! it is Giambattista Tiepolo's prints, in other words pictures without color, that hail him as a colorist, even more than his paintings." The secret was the light, "a certain glittering of light" produced on the whiteness of the sheet by an etching that is "vibrant, light and fragmented." Blanc identified the peculiarity of Tiepolo's etching technique; nonetheless he was seized by a kind of bewilderment when faced with the *Scherzi:* "But while he lets the point run over the paint in obedience to the fantasies of his unbridled imagination, as he did in the series of the *Vari Capricci,* his work reveals the consequences of the fever that possesses him; nothing is stable, fixed

and willed; his hand trembles everywhere, and everywhere it expresses unequal, tangled forms, broken objects and a kind of luminous tremor. The ground shakes, the foliage shivers, the sky shifts, the drapes look like rags; the marbles are worn, the thrones devastated, the books in pieces. All is creased, threadbare, flaking, cracked, corroded, dented." Precisely in its excesses and repulsion, Blanc's description finally says what we see—albeit not what happens—in the *Scherzi*. The relentless singularity of those images, marked by the convergence of a superabundance of light and a kind of internal corrosion of the objects, a phenomenon that does not diminish them but intensifies their presence and power: this had never happened in the tortuous history of etching and has remained unrivaled to this day.

The first element that the characters in the *Scherzi* have in common is a certain gravity. They neither laugh nor smile. They often appear to be concentrating, pointing at something or looking at something that is being pointed at, perhaps amazed, perhaps terrified. Something is happening—and it is never completely clear what it is. Perhaps what is happening is invisible. It is the invisible that allows itself to be perceived. We are tempted to think this if we recall the *Capriccio* where Death grants an audience. If Death is the foremost of invisible entities, never has he been so familiar. All those present, even the hairless dog, have their gaze fixed on Death. Death is a skeleton, seated comfortably, with a certain elegance. His head is covered, like that of a woman in church. His shoulders are draped with a short cloak. Death behaves like one of the various characters in the habit of meeting in that place with its half-buried stones and bare, severed trunks. Seated at his ease, Death is holding an in-folio volume and his left

hand is keeping the place on two pages, with the air of one accustomed to books. His mouth is half open because Death—probably—is talking about something in connection with that book. What is there around him? One would say a carelessly draped cloth from which peeps a scroll: again, something that can be read. Behind Death there is a bucranium, but a particularly large one, like that of some prehistoric beast. This is accompanied by another bucranium, together with a skull, a bone, and other remains jumbled together on an altar that is taller than the characters listening intently to Death. A strange altar, if it is one. Perhaps it is a large square block, upon which those remains have simply been deposited. Even stranger. There is also an upright stone slab with a metal ring. The characters are grouped between the upright stone and the altar. The central character, a vigorous bearded man—one of those traditionally defined as Philosophers or Magi or Orientals in general—has one bare arm resting on the upright stone. He seems to be the one most intent on understanding what Death is saying. He too holds a scroll in his arms. Beside him, a very beautiful ephebe of noble countenance, whose gaze is fixed on Death. Behind the Oriental, a young blond woman with her hair up. She is holding a jar that is resting upon the upright slab. Other heads emerge from behind her, and a soldier's arm, with sword and shield, pointing at Death. Perhaps the soldier is the last to have noticed Death's presence. The Oriental and the young man seem to have been looking upon Death for some time already. It is superfluous for others to point this out to them. But the one whose gaze is fixed with the greatest intensity on Death, the one who is pointing at him in fact, is the hairless dog. This is not one of Tiepolo's ceremonial greyhounds. It is just an everyday, generic, skinny mutt. In pointing at Death he stands tense on his paws, expectant. A

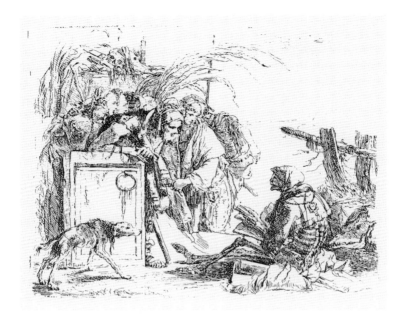

primordial hostility dominates him. There is none of that inter-
est, that indefinable kind of participation revealed by the group
of characters listening to Death. The dog has no need to listen to
him. It suffices for him to see Death, to recognize him.

The place is always the same: high ground. In the background we
can glimpse a plateau and the outline of some mountains, and
sometimes a city not too far in the distance (*Scherzi* 11, 18, 23), or
a tower with a house alongside it (*Scherzo* 22). There are trees:
some leafy, others bare, others with broken-off trunks, trees that
almost never grow straight. It is a place feared since biblical
times: "by the green trees upon the high ground," says Jeremiah.
But what was it that people feared to find in those places? The
Asherah. An odd word that recurs obsessively in the Bible,

where it appears in forty passages: "Burn their Asherah in the fire and cut down the idols of their gods"; "Cut down their Asherah and burn their idols in the fire." How many times, and with what stubborn vehemence, does Yahweh enjoin his people. Asherah designates a goddess, the partner of Baal. And at the same time certain sacred poles, which were worshipped. Asherah is a name

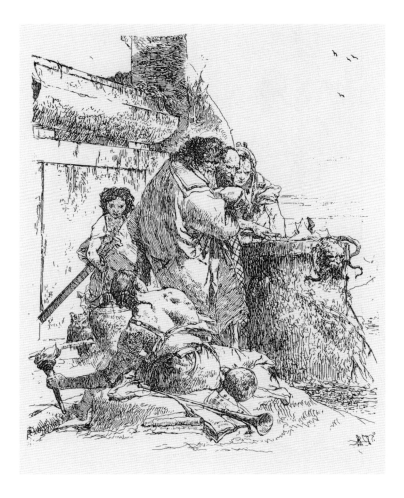

that condenses within itself the abomination of idolatry. Yet for a long time, until the reign of Manasseh, it happened that "the objects that had been made for Baal, for the Asherah, and for all the heavenly host" were housed *inside* the temple of Yahweh. For Israel, the perennial risk was that the house of Yahweh still contained altars for other divine beings. Hence Manasseh "made his

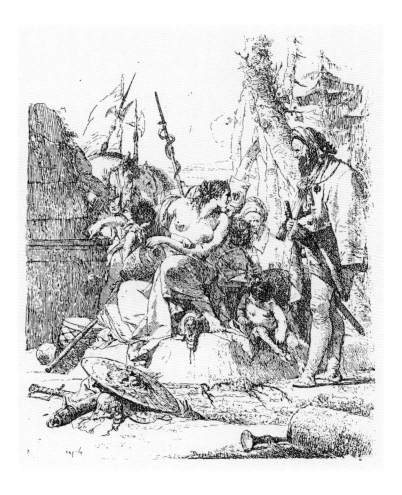

son pass through the fire [to make him immortal, as in Eleusis?], and practiced astrology, and magic, and dealt with familiar spirits and wizards: he wrought much wickedness in the sight of the LORD, to provoke him to anger."

Perhaps what Manasseh did was not wholly unrelated to the doings of the company assembled by Tiepolo in the *Scherzi*. Let

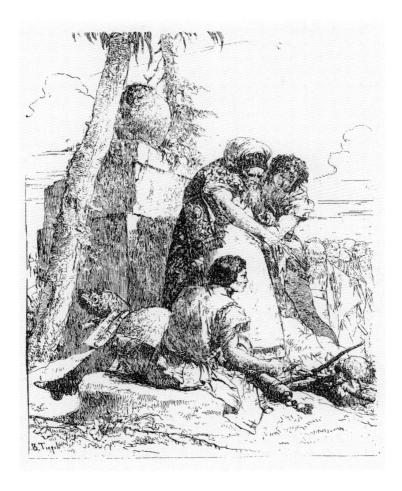

us leaf through these disparate beings, right from the blank title page. There to welcome our gaze are nine owls. Two are staring at the intruder, the viewer. Others ignore him. One is perched on a short branch and turns its soft wings to us, closed and indifferent. These nocturnal creatures have met up in broad daylight, a daylight one would say was sunny and perhaps even dazzlingly

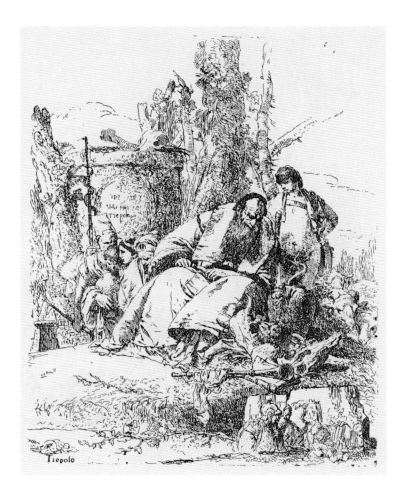

so. Six of them are sitting on a massive stone parallelepiped, not perfectly square, and half buried. On the ground there lie a stick and a sheaf of grass, signs that someone has passed by that way. And above all the scene is crossed by a long bare tree trunk, whose beginning and end cannot be seen: an uprooted trunk, much like a pole. That long, sharp, oblique line is like Giambat-

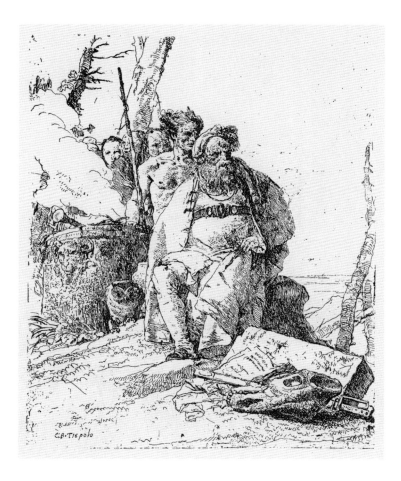

tista Tiepolo's signature. In his frescoes and etchings, in his myth-
ological and religious paintings, in formats large and small,
everywhere in Tiepolo's compositions we encounter an unrea-
sonable number of poles, flags, pennants, tree trunks, stakes,
staves, masting, branches, and halberds. Provided they are long
segments, preferably parallel or undulating, oblique and irregu-
lar lines, whatever kind they may be, they are welcome.

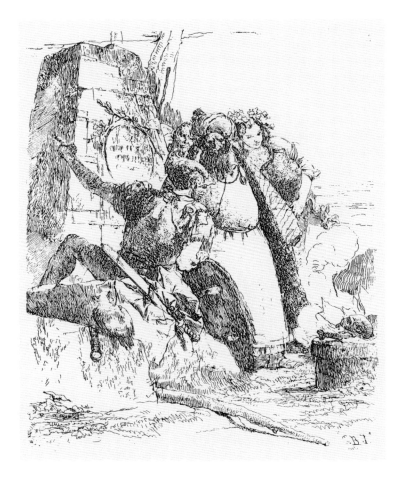

Before this, where had we seen those slanted trunks in paint-ings? In Veronese, naturally, for example in *The Finding of Moses,* which Tiepolo knew well. But in Veronese they are a matter of occasional and functional presences. For Tiepolo they are the matrix of painting. Why? So irrepressible is Tiepolo's sense of the boundless, overmastering nature of space—a sense he allows to issue freely from his painting—that we are led to presume that

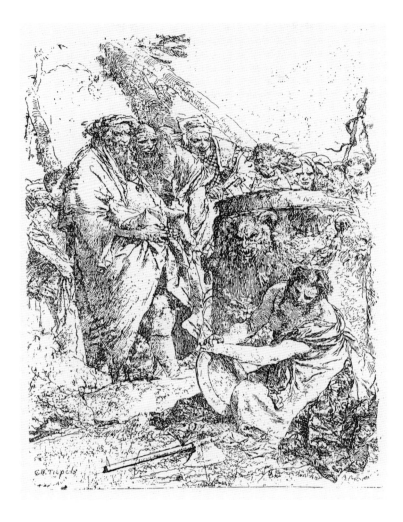

those intrusive posts, those trunks or poles or staves that appear everywhere without any plausible explanation, serve to mark and explore the immensity of the atmosphere. They are tokens of the momentary, fleeting order needed by that which happens in order to detach, isolate, and confine itself in space, in order to

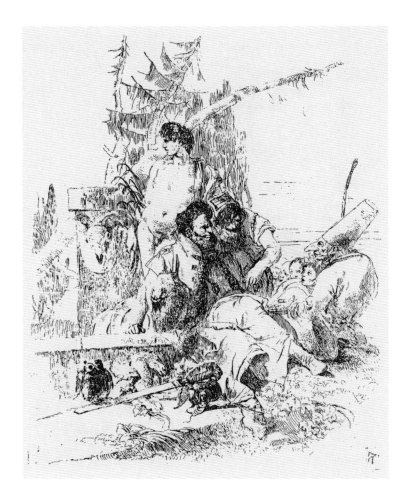

make a lucky escape from the terror of that which contains within itself infinity—potentially, if not even actually. And this is exactly what space is. Except for the sky, an entity whose "enigmatic instability" can only be attested to by clouds—another of Tiepolo's favorite elements. Every place is fit to be divided, wounded, etched by what—to use a generic collective—we

might call *poles*. Tiepolo is first and foremost the painter of poles. They are his phrasing, they mark the tempo of the musical articulation of space. In a transient and irregular way, the poles serve to demarcate portions of space. Without at least a hint of a frame there is no image, but at the same time only a boundless immensity can be the background against which the image stands out.

Never as in the *Scherzi* is this secret of Tiepolo's so manifest, asserted, flaunted; never as in the idolatrous high ground of the *Scherzi* does it take on so many new meanings.

It is sufficient to see in what company those poles appear. Let's take a look at who comes forward in the first *Scherzo* after the title page: three men—two bearded and imposing, one young and very handsome—a woman with bared shoulders, a

little boy, and an owl. The place is enclosed by stones: a sarcoph-
agus resting on a large cube, provided with a panel, an altar with
a head in relief, around which a snake is coiled. At first, the poles
are not too noticeable. But there is a thick trunk, smooth and
regular, that covers another, gnarled one. The little boy is hold-
ing a sheathed sword and what might be an in-folio. The owl is

clinging to an incongruous branch, just above the ground. Then
we discover other rectilinear elements: a long trumpet lying on
the ground, a short staff in the hands of one of the bearded men,
a torch in the woman's hand. Finally the altar itself, cylindrical,
massive. In the Pignatti edition, the title attributed to this *Scherzo*
is *Three Magi Burning a Snake*. In the 1996 catalog, Keith Chris-

tiansen contents himself with a generic: *Necromancy Scene.* But are we sure about what is happening on the altar? It's not easy to burn a snake, and it is an act full of consequences. All the inexhaustible events of the Mātabhārata originate in a sacrifice aimed at exterminating snakes. But snakes do not let themselves be exterminated.

Here we see small luminous waves that might be flames. And a black lump emerging from them that might be a snake's head. But in that case there should be at least two snakes, coiled around the face sculpted in relief on the altar. In its turn, this face has features very similar to, albeit more beastlike than, those of one of the three magi. On the ground, below the trum-

pet, there is a big open book and two rolls of parchment. And, under one of the women's feet, there is another pole or branch, thicker than the one on which the owl is perched. Between the woman and the small boy, a flask. Alongside the woman who is holding the torch, a wineskin. Four birds fly across the sky.

All these elements, even those that might seem minor or for-

tuitous, reappear in the other *Scherzi*. It is as if Tiepolo, in the twenty-three images of the series, had radically reduced the elements that make up the world. As if he had said: the game, our secret game, is made of these entities, which the viewer is permitted to see, even though he is still an intruder. Every *Scherzo* is a variation of that game. Every time the figures meet up again,

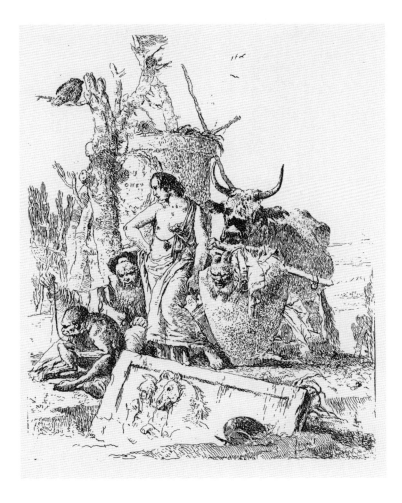

they exchange roles, take part in the same events, which are unclear and—for the viewer—never have any precise name. In over two hundred years, all attempts to define *what is happening* in these images have proved invariably inadequate. Only the actors know—and even they are often astonished. But something binds them together. Maybe they all belong, starting with

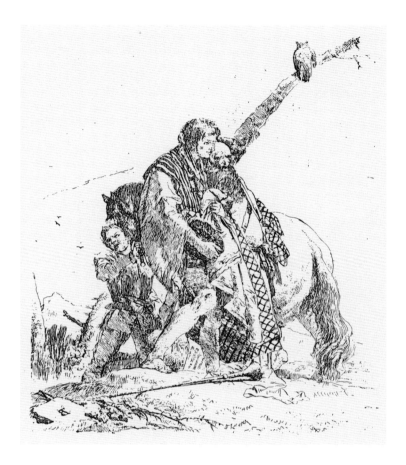

the owls, to the same sect or brotherhood. And they all know, without any doubt, why they have met in that place.

Now let's take a look at the next *Scherzo,* which Pignatti titles *Half-Naked Nymph with Two Youths, Surrounded by Six Men,* whereas in the 1986 catalog edited by Dario Succi it appears as *Seated Woman Talking to an Old Man,* and finally in the 1996 catalog for Ca' Rezzonico and the Metropolitan Museum it is defined as *A Witch Granting an Audience,* proof of the contrasting ideas held by the most diverse experts regarding what Tiepolo was portraying.

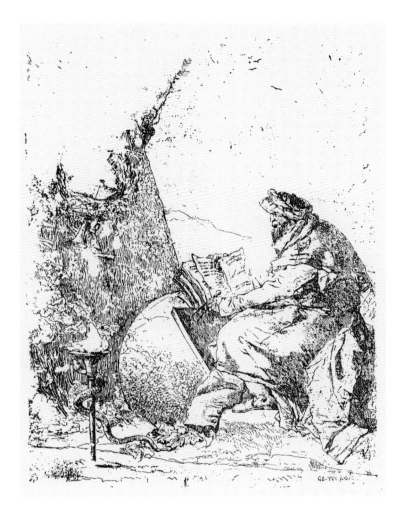

Here we have the immediate impression that we have once more found the woman whom we have so far seen only from her powerful, almost virile back. Now she shows herself face on. She has a voluptuous, naked bosom. Her hair is gathered up at her nape, a little disheveled, exactly as in the preceding *Scherzo*. Of the two children around her, as if seeking maternal protection,

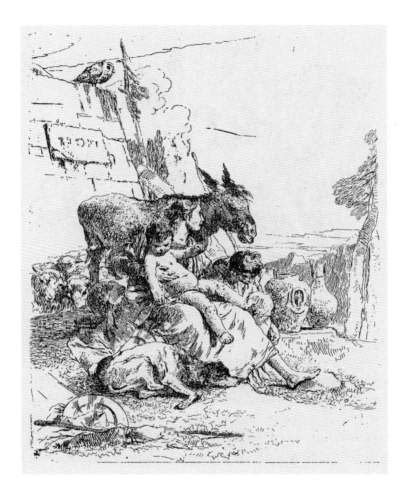

one is trying to climb up on her. The other is smaller, completely naked, and standing a little to one side. Only now do we notice his goatlike hooves, such is the continuity between his figure and that of his mother.

In Tiepolo's *geometrical locus* women can be surrounded equally by human children or Satyrlike offspring. What's more,

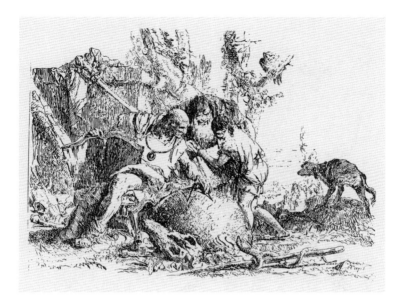

moving on from *Scherzo* 10 to *Scherzo* 11, she who is undoubtedly the same woman, with the same profile, the same breasts, and her hair worn up at the nape of her neck, reveals that she is *also* a Satyress. Nimble, strong, and covered with hair to the tops of the thighs, her caprine legs bear up a child who could be the little one who appeared in the other image. Alongside, to round off this family of Satyrs, there is a figure whose arched back is the only part we can see. It is in the same position as the woman when we saw her for the first time. And this back is only a little broader and more muscular. We are witnessing this woodland family in a moment of idleness. A musical family, one would say: abandoned on the ground are a trumpet, which we know already, and a tambourine. Evidently in Tiepolo's locus, to a certain extent, there still exists that continuity among beings that dates back to the remote past, when the distinctions among the

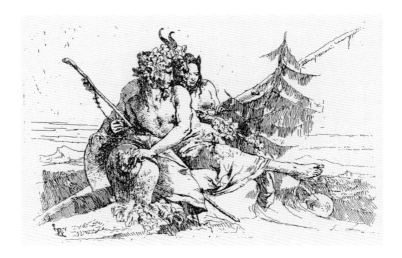

realms of nature were not so distinct and insuperable. And this applies to all the beings that appear among those trunks and stones: unversed moderns have good reasons for not knowing well whom they are dealing with.

It's easy to talk of necromancy or pyromancy—as if they were informatics or gardening. But, if we look at the gestures, things change. Now they are frightening. In *Scherzo* 4, an Oriental with a white beard, wearing a turban and an embroidered cloak, is pointing at something burning on the ground, among scraggy stumps: a human head. Two noble young men are also staring at this head. And not only them: in the background there is a crowd of other figures. In their midst, there stands out another Oriental with a beard and a cloak, but without a turban. A strong, hard expression. He is looking to one side. But behind him we see other gazes, trained on the severed head. They express a sense of alarm, of horror. Ragged clouds travel across the sky.

*Scherzo* 5 marks the return of the snake coiled around a staff and brandished like a standard by a character of whom all we can see is that he is wearing tall headgear. Again there is an Oriental dressed in flowing garments who is observing something. Animal skulls, a bucranium, a trumpet, a large book: all piled up. In their midst, an owl, and a jar with a snake's tail darting out of it. On the jar, as on the shields in *Scherzi* 2 and 4, a grinning face in relief, which could be that of a Satyr. But, as we know, it is not easy to distinguish a Satyr from the Devil.

Beside the Oriental is a half-naked youth. These powerful characters do not like to be alone. They stay close to young creatures who are always attractive. The snake's tail seems to be emerging from the youth's shadowy belly. But the fire has passed through here too. We need merely look up: above all the figures stands an altar, with bones and the skull of an animal. It is not clear who could stand high enough to dominate this altar. Only in the end do we notice that on the right, low down, there are the muzzles of some sheep. They have no shepherd. Why are they there? They are looking at the skulls of other animals.

Another Oriental with a cloak and turban appears in *Scherzo* 6. He has his back to an altar, which this time is smoking. A trumpet is also lying crosswise. Why? Between the altar and the Oriental, an owl keeps vigil. Behind the Oriental a young man, of rare beauty. Farther behind, other heads emerge. Slanted tree trunks intersect one another. In front, on the ground, a horse's skull, a sword, and a book. All the characters wear frowning, severe expressions. They are looking at something we cannot see.

There is another turbaned Oriental in *Scherzo* 7 (they all look the same, but as soon as we look at them carefully, they turn out to be very different). Yet again, he is looking at a burning head,

but this time it is almost reduced to a skull. The Oriental is escorted by a young girl, a delightful Bacchante, one would say, judging by the vine leaves decorating her head. But the scene does not consist only of the fire and the burning head. A helmeted soldier is looking at the fire and pointing in the opposite direction. Something else is happening, something that eludes us. And maybe it explains everything. Behind the Oriental emerge various figures, to one side of a truncated pyramid, which is to reappear several times. It is the axis of the place.

An even more alarming scene appears in *Scherzo* 8: there is still an altar, with Satyrs or Demons in relief, but the altar is still free of objects. It is waiting for something, someone. Around it, a crowd of faces, dominated by three Orientals—cold, engrossed, hard. On the other side of the altar there is a young woman with a bared breast and her hands resting on a metal plate. On the ground, an ax. Are they waiting for her? From between the legs and the flowing robes of an Oriental peep the eyes of an owl. And, in the background, the inevitable snake coiled around a staff. It is a reminder of who owns the place.

Finally, in *Scherzo* 9, a new character makes his appearance: it is Punchinello, who here does not seem to be much different from the Orientals. Even his hat might be that of a priest of Dura Europos. Again there is an altar, this time with a ram's head in relief. And once more there are outstandingly beautiful young men. One is half naked, behind two Orientals, with his delicate side and penis visible. Another, almost a boy, is behind Punchinello. We glimpse his noble, regular features, which contrast with those of the mask. Once more there is an owl on guard, this time beside the blade of a sword. For the second time (after *Scherzo* 5) we see a marble slab with horses in relief. The

classical ruins form the wings of the scene. Punchinello has the air of an old acquaintance who has joined the group. Perhaps he is passing through. Perhaps he is giving advice. Perhaps— simply—he is conversing, holding one arm straight like a puppet. It is his natural pose.

*Scherzi* 10 and 11 provide us with a breather. All have moved off, the Orientals first of all. This leaves a family of Satyrs, in agreeable inactivity. The mother has the same profile and the same voluptuous breasts as the woman in *Scherzo* 3, who held a little Satyr close to her. Perhaps it is the same person, sometimes a woman, other times a Satyress. The little Satyr twines his arm around his mother's arm with a trusting, delicate gesture. To one side the paterfamilias wears a grin. Some have seen mirth in that grin. It's not certain. Perched on a pole, an owl keeps watch. And, lest it be forgotten, a slim snake has coiled itself around the pole.

Then, in *Scherzo* 11, the family has moved. The Satyress still displays affection for her younger son, while in the shadows another little Satyr—an older son?—is holding up a stick with a snake waving at its top, like a ship's flag. This too seems like a moment of an afternoon rest. But this time alongside the truncated pyramid. The entire scene is traversed by an extremely long, bare, curved, improbably slanted tree trunk. It represents all the other trunks, which are missing here. Around the pyramid there must be a ditch, from which peep the heads and eyes of sheep. This time they look like specters of sheep, piled up. The adult male Satyr keeps a trumpet and a tambourine close to him. But why those sheep? It's not clear whether they are alive or dead, whether they are crowding the corner of a pen or of a slaughterhouse. Anyone taking a quick look at this image won't

even see them. In the background, on the plain, there is a sketchy outline of a city.

In *Scherzo* 12 the characters' looks are once more trained on something. Six of them are staring at a snake coiling and writhing about on the ground. The group is headed by an Oriental with a dark beard, who is resting one hand on another classical relief, in which we recognize a young girl who looks very like the one standing behind him. But in the relief it is she who covers a solemn old man with a white beard. A shifting of planes and periods. In the simulacrum and in the past something has happened that is inverted in the present and in reality. The most disquieting element of the scene appears in the background: behind the girl we glimpse half of a head, one that we might suspect is that of Death. It has black, empty eye sockets, but it would be quite easy not to notice them. And this is what is frightening: the ease with which Death passes unobserved. Higher up, the torso of a grinning Satyr. To one side, an owl looks on.

The lord of the place is the snake. *Scherzo* 13 provides proof of this. The figures are reduced to a minimum: two Orientals and a small boy. But this time the Oriental with the bushy black beard (perhaps the same one as in the previous *Scherzo*) is pointing out to the boy a snake coiling around a sword. All the variations of the serpent wand of Hermes must be experimented with. And it is never too soon to learn the serpent doctrine, even for the chubby little boy clinging to the Oriental's robes. An owl takes no interest in the scene and looks toward the plain from a truncated branch.

None of the characters in the *Scherzi* wears an expression that is cloying, insipid, posturing, sham, or required by circumstances. Whereas all of this is present in Tiepolo's oeuvre, especially in his religious paintings, it is absent in the *Scherzi*. The

*Scherzi* (which means "jokes") contain no trace of humor. The moment obliges a specific seriousness with which all comply: Satyrs and ephebes, Bacchantes and soldiers, Punchinello and sheep. The occasion that brings these characters together looms over them like a ceremonial duty, marked by a pervasive dread. A holy dread.

One might say that the Orientals are willing to teach the children and adolescents who surround them. For them, teaching means above all *pointing*. First it was the snake's turn, now (in *Scherzo* 14) an Oriental uses a stylus to point to something on a large, half-buried globe. A scene of lofty instruction. One of the two boys listening to the lesson is bent under the weight of an in-folio he is about to hand over to the Oriental. Behind, we see another in-folio opened wide. They must have just consulted it. It is a kind of open-air college, in the shade of the truncated pyramid. In other scenes, certain Orientals use compasses. Here, people read, write, and above all, they look. As Goethe put it: "Thinking is more interesting than knowing, but not than looking." Very often they are looking at snakes. This time too, behind the Oriental who is teaching the two boys another Oriental appears. He wears a fixed grin that is not very reassuring and he is holding the customary staff with a snake coiled around it. Meek sheep observe them, alongside a bucranium.

Is there a high point in the sequence? If there is, it is found in the only scene (*Scherzo* 17) where the pointer is not an Oriental, but a most beautiful, half-naked young man. He is pointing at Punchinello, who has reappeared. But this time he is dead. He is leaning against a stone slab. Is his the stiffness of a corpse and is the stone his coffin? Or is Punchinello too a relief in stone? We are in a place where both possibilities may hold. And where they may also coincide. Death makes his presence felt first through an

hourglass and a bone, which jut out from a tall boulder. And per-
haps we recognize him again, among the crowd of people behind
the young man who is pointing. Once again, we glimpse a face
whose eye sockets are too dark and hollow. Behind this head, as
in *Scherzo* 12, an incongruous staff rises up. On the ground,
coiled around another staff, a snake points its head at Punchi-
nello. It too is curious. A woman with a noble expression, her
hair worn up and with one bared breast, whom we have already
met on various occasions, is also contemplating the dead
Punchinello—the secret event that is now shown. With one
hand perhaps she is fondling an owl lurking beside the skull of a
horse, which is staring at something beyond the margins of the
etching.

The novel that unfolds in the *Scherzi* is circular and never-ending.
Every scene could follow every other and come before every
other. *Scherzo* 23, the last of Giandomenico's numbering, gives
off a sense of stasis and silence. Yet again, three gazes are trained
toward something we cannot see, at slightly differing angles. A
Bacchante with vine leaves and a rudimentary thyrsus, a Satyr
with twisted horns and a hint of a grin, a pensive Satyress with
pointed ears. We see no snakes, but a very long, imperious trunk
diagonally traverses the entire scene. This is another way of
reminding us where we are. In the background, on the plain, we
recognize the outline of a city. Inhabited by those who do not
know about, or who perhaps are unaware of, the meetings of
that company ready to come together again, shortly after—and
to break up once more. A company, in short, that—since then—
has never ceased meeting up.

With regard to Tiepolo's *Capricci* (a title that for him also
meant the *Scherzi*), Barrès finally found words suited to those

plates that until then had traveled through time virtually incognito and had lost their best chance—that of coming to the attention of Baudelaire. There was a reason why the understanding of such fascinating images had met with so much resistance and why they aroused a secret fear: "Tiepolo's *Capricci* are heroic collections in which all the souls of Venice are brought together; but when many centuries are condensed into symbolic figures, that repressed smile, that melancholy amid opulence are informed by a skepticism too delicate for the majority of men. A man who is too clear-sighted seems enigmatic." Hence Tiepolo had been shelved by posterity not because he was too fluent and malleable, but because he was too clear-sighted. Yet he continued to observe posterity, with ill-concealed irony, from the heights of his ceilings, where "sky, flags, marbles, books, adolescents, all that Tiepolo paints is threadbare, crumpled, devoured by his fever and this torrent of light."

But what is this light that floods into the *Scherzi?* The answer comes from the Neo-Platonist Iamblicus: "Now the light that one sees is a continuum (*synechés*), whole and identical everywhere, and so it is not possible to sever a part of it or to confine it within a circle or detach it from that which dispenses it." The continuity of that light guarantees that no barrier may block the path toward the gods—and from the gods toward the world. It guarantees the "theurgical communion," *theourgikè koinōnía,* without which no magic would be possible—or any thought that recognizes what the world is made of.

The Tiepolo devotee may also be recognized thus: he cannot resist following the artist's characters from the paintings to the frescoes, to the drawings and the etchings, as if they were so many characters from a novel, in fact a chain of novels, a *comédie*

*humaine* in which at some points they play a starring role, at others a marginal one, and at others again they simply move across the scene, like anonymous passersby.

After forty years of studying the etchings, even an austere and discreet scholar like Maria Santifaller decided to illustrate the story of a character from the *Scherzi*. He is the "nude young man," of rare beauty, who appears in *Scherzo* 17. This is how she describes him: "A vigorous, athletic torso, bull neck, strong, Herculean limbs; a thick head of rather wavy hair, a classic profile." In *Scherzo* 17 he is portrayed as—for the benefit of an Oriental—he points at the dead Punchinello, resting against a stone slab as if he were seated. Around, there is a crowd of the various characters who frequent the place. But in a drawing in the Victoria and Albert Museum (Knox 45) the same youth appears again, with the same Oriental. But now their positions are reversed. This time, the one pointing is the Oriental. The youth is captured "in a relaxed pose, intent solely on looking in the direction that the old man is indicating with his magic wand." The actor has become the spectator, while the Oriental, previously the spectator, has become the actor. But the two scenes could have followed each other within a short time span, perhaps even the very same day. Maria Santifaller notes that the youth is half-naked in *the same way:* "A shawl or a garment like the one in the drawing, is draped across his shoulder, and in his hand he holds leaves or leafy twigs also shown in the sketch." Even the frond the young man is holding is highly similar in both the etching and the sketch. There is no clue that allows us to establish whether the sketch was drawn hours or months or years before the etching. The only thing we can be sure of is that for Tiepolo the two moments, the two scenes coexisted and pointed to each other. The dead Punchinello who is missing from the sketch could

be situated immediately beyond the margins of the etching. Per-
haps he is the one the Oriental is pointing at with his wand (and,
naturally, in this case too there are other figures, in the back-
ground, observing the scene). But here there is a disconcerting
detail, which Santifaller does not mention: in the sketch the
young man's foot is trampling a shapeless white garment left
lying on the ground, while behind his calf we glimpse, lying on an
altar, the outline of what might be Punchinello's conical hat. Per-
haps what the Oriental is pointing at is the dead Punchinello
stripped of his clothes and his hat? But whoever saw Punchinello
without his clothes and hat? Perhaps this is why his figure is not
visible.

·   ·   ·

There is singular agreement among experts when they find themselves obliged to say what Tiepolo's *Scherzi* and *Capricci* represent. Perhaps exhausted by the disputes over questions of dating and etching technique, they suddenly fall silent or start meekly intoning words such as *magic, sacrifices,* and *necromancy.* At times, exasperated, they reach the point of mentioning "absurd rites." But what criterion can be applied to define a rite as *absurd?* And, in the first place, couldn't we describe Mass in the same way? People talk of magic, sacrifices, and necromancy. But of what kind? Aimed at whom? And why did Tiepolo isolate those scenes and arrange them in a sequence? Perhaps in an attempt to answer these questions, George Knox ventured that the *Scherzi* might well represent "themes relating to magic and witchcraft," but covered by a "satirical surface." A clumsy attempt to conceal embarrassment, because the foremost distinctive trait of the *Scherzi,* by way of a counterpoint to the title, is their total gravity. The most constant sentiment they arouse may be fear. Or a malaise that is very hard to dispel. There is not the slightest trace of satirical elements. Even the appearance of Punchinello marks the acme of distress, not of playfulness. Far less of satire.

But there is always a more refined degree of lack of understanding. And this is reached with the formulation of the hypothesis of the Gnostic nature of the *Scherzi.* For twenty centuries, by now, the word *Gnostic* has served as an inestimable aid to denoting something people are determined not to understand and from which they wish to flee at all costs. And, since snakes are constant, central characters in the *Scherzi,* scholars such as Charles Dempsey and Christel Thiem have suggested with remarkable presumption that Tiepolo wanted to stage an Ophidian cult, renewing links with a sect from the earliest centuries of

Christianity, and consequently thought to be still operating in the heart of eighteenth-century Venice: "This sect . . . appears to have been popular in Venice during the first third of the eighteenth century," Christel Thiem writes impassively, but she does not grant us references to any source whatsoever, and above all she does not specify what happened to such a "popular" sect in the *second* third of the eighteenth century. Perhaps, as we are dealing with a highly esoteric sect, one should not be surprised that it left no trace of its existence, except of course for the *Scherzi*. And moreover, Origen, who was writing toward the end of the second century A.D., had already spoken of the Ophites as "a very obscure sect." But the most striking thing about these hypotheses is their hastiness. To what branch of the Ophites, for example, was Tiepolo presumed to belong? To the Cainites, the Perates, the Sethites, the Barbelo-Gnostics, the Severians, the Nicolaitans, the Archontics? No answer is given. The space allotted to expound the Gnostic theory is generally equal to roughly one-tenth of that devoted by the same scholars to the problems of dating, often unsolvable—and also vain—in Tiepolo's case, because his mastery is prodigious right from the start and the same questions about dates are posed for those works that could pass for preparatory drawings, while the external sources that might offer us any sound testimony about the *Scherzi* are extremely thin on the ground. Hence it would be appropriate to yield before the evidence: the *Scherzi* are a ghost composition. Without them, Tiepolo's oeuvre would have its admirable fullness, devoid of lacunae. But, in their presence, the meaning of the whole changes radically. And all the more unexpectedly because the *Scherzi* are part of the work of an artist who never took the initiative in all his life and who waited for opportunities to come to him from the outside. In the meantime, variations

and repetitions of an obscure scene, always connected to the same place, continued to run through his mind. Something like a *primal scene* of painting.

When Tiepolo left for Würzburg, in November 1750, charged with frescoing the prince-bishop's Residenz in exchange for a fee of ten thousand Rhenish florins, the Ophites were not the topic of the day in Venice, but people certainly did talk and write a lot about witches and warlocks. Especially after the learned scholar from Rovereto, Girolamo Tartarotti, published (with the eminent Venetian publisher Giambattista Pasquali) his treatise *Del Congresso Notturno delle Lammie* (On the Nocturnal Meetings of Witches, 1749), which aroused immediate reactions and culminated with a smaller treatise by an even more illustrious scholar, Scipione Maffei, who chose for the occasion a mocking title: *Arte Magica Dileguata* (Magical Art Defeated).

Nor could Tiepolo think to get that far away, despite his journey, from this debate. Tartarotti mentioned in his book that "in Erbipoli [the Italian name for Würzburg] . . . in little more than two years, that is between 1627 and 1629, one hundred fifty witches and warlocks, including fourteen Curates, and five Canons, were decapitated and burned." Nor were these solely stories from the past. Again in Würzburg, just one year before Tiepolo's departure (and hence in 1749), one of the last witches in Europe was decapitated and her body burned. Her name was Maria Renata Singerin, and she had been "convinced since childhood of having had relations with the Devil and of having succeeded in concealing such wickedness until the age of seventy-three years." Tartarotti's intention was to ensure that atrocious stories such as that of the witch of Würzburg would not be repeated. But they were repeated: in 1751, in Salzburg, a

"hapless sixteen-year-old girl" accused of witchcraft was decapitated. Tartarotti intervened on her behalf, but without success. After much reading and six years of work on the *Congresso Notturno,* Tartarotti had worked out a very simple and linear theory, albeit one argued with all the appropriate and cumbersome caution: witchcraft did not exist, but magic did. Witchcraft was stuff for wretched, credulous women; magic, although false doctrine, was something for the learned, and hence his colleagues. If this were true, witches did not exist, therefore one could—and should—try to save those poor wretches who still lived under threat, especially in northern Europe. As for magic, it was inopportune to deny its existence, even if it was deplored. Above all because an imposing tradition of thinkers had maintained it did exist, but also for another, less obvious reason: by denying magic you paved the way for the negation of devils and then, gradually, for a possible intellectual impiety: "Does not denying the existence of devils pave the way, and even lead to denying the existence of God?" This observation was soon to appear in the *Animavversioni critiche sopra il notturno congresso delle lammie* (Critical Commentaries on the Nocturnal Meetings of Witches), one of the polemical works that Tartarotti's book triggered. The stakes were therefore very high indeed: from the impetus supplied by the negation of witchcraft it was possible to proceed to mock magic—as "the nothing that deceives the world" (the title of a work by a German Augustinian friar of the period)—and from that point it was not clear how things would end: perhaps as far as the blasphemy of *l'homme machine,* a new character on the European scene, whom Julien Offray de La Mettrie had introduced only two years before the publication of the *Congresso Notturno.*

A learned man from the provinces and a moderate spirit,

Girolamo Tartarotti wanted to put his vast knowledge as a jurist, historian, and antiquary at the service of a cause: to convince people that it was no longer necessary "to burn an infinite number of witches," thereby putting an end to the "great slaughter of those hapless women." He was convinced that "the more you burn them, the more they come teeming back." So he suggested considering the question as if it were a matter of the delusions of poor women, who were certainly blameworthy but not to be sent to the executioner, since "such a crime was no more than a trick of the fancy." The expression he used for a trick of the fancy was "*Scherzo* di fantasia," and we cannot hide the fact that this was the very expression used by Giandomenico for his father's etchings. In fact, this view of the cause of witchcraft had been widespread—Tartarotti pointed out with a vigilant sense of history—until the late fourteenth century, when we come across the first trace of the persuasion that the evil of witchcraft should be cured "with fire, and with the executioner": advice on a witchcraft case was asked of the great jurist Bartolo da Sassoferrato—and "Bartolo decided that she must be burned." The murderous fury directed against witches was therefore a recent, modern phenomenon. As the Enlightenment proceeded, so did credulity—and ferocity.

There is no need to fall back on Scipione Maffei if we are looking for the deprecation of magic. Pliny the Elder was far more effective. Dry, rigorous, and concise, on coming to book 30 of his *Natural History* he finally had the chance to vent his spleen. "Fraudulent more than any other art," magic was nonetheless the art that "more than any other and for a greater number of centuries has asserted itself." This Pliny admitted—and we might define this as the encyclopedist's cross, in the sense that the art endowed with the "greatest authority" coincided with the great-

est imposture. It is a singular condition of humanity, whereby the only thing strong enough to resist time and transmit itself unharmed is fraud. All this amounts to a radical uncertainty, which affected every form of knowledge and every tradition.

But Pliny did not give up and he tried to make sense of this monstrous phenomenon: magic had so much power that it succeeded in making three "arts" converge in itself: medicine, religion ("the fog of humankind"), and finally astrology. By tying up the mind with this "triple bond," magic had reached its peak. Consequently, Pliny admitted, "even today it is predominant among most peoples and in the East it imposes itself upon the king of kings."

For Pliny, authority was therefore mixed at the source with fraud. The greater the antiquity, the more brazen the imposture. Brusquely, Pliny expounded a doctrine that was to become engraved in the Western mind: Enlightenment scholars were merely his epigones. But Pliny wanted to exacerbate the situation by offering a swift historical profile: "Without a doubt [magic] arose in Persia with Zoroaster, as the authors concur." According to Eudoxus, Zoroaster lived "six thousand years before Plato's death; Aristotle thinks so too." The master of reason therefore accepted that Zoroaster had preceded him by a few thousand years. There was something very odd about that story. "*Mirum hoc in primis*" (First and foremost one is amazed by the fact), wrote Pliny, that magical doctrine was transmitted for such a long time without being "preserved by a series of illustrious intermediaries." The disarming candor of the scholar, which we find again in the following observation: nothing is as surprising as Homer's silence on magic, although it permeates his stories (here Pliny cites as examples Proteus, the Sirens, and Circe).

If we are to believe Herodotus, magic reached Greece with

the army of Xerxes. In his train there was also the magus Ostanes, he who "disseminated in every place that prodigious art, infecting the world wherever it crept in." Tiepolo's Orientals were descendants of that Ostanes, laden with a most ancient and treacherous authority.

According to a dating by now proven, Tiepolo's *Capricci* and *Scherzi* are from the same decade that ended with the Venetian debate between Tartarotti and Maffei on magic and witchcraft. There is no point in wondering what Tiepolo thought about this. His letters—not numerous—are devoted solely to works in progress, commissions, money, and obsequious formulas for the recipient. Not a word about intellectual topics—and certainly not about magic, a subject to which Tiepolo has never been linked, even indirectly, by any sources about him still extant. Yet even the critics most reluctant to understand have admitted that at the center of the *Capricci* and the *Scherzi* lie scenes of magic. But which magic? Theurgical, necromantic, apotropaic, talismanic? And from what point of view would Tiepolo have portrayed those ceremonies? From that of an initiate or that of a critic? By whom is he enchanted or by whom is he horrified? And which is which? And what do the characters in Tiepolo's *Scherzi* see? What are they pointing at? Not just what appears: the ashes, the snakes, the bones. But something else, which is not admitted, which has no name. In them there already resounds the baritone voice that Joseph de Maistre was to give the senator of St. Petersburg as he says: "I have read millions of witticisms about the ignorance of the ancients *who saw spirits everywhere:* it seems to me that we who see them nowhere are much more foolish."

What the characters in the *Scherzi* are about—when not absorbed in some reflection or perhaps in nothingness—is a

series of ritual gestures, but those of some ritual that will not be expressed in words. They and only they know what is going on. What is happening is the opposite of what we see on the bas-relief of the Ara Pacis. There, a procession of people and animals is on its way to a sacrifice. We know how the sacrifice will take place and what animal will be immolated. We know why the ceremony is being celebrated. We know who the ministrants are. All is public—and the image celebrates a celebration.

The opposite occurs on the high ground of the *Scherzi*. We see a group of people, separated from the community—distant and ignored. We do not know who they are, nor why they are holding a ceremony. Nor how they will hold it. There is fire and an altar, but one that is an archeological relic. The fire is devouring something. This is all we need to see to know that we are witnessing a ritual. But it is a silent rite, a rite that wishes to be such.

*Theourgía* "means etymologically and in fact *the constriction of the gods,* in other words a procedure or method that, practiced by men, acts *in a binding fashion* on the gods or—in a more general sense—on all classes of superhuman, higher beings (*kreíttona génē*) and hence establishes a direct connection between these last and men with a view to the attainment of specific goals." This is what Theodor Hopfner (the Egyptologist and classicist, and the author of an invaluable commentary on Plutarch's pamphlet *On Isis and Osiris*) has to say in the Pauly-Wissowa. Theurgy is therefore an inner zone of magic, the most secret, perhaps the highest. A form of magic that many take pains to distinguish from the coarse *goēteía*. Even in Saint Augustine, an adversary of both, the distinction is clear: "Magic or *goëtia,* its more detestable name; or *theurgy,* its more honorable name," if for no

other reason than the fact that theurgy was based on the most remote wisdom: Chaldean, Egyptian, Persian. Hopfner goes on to say: "The foundation of all magic and its topmost step, theurgy is the knowledge (*gnosis*) of the true essence of the gods or higher beings in general, which culminates in the *gnosis* of the true, authentic name; for this, as it is an authentic name, embodies the essence of what it names and hence permits he who knows it to influence the entity named." Linked to theurgy, insofar as it is a *téchnē magiké,* is a certain skill in dealing with *magical matter,* which is made up of formulas, names, gestures, offerings, and amulets. In certain cases, however, observes Proclus, theurgy can do without all this. Hence theurgists "in the end, by abandoning nature and physical energies, had a rapport with elemental and divine powers." For example, according to Porphyry, Plotinus succeeded on four occasions—during the nine years Porphyry lived with him—in "remaining in the divine." And this by virtue of "an indescribable act and not of magical powers." Porphyry added that he himself had managed this only once, at sixty-eight years of age.

At one and the same time, theurgy contains within itself the most conspicuous and the most imperceptible parts of the magic arts. Often, it is based on talismans, liturgical gestures, offerings, and formulas, but it can also manifest itself in immobility and silence. Both are forms of theurgy, because both recognize that the world is inhabited by a variety of beings who are in some way a part of the divine, beings with whom thought can— indeed should—establish constant relations, visible or invisible. Consequently, theurgy can assume opposite aspects. It may be confused with the mumblings of the witch, but it can also correspond to he who "having awakened to himself and having left behind his body and all other things, sinks into himself." This is

how Plotinus described something that had happened to him "several times."

*Magus, rose, paradise:* words that passed from Persia to Greece—and from Greece to Europe. Resistant words, which will not let themselves be replaced. "It is said that the rose was a gift made to us by Persia in the bronze age," Arnaldo Momigliano once noted.

The *mágoi* were a class of priests—the most powerful—in Zoroaster's Persia. Guardians of a wisdom that is obscure and controversial, if for no other reason than that their liturgical texts were handed down by very irregular and tortuous ways. For the magi there is no *corpus* comparable to the Brahmana of their Vedic brothers and antagonists. But for Greece the *mágoi* were the first image of foreign wisdom, contiguous and often superimposed over that of the Chaldeans, guardians of the other Asiatic wisdom, the Mesopotamian variety. On the eastern front, Greece did not shine out alone, as the nineteenth-century German classicists naively thought, but was oppressed by three powerful shadows: the Egyptians, compared to whom—according to Plato—the Greeks were "still children"; the Chaldeans; and the Persian magi. Nor were the Egyptians always thought to be the most ancient: according to some, Zoroaster had preceded them. And so the figure of the *mágos* came to superimpose itself, on a higher and more mysterious level, over that of the *góēs,* a term that designated anyone who practiced the magic arts. Until, in the Hellenic period, the two traditions, that of the Chaldeans and the magi, were irrevocably blended together.

The doctrines of the magi, however, reached the Greeks with the enemy empire, the only one with which they found themselves fighting before they gave new form, with Alexander, to the very idea of empire (but his father, Philip, had already tried

to imitate certain structures of the Persian Empire). This was the ambivalent background of the relations with the magi, especially considering—as Arnaldo Momigliano pointed out—that, as a consequence of Persian expansionism, "if there was a time in which the magi could export their doctrines to a Greek world ready to accept them, this was the second half of the sixth century B.C." And that was also the moment marking the blooming of the pre-Socratics.

Plato died on the day of his eighty-first birthday. At his bedside there was a Chaldean, of whom we know nothing else. This information comes from a papyrus from Herculaneum (*Academicorum Index Herculanensis*) dating at the latest from the first century B.C. That anonymous and mysterious Chaldean is the soundest link between Asia and Europe. At that time the commingling of Persian magi and Chaldeans was already under way. This is confirmed by a letter of Seneca's in which there is mention of certain "magi who chanced to be in Athens then," who "held a sacrifice for the deceased [Plato], maintaining that his fate went beyond the human, because he had attained exactly the most perfect number, which is nine multiplied by nine." A mention that overlaps and entwines with a fragment of an elegy written by Aristotle to a certain Eudemus (perhaps Eudemus of Rhodes), which mentions an unknown foreigner who "having gained the renowned land of Kekrops, / devoutly prompted by a venerable friendship (*semnês philíēs*) erected an altar / in honor of the man whose name the wicked may not lawfully utter": Plato. Once again, in the foreigner of the fragment we glimpse the features of the mysterious Chaldean who kept vigil at Plato's deathbed.

·  ·  ·

The world of the invisible teems with beings and is a dangerous place. He who sets in motion a ritual act or merely manipulates *magical matter* must be ready for any surprise. Errors in gesture or word can be fatal. Pliny tells us of Tullius Hostilius, who "having attempted to summon Jupiter from the heavens according to the books of Numa and making the same sacrifice as practiced therein, was struck by a thunderbolt because he had made certain gestures without precise observation of the ritual."

Tiepolo chose to portray the moment in which the invisible is about to appear—or maybe it has just appeared or is taking shape. It does not seem that others attempted this, and especially not in the guise of variations in sequence. It's pointless to look for predecessors, not only in the eighteenth century, which so frequently affected to ignore the invisible, but in the two centuries before. Tiepolo was disinclined to put symbols onstage, but he intended to show what happens when a symbol is discovered, sometimes beyond the scene portrayed. And in that case this cannot even be defined as a "symbol." For it is a vision, swinging between the formless—Proclus specified that "every god is formless"—and well-defined "simulacra" (*agálmata,* the same word that stands for "statues"). How to explain the oscillation? At this point Proclus appealed to the Chaldean Oracles, "which tell the theurgist that all divine beings are incorporeal, but 'take on bodies for your sake,' since you cannot see the incorporeal incorporeally, because of the 'corporeal nature onto which you have been grafted.' "

One of Heliodorus's characters, in the *Aethiopica,* took pains to distinguish between two forms of wisdom possessed by the Egyptians: a vulgar form, which "creeps upon the ground, like a slave of the simulacra, moving around the corpses of the dead";

and "true wisdom, of which the other [form] has usurped the name," which instead "looks toward the sky, is a companion of the gods and takes part in the nature of higher beings, studies the movement of the heavenly bodies and wins foreknowledge of the future."

But the *Scherzi* allow of no division between the two types. Tiepolo's Orientals seem noble and majestic, often concentrating on books and compasses. Yet in the scenario surrounding them we recognize bucrania, tibias, and other dubious ceremonial relics. And at times the expression of the Orientals has something feral and grim about it. The oscillations are many. In comparison with Giorgione's *Three Philosophers,* one senses the breath of another epoch, in which theurgical wisdom had become suspicious and clandestine in all its forms. By then the vision of the divine and the practices of witches had become equally ill famed, so it was no longer possible to make a firm distinction between them. In the *Scherzi,* Tiepolo wove the countermelody to the Enlightenment. No one else would have succeeded in calling that up.

For any kind of magic—both the inferior *goēteía* and the supreme *theourgía*—the time for working is at night. This makes things all the more disconcerting, for the theurgical scenes in the *Scherzi* take place in the full light of the afternoon—supervised by eminently nocturnal animals such as owls. This fact, arguably the most evident paradox and hazard in the *Scherzi,* has not been deemed worthy of comment. At most, of passing mention.

What did Tiepolo intend to do? Being unable to give up on light, the keyboard of his art, he showed that every mystery can be grasped in full light. The air and the shadows tremble in the same way while a human head is burning on an altar or while an

Oriental, finally alone, is concentrating on his calculations. Light
is a kind of absolute within which every scene and combination
finds its place. It is the sole thread in which the individual figures
are knotted or undone. Every scene of witchcraft—like Salvator
Rosa's *Sabbat*—had been until then a shadowy variant of genre
painting. But this cannot be applied to the *Scherzi,* which may not
be assigned to any genre, if for no other reason than the fact that
their genre is delineated by and vanishes with those twenty-
three plates.

*Ousía,* the metaphysical term par excellence, which we come
across everywhere in Plato and Aristotle and which stands for,
according to context, "essence" or "substance"—or in any event
something whose eminent attribute is being—is also to be found
in the magical lexicon, where it signifies the matter to be acted
upon, the palpable entity on which magic works. For the Neo-
Platonist who aimed above all at detachment—Plotinus and
his disciple Porphyry—that association was a source of embar-
rassment, but at the same time it revealed something undeni-
able: magic was based in re, and could not be dismissed as mere
superstition.

As Porphyry observed, it was certainly true that divination
works better, in other words with greater precision, on the bod-
ies of those who have just been killed, but this was not enough to
justify human sacrifice. It was therefore necessary to justify the
fact that abolishing bloody sacrifices would have been deleteri-
ous to *knowledge.* Porphyry's argument went like this: "Someone
might say that in this way we ruin a large part of mantic art, the
part that works through the inspection of the viscera, if we
abstain from destroying animals. But then it would be necessary
to add men because, judging by what they say, the future appears

better from human viscera; and among the barbarians many practice divination through human viscera." These words express an involuntary black humor. The mild yet most resolute Porphyry did not intend to admit any argument in favor of the killing of living beings. But at the same time it never crossed his mind to doubt the soundness of divination. This would have meant dissolving the world of correspondences, slashing the huge fabric of analogies, negating the principle of sympathy and resonance among the various degrees of being. And this is not something you can ask a Neo-Platonist to do.

There is no doubt about the influence that Salvator Rosa and Benedetto Castiglione had on Tiepolo, especially through two etchings: Salvator Rosa's *Democritus* and Castiglione's *Diogenes*. It is as if Tiepolo wished to refer to them to produce a pensive character surrounded by nocturnal animals, archeological remains, scattered bones, and slanted tree trunks. *Democritus* and *Diogenes* were two ancestors of his Orientals, highly congenial (Castiglione's *Diogenes* more than any other) in style and the play of shadows. But both Salvator Rosa and Castiglione had added an inscription to their images to explain their meaning and exemplarity. This is not the case with Tiepolo. The *Scherzi* lack not only inscriptions, but also titles. All unfolds in perfect silence. Above all there is no hint of exemplarity. The single scenes are instants linked together to form a story. His predecessors aimed at composing an emblem, while Tiepolo wanted above all to tell a story that unfolds, without a beginning or an end. And he also wished to be the sole guardian of its secret. In the spirit of an occult antiquarian, in the *Scherzi* Tiepolo dipped into the vast reservoir of the pansophic seventeenth century, but without ever needing to emphasize the fact that certain images were symbols. And it

would be pointless to search for these, as modern scholars have observed with some irritation. Tiepolo pursued other goals: he showed groups of people whose minds were besieged, tormented by symbols (and what else are magi interested in?). And even his young men had seen something unknown to their peers, who would soon return to meet up on the plain. The man who spent a lifetime carrying out commissions dictated by higher powers—ecclesiastical, royal, aristocratic—for once seemed to have dictated himself a *program*, on condition that he would be the only one to possess the key to it. The enterprise was a success—and one appreciates the frankness with which Diane Russell recognizes this, more than two centuries later, in her introduction to the Washington exhibition of the plates from the splendid Rosenwald album: "The etchings of the *Capricci* and the *Scherzi* have remained a mystery from the standpoint of iconography."

Michael Levey noted shrewdly that, although all the scenes in the *Scherzi* take place in the open air, there is something "claustrophobic" about them. It is the sensation felt by one who approaches a magic circle—and then is inadvertently captured by it. This is what happens to those who observe the *Scherzi*. Curious, they draw near to groups of people who sometimes seem to be merely loafing around or cautiously devoting themselves to something that is unclear. But, as soon as they step over a certain invisible line, they are seized by a sort of force field, sometimes a very powerful one, and in any case of unknown origin. These are conversation pieces where all seems suspended, but perhaps something dreadful is happening. But that something will always elude those who approach from the outside— and who might even move away immediately, thinking they have

met a group of people about whom there is something strange, suspicious. Almost a definition of the esoteric.

Yet Michael Levey maintained that the *Scherzi* are "a highly personal dream-world of fancy and musings" and "exude a wisdom which has nothing to do with their philosopher-style magi or the paraphernalia of globes and books that accompany them." Free for once of all duties toward patrons, Tiepolo apparently gave himself over to liberating the *Scherzi* from all "ulterior significance." This is an easy way to avoid the discomfiture aroused by a work that on the one hand Levey himself acknowledges "could be claimed as the most perfect productions of all Tiepolo's art"; while on the other hand he has no intention of examining this strangeness in any real depth. In a typically English manner, thoughts that go too far are dismissed as amiable oddities. Wasn't it a matter of "jokes," after all? So Levey ends up saying that, as such, they "start from the basis of diverting their creator."

But then it is unclear why the airiest of painters, the one most accustomed to moving among skies and clouds, should have cultivated and developed—in the secret chamber of his mind—this chain of images of claustrophobia *en plein air,* charged with burning intensity. Images that all—even the scholars most faithful to Tiepolo, like Levey—seem to wish to flee from as fast as possible, murmuring a few words of cursory admiration. If the *Scherzi* are Tiepolo's secret, then it must also be admitted that it is a well-protected one.

In the *Capricci* and the *Scherzi* the Orientals dominate the scene and control the course of events. But what happens to them elsewhere? Do they vanish? After a fast run through Tiepolo's paintings and frescoes one is obliged to conclude that they reap-

pear everywhere. No longer in the center, but to one side. They are reabsorbed by those packed groups of Orientals already noted in the *Scherzi*. Each head emerges one partly hidden by the other. The eyes have multiplied. But the faces and the cloaks are always the same, inexhaustibly varied. They are *the observers of the scene*. They are the internal eye of the painting and their task is to insert the mind into that which appears. In this way we have the creation of a first disparity, which precedes the final disparity, constituted by the viewer who looks at the picture.

In certain religious paintings—as in *The Flagellation* and *The Crowning with Thorns* in Sant'Alvise—the composition is particularly eloquent. In both cases, behind the suffering Christ we see the Orientals looking on. They might be Jewish dignitaries, pleased about the punishment. But their expressions are grave, sorrowful. The Orientals are the eye hidden in every scene, an eye that transforms it into a mental vision, often hinted at (as in *The Crowning with Thorns*) by a pointing hand.

But what is most surprising and confirms this sharp disparity between the Orientals and the rest of the painting, as if they belonged to two different levels of existence, is the light. This element is totally unrealistic in *The Crowning with Thorns,* where, in the middle of a shadowy, oppressive scene, the Orientals emerge as an ashen patch illuminated by an inexplicable source of light. Moreover, they are painted as if they had been transferred from another picture, in a style that brings them very close to the etchings and has nothing to do with the sharp chiaroscuro of the other figures and Christ. Something similar— but more explicable—happens in *The Flagellation,* where the Orientals appear just outside a loggia—and their light, which clashes with that of the rest of the picture, is none other than the light of the outside world.

But the Orientals are present everywhere. Their noble, indecipherable heads emerge behind every scene. There is always an eye looking on and presumably not forgiving. At times Tiepolo might have felt that their presence risked being too intrusive, as in *The Last Communion of St. Lucy,* where in the modello three Orientals look out from behind the saint thus drawing attention to themselves, whereas in the final version in the church of the Santi Apostoli in Venice they have vanished, leaving in their place a shapeless black patch. In which we finally recognize the head of a young man—and behind it a perfect eye, looking at us. An eye, this time, of a boy, but no less disturbing than those of the Orientals. So can they really have vanished? All we need do is look up and we see them leaning out over a dazzlingly white balcony. They never want to miss a thing.

In the *Scherzi,* the Orientals are those who act *and* look on. Theirs is the highest, most complicated rank. The rank of Magus, so defined because he not only sees, but acts. Having left the high ground of the *Scherzi* and returned to the streets and buildings of the city, the Orientals fall back on the function of those who look on. They assemble in small groups. Now they only watch, and do not act. But their role is still crucial, their presence indispensable.

The Orientals of the *Scherzi* descend from the Magi who appeared in Bethlehem and also from the followers of Hermes Trismegistus. Their doctrine is the *prisca Aegyptiorum sapientia.* The port where they landed in Europe was Venice. Tiepolo merely had to make slight variations on figures that had already emerged around him, from Giorgione to Veronese. But now they were becoming a sect. The most severe, most impenetrable, most ambiguous of countenances. They were the last physiog-

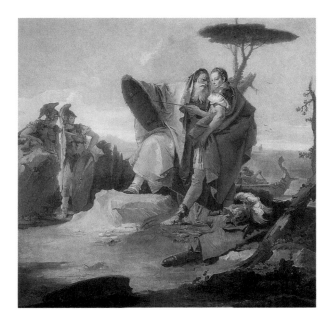

nomic manifestation of *auctoritas* in the West. After them, it would disappear. In the nineteenth century it was already ignored, whereas Tiepolo's Orientals were still sovereign. Every *potestas* was subject to them. Armed men, when they appear, are subordinate and functional. And so on his ceilings and his plates the most fluent and lightest of painters paraded the last representatives of spiritual power.

Although modern scholars, alarmed and disoriented, have often seen them only as fierce, lecherous old men, Tiepolo's Orientals belong to the saturnine stock of Sarastrus. Their Good, however, is not equally unambiguous. Nor does it allow us to exclude with certainty that it is not a mask for Evil. And this holds for the converse too. The only certain thing is the power that the Orientals emanate. But is not this unsolvable

doubleness perhaps a sign of the new times? Otherwise why would Baudelaire one day title his poems *Les Fleurs du mal*?

When they abandon the high ground of the *Scherzi,* the Orientals usually take on the role of *egrégoroi*. They are the "watchers" who guard what appears in the recess of their gaze. But sometimes—if a literary or mythological trace permits it—they also take on a name and a precise function. This was the case with the Magus of Ascalon who releases Rinaldo from Harmony's spell. Magus against sorceress: it is the invisible story of every day. And just as Armida, in order to gaze upon her lover, looks at his reflection in a mirror, so did the Magus of Ascalon oblige Rinaldo to look at his own reflection in a mirror in order to break the spell. The decisive thing—for both the Magus and the sorceress—is the mirror, the reflection, the simulacrum. And the Magus of Ascalon points at the mirror with the wand he is holding. Behind Rinaldo, two tree trunks part and diverge. One is bare, the other is an umbrella pine. On the right, a third trunk slants discreetly across the scene. If it were not for the sea immediately behind, where a ship waits to take Rinaldo back to his soldierly mission, we might think we were in the place of the *Scherzi*.

And it comes all the more naturally to think this if we observe the two ovals that plausibly were conceived as overdoors in the Venetian palazzo that housed Tiepolo's series of twelve paintings inspired by *Jerusalem Delivered.* Even though here there is the addition of vivid, bewitching color, the gestures and poses of the Satyr and the Satyress are irresistibly reminiscent of *Scherzo* 11, not without the due counterpoint of bare, slanted tree trunks. Perhaps Armida's garden was only a legendary opportunity to sneak in some of the regular, immutable elements who used to meet on the high ground of the *Scherzi*. Whether the legend was

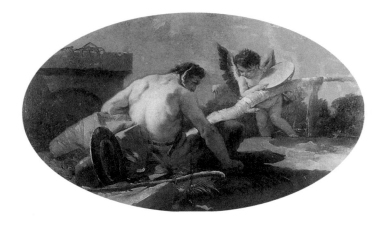

pagan or Christian—of Satyrs or Crusaders—does not seem to make any difference to Tiepolo, who welcomes all among the same stones and the same plants while flooding them with the same light.

Orientals circulate everywhere in Venetian painting, right from the ordered ranks of spring toys painted by Gentile Bellini. But the direct predecessors of Tiepolo's Orientals were Giorgione's *Three Philosophers.* We find them again in the male characters who frequent the high ground of the *Scherzi:* the curly-haired surveyor among the youths, the philosopher with the turban and the one with the hood among the various Orientals. Even the place is prefigured in Giorgione: as was to happen with Tiepolo, the three philosophers meet on high ground from where we glimpse, in the distance, an inhabited place. Behind the three philosophers we also see slanted tree trunks, while over all this looms a gloomy crag, a "rock so admirably simulated," as Marcantonio Michiel wrote at the time. The "rock" took up a huge part of the canvas before it was cut. In Tiepolo it was to be

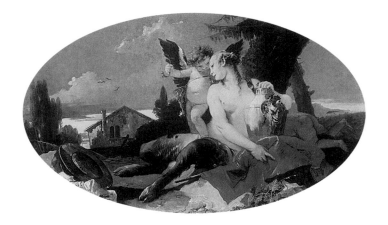

replaced by tangles of foliage and by the outline of a truncated pyramid.

The father of the Orientals—both Tiepolo's and Giorgione's—is to be seen just across the threshold of Siena Cathedral. On the stunning marble intarsia floor, which dates from around 1480, the first figure to appear, the only male (all the others are enchanting, disquieting, and elegant Sibyls), is an imposing old man with a long white beard, flowing robes, and exotic headgear, beneath whom there is a scroll: HERMES MERCURIUS TRIMEGISTUS / CONTEMPORANEUS MOYSI. In his right hand Hermes Trismegistus is holding a book that he is proffering to a turbaned individual, who is bowing in token of homage. On the open page we read: SUSCIPITE O LICTERAS ET LEGES EGIPTII (Take the letters and read them, O Egyptians). In parallel with Moses, Hermes Trismegistus is therefore presented as the people's lawgiver most venerated among the pagans. His left hand is resting on a tablet supported by two sphinxes, where we read: DEUS OMNIUM CREATOR / SECUM DEUM FECIT / VISIBILEM ET HUNC / FECIT PRIMUM ET SOLUM / QUO OBLECTATUS EST ET / VALDE AMAVIT PRO-

PRIUM / FILIUM QUI APPELLATUR SANCTUM VERBUM (God the creator of all things / made of himself / a visible god, / the first and only, / in whom he was pleased, / and greatly did he love his own / son, who was called Holy Word). The confluence between the most ancient pagan doctrine and Christian revelation could not have been stated with more resolution. Hermes Trismegistus's left hand rests on the tablet of the Christian Annunciation with tranquillity and familiarity, almost as if Hermes were its keeper and guardian. In the very years in which the floor of Siena Cathedral was being inlaid, Pico della Mirandola told Marsilio Ficino in effusive terms of his enthusiasm for "the Chaldean books," where, he maintained, "those things that are mistaken and missing among the Greeks can be read complete and perfect." Beyond Plato, the profile of the anonymous Chaldean sitting by his deathbed once more begins to take shape.

Leafing through the *Capricci* and the *Scherzi,* we cannot fail to realize that the most constant presences are the Orientals and the snakes. The Orientals appear in eighteen plates, the snakes in fourteen. And, wherever the snakes are, the Orientals are there too (or otherwise, but only in two cases, Satyrs and Satyresses).

The first temptation, as far as the Orientals are concerned, is to think that Tiepolo, owing to his penchant for the exotic and the picturesque, chose to recruit the main figures for his paintings almost exclusively from their number, like a director who always wants to work with the same actors. It is easy to show that this is not the case, if we consider the obsessive regularity and the subtle ways in which the Orientals are shown. In any event the same argument would not be applicable to the snakes, which could not serve in any way as innocuous costars.

If there is a secret in Tiepolo, it is the snakes. It is hard to make

a census of them, because they can be discovered everywhere. Their center of diffusion is the high ground of the *Capricci* and the *Scherzi*. And the Orientals are those who, more than all the others, have to do with the snakes. They are the ones who look at them, first of all. The ones who burn them, perhaps. Burning snakes is an act laden with incalculable consequences. Certain Vedic seers said this. And Tiepolo's Orientals—the closest Western equivalent to the Vedic seers—would have said the same.

Why are there so many snakes in the *Scherzi*? Most commentators never even noticed them nor have they held them worthy of mention. With greater meticulousness, Anna Pallucchini noted: "staff with snake, symbol of magical wisdom." In their generic vagueness, these words refer back to at least two figures from classical antiquity: Hermes's serpent wand and Aesculapius's

staff, with the serpent coiled around it. Images that do no more than shift the question onto other grounds. Why should the god of healing and health have as his emblem the animal that is dangerous and venomous par excellence? Why should the psychopompal god, the gateway to the Mysteries, announce himself with two coiled serpents? Of course, we can always fall back on the *decorative*. Both in Aesculapius's staff and in the hermetic serpent wand (or finally in the aegis of Athena) the serpents could be a late, "purely ornamental" addition. This is what we read in the most authoritative monument of philological science, the Pauly-Wissowa. But in the jargon of the West "ornamental" is a way of saying *innocuous*. And it's hard to pass snakes off as innocuous animals, while they are certainly omnipresent wherever there is talk of Mysteries, be they the Orphic variety or that of Sabazios. And there is no doubt that they must have had something to do with "magical wisdom," if some Valentinians affirmed that "Sophia herself had become a serpent."

But there is another snake story that runs through the Mediterranean past, from the Old to the New Testament. Before condemning the man and the woman, Yahweh decided to curse the serpent, in Paradise: "And I will put enmity between thee and the woman, and between thy seed and her seed; she shall bruise thy head, and thou shalt bruise her heel." So Yahweh's first corrective action in the world he had just created was aimed at the serpent. Almost as if it came before all others. And it seems to be a complete rejection.

But, on reaching Moses's time, and hence the Ancient Alliance with men, certain episodes occurred that once more involved both snakes and Yahweh. Their meaning is not as clear as it would seem in rabbinical and Christian exegesis, which have done their utmost over the centuries to avoid explaining them.

Moses is a shepherd in the land of Madian when Yahweh

appears to him as a burning bush, enjoining him: "I will send thee unto Pharaoh, that thou mayest bring forth my people the children of Israel out of Egypt." Uncertain, stammering, Moses tries to shirk this task: "Who am I, that I should go unto Pharaoh, and that I should bring forth the children of Israel out of Egypt?" Yahweh reasons with Moses, and even reveals his name ("I am that I am!"). Yet Moses is still not convinced ("But, behold, they will not believe me, nor hearken unto my voice"). And here finally Yahweh stops reasoning, and *shows* Moses something: the serpent. A convulsive dialogue follows: "And the Lord said unto him, What is that in thine hand? And he said, A rod. And he said, Cast it on the ground. And he cast it on the ground, and it became a serpent; and Moses fled from before it. And the Lord said unto Moses, Put forth thine hand, and take it by the tail. And he put forth his hand, and caught it, and it became a rod in his hand." It is like a dialogue between a magician and an apprentice. Stubbornly, Moses continues to harbor doubts. But Yahweh is impatient. He grants Moses Aaron as an intermediary ("I will be with thy mouth, and with his mouth, and will teach you what ye shall do"). But, immediately before dismissing him, the final exhortation regards his serpent rod: "And thou shalt take this rod in thine hand, wherewith thou shalt do signs." And with these words the scene ends.

Then many days go by without any talk of the serpent rod. Moses is eighty years old and Aaron eighty-three when they present themselves before the Pharaoh: "And Moses and Aaron went in unto Pharaoh, and they did so as the Lord had commanded: and Aaron cast down his rod before Pharaoh, and before his servants, and it became a serpent. Then Pharaoh also called the wise men and the sorcerers: now the magicians of Egypt, they also did in like manner with their enchantments. For

they cast down every man his rod, and they became serpents: but Aaron's rod swallowed up their rods." For the first time, Jewish magic had prevailed over Egyptian magic, from which it had sprung. A theurgical ordeal, a clash of simulacra and emblems. A model for all the meetings of Tiepolo's Orientals.

More days go by. Moses's sister Miriam dies. The Jews cross the desert and murmur more and more against Moses ("Wherefore is this that thou hast brought us up out of Egypt, to kill us and our children and our cattle with thirst?"). Aaron dies. There is more fighting, against the Canaanites. The Jews continue to murmur "against Elohim and against Moses." Stubbornly, they keep on asking why they had to leave Egypt for this life of privation.

And here the snakes reappear: "And the Lord sent fiery serpents among the people, and they bit the people; and much people of Israel died. Therefore the people came to Moses, and said, We have sinned, for we have spoken against the Lord, and against thee; pray unto the Lord, that he take away the serpents from us. And Moses prayed for the people. And the Lord said unto Moses, Make thee a fiery serpent, and set it upon a pole: and it shall come to pass, that every one that is bitten, when he looketh upon it, shall live. And Moses made a serpent of brass, and put it upon a pole, and it came to pass, that if a serpent had bitten any man, when he beheld the serpent of brass, he lived."

This is all that is said about this episode in the Old Testament; generally the more mysterious it is, the more it is laconic, as we know from the story of the Tree of Life and the Tree of the Knowledge of Good and Evil. And here there is a similar semantic knot, which commentators ancient and modern have tried in every way to ignore. According to the highly detailed Gerhard Kittel: "the story of the bronze serpent can be clearly explained in theological terms." A footnote refers to other redeeming acts

of Yahweh. And then Kittel adds, impassively: "The story of the bronze serpent perhaps constitutes an oddity insofar as in this case—unlike the episode of the manna or the water flowing from the rock—a marvel does not occur that aids the people as a whole, but God's help is granted to the individual who contemplates the symbol that has been erected." This is not an unimportant difference. It is the difference between the salvation of the community and the salvation of the individual. And it is also the difference between *eating* and *looking*. Which is the primordial distinction. On the one hand, man in his inevitable dependence on the outside, from which he draws air and food; on the other, man in his fictitious sovereignty as contemplator, which allows him to grasp every *perceptum* in the mind and there bring it back to life, detached from what originally surrounded it. It is the art of detachment, of the discrete (in the mathematical sense) image, which is separated from the perceptive continuum and introduces a shard of illusory permanence in the stream of consciousness. And so it appears evident why, this time, salvation is reserved solely for those who *choose* to look. But to look at what? A bronze serpent. Not only the malign animal, but malignity itself: a simulacrum, an *eídōlon,* an idol. Why should a golden calf have been an abomination, if a bronze serpent signified salvation? The doubt is very sharp indeed. Yet the rabbinical tradition, the Fathers of the Church, and biblical scholars have doggedly avoided providing an answer.

Many years passed again. Hezekiah became king of Judah: "And he did that which was right in the sight of the Lord, according to all that David his father did. He removed the high places, and brake the images, and cut down the groves, and brake in pieces the brazen serpent that Moses had made: for unto those days the children of Israel did burn incense to it: and

he called it Nehushtan." For various centuries, therefore, the bronze serpent that Moses had brandished in the desert had been kept in the temple and worshipped. It became similar to the other idols venerated in neighboring countries. And Hezekiah "brake it in pieces" with the same fury that he demolished the Asherah, the images of the goddess worshipped by others under the name Astarte. The commentators avoid this point too, as if it were merely one of the numerous destructions of Asherah mentioned in the Bible. But in this case the destruction involved a relic from the time of Moses. The talisman that had once saved Israel was now an enemy to be broken to pieces. But it was still a metal object. And it still represented an animal. Since then there was to be no more talk of the bronze serpent. Or rather: no one would have *seen* it anymore, even though sometimes, especially in the hardest moments, people still recalled that episode during the crossing of the wilderness.

More centuries passed. One night, in Jerusalem, shortly before Passover, Nicodemus went to visit Jesus. He was an important Pharisee, riddled with doubt. Jesus's miracles had impressed him, but he couldn't decide whether to follow him or not. That night, according to John, Jesus uttered some of his most cutting words: "no one can see [and right away we have a mention of *seeing*] the kingdom of God unless he is born again from on high." And then: "Flesh gives birth to flesh, but the spirit gives birth to spirit." After saying this, Jesus invites Nicodemus not to be amazed at his words, because "[t]he wind blows wherever it pleases. You hear its sound, but you cannot tell where it comes from or where it is going. So it is with everyone born of the Spirit." Nicodemus is more and more puzzled. Jesus switches to irony: "You are Israel's teacher and do you not understand these things?" Nicodemus's puzzlement grows even greater.

Jesus adds: "I have spoken to you of earthly things and you do not believe; how then will you believe if I speak of heavenly things?" This could have spelled the end of the meeting. But without a pause, Jesus goes on: "Just as Moses lifted up the snake in the desert, so the Son of Man must be lifted up." This marks the reappearance of the bronze serpent, which Hezekiah had smashed to pieces in the temple seven centuries before. And what was done with the serpent represented what Jesus was about to do: to let himself be lifted up. *Exaltavit,* we read in the Vulgate—and the verb hints at a raising up into glory. What closer relationship could there have been between that metal animal and Jesus? It was the moment in which all the doubts, all the undispelled shadows in the story of the bronze serpent manifested themselves once more. As Georg Bertram observed: "In the Gospel of Saint John, in all the passages in which it appears (3, 14; 8, 28; 12, 32.34), *hypsóō* [raising up] is deliberately used with a double sense. It means the raising up on the cross and at the same time the raising up into the heavens. *Hypsóō* refers to the salvific event. Just as in Numbers 21:8 looking on the raised serpent saves life, so will he who believes in the son of man, who is raised up, have eternal life (John 3, 14). The *tertium comparationis* between serpent and son of man lies in their being raised up."

But, to be raised up, you need a *detachment.* It is the detachment that creates the image, isolating it within a frame. And this presupposes that the image is perceived as a simulacrum. Not all the Jews in the wilderness were saved. Only those who were bitten and gazed upon the bronze serpent. This is the ultimate, most hidden relationship between poison and the image. The image can save only those who have already been poisoned. But the essential thing is the detachment, the shift to the simulacrum, the capacity to look away from the snake that creeps and

bites, and to fix one's gaze on the metal serpent, brandished in the air. Death is implied in detachment. Or at least we can say that this was certainly what John thought. To the point that he was bold enough to go as far as to gloss some of Christ's last words. Who, on another occasion, apparently said: "And I, once I am raised up, will draw all unto me." John immediately added: "He said this to indicate the kind of death he was about to die."

It was that theologian among painters, Michelangelo, who grasped this point more than anyone else. In a subtly significant position, in the pendentive to the right above the altar in the Sistine Chapel, and hence before the eyes of the officiant, he painted the episode of the bronze serpent, in correspondence with the other pendentive, on which is portrayed the crucifixion of Haman. As Edgar Wind has shown, it was a dizzying and paradoxical condensation of the stages in the story of salvation. In the Sistine Chapel, the scene of the bronze serpent makes its appearance in ways that no one had ever dared to depict it before. It would be a good idea to consider it in detail: first of all, in Michelangelo the bronze serpent is a *living* snake, coiled not around a cross or a Tau, as is often the case in Christian iconography, but around a pole, a staff standing upright on the ground. It stands out against the glow of the sky. We can see almost nothing of the desert, because it is covered by a crowd of people, separated by the opening of an empty vortex in the middle. The image of the serpent has divided the tormented Jews in two. To the left are the elect: those who *see* the serpent and are saved. Among their number is a child, who even dares to stretch out a hand toward the snake's head, as if it were a plaything. On the right, there are those who flee, bitten by snakes, who *do not see* and are doomed. In their poses Michelangelo has abstracted a few gestures from the pagan repertoire, like an atavistic mem-

ory that portends ruin. Wind illustrates them with masterly precision: "Among the figures struggling with or succumbing to the serpents, Michelangelo introduced—inevitably, it would seem—three poignant variations of the Laocoon theme; and to these he added, again with a kind of paralogistic pleasure, a crouching figure fashioned after a classical Leda, attacked and entangled by a serpent that grimly mimics the embrace of the swan. In the background, a cloud of heads with tormented faces is set off by an incident rather minutely rendered: a woman fleeing from the pursuing snakes turns her back inadvertently to the token of safety, but the child she carries on her doomed shoulders looks around and partakes of the healing sight. Opposite to these struggling sinners convulsed in their agony, those safe and cured greet the miraculous symbol as a quiet group, solidly absorbed in its contemplation, and exposing their eyes and hands to the healing force. This group again terminates in a child, placed on the shoulders of a man and touching his head while playfully stretching out its arm towards the Brazen Serpent as if to grasp it."

*Salvation through looking,* which the Fathers of the Church would ignore—because the only thing that truly concerned them about the story of the brazen serpent was the prefiguration of the Cross, which was recognized by a painter before any theologian. Tiepolo's *Scherzi* were to be a constant variation on the same theme, which had accompanied—and beset—him since his youth. Hence the serpents: horror, fascination, perhaps revelation. A tangle that no one can loosen, unless he joins those Orientals, youths, and Satyresses under a dazzling noonday sun, as in the desert.

Still in Nietzsche's day certain German classical philologists, sometimes formidably learned, were convinced that the ancient

Greeks were the only race ever to appear capable of inventing gods who were totally human and devoid of any vestiges of animality in their perfect, radiant figures. A mistaken conviction, tenable only if we set ourselves not to consider a vast number of texts and images. First of all because every kind of *humanism* is unsuited to grasp the divine, precisely because of its bias in favor of the human. And then for the complicity and ineradicable connivance between the Olympians and the animal world, starting from its remotest and most hostile forms, such as the serpent. Zeus seemed to have a penchant for this, in certain of his epiphanies that marked the epochs. In the beginning of the beginnings, according to the Orphics, Zeus coupled with Rhea in the form of a snake. In their coitus they wound together to form a knot— the Heracleotic knot—which later migrated to Hermes's serpent wand. Again in the form of a serpent, Zeus crept into the cave where his daughter Persephone was weaving a cosmic mantle, put her guardians to sleep, and coupled with her. "He licked the maiden's limbs with a lover's lips, sweet as honey," wrote Nonnos. In his coitus with Semele, which led to the conception of Dionysus, Zeus went through various metamorphoses, culminating in the serpent. And Zeus transmitted his familiarity with snakes to his offspring. Athena, born from his cranium, kept on her breast Medusa's face framed by snakes. And, in the hollow between her breasts, she kept a child, Erichthonius, who had a serpent's tail. In Epidaurus, in the sanctuary of Aesculapius, the god of healing, the occult center was the *thólos,* a labyrinthine rotunda where a serpent was presumed to lie hidden. And a snake was coiled around the staff on which the god leaned. Even when seated, Aesculapius is portrayed clutching a snake, as if it were the arm of a chair. His daughter Hygeia wound a serpent in triple coils around her waist, while she offered it fruit and eggs

in a bowl held in her right hand. The Maenads too kept coiled snakes that they hurled at the Silens when the latter molested them. The goddesses or priestesses or anonymous women who appear on certain Cretan seals wore long, flounced dresses, flaunting completely naked breasts and brandishing snakes in their outstretched arms. The beautiful Dioscuri rose up in snake form around the amphorae prepared for them and partook of the offerings. Gaea, the "black earth," was the mother of serpents and protected them. Gods and heroes such as Apollo and Cadmus had to expiate the sin of having killed serpents. And Cadmus ended up being transformed, together with Harmony, into a snake. In the darkness of a cave on Cithaeron, even Hera, so scornful and persecutory toward her consort Zeus's animal metamorphoses, was said to have given birth to Typhon—a monster whose body was fringed with vipers and who was conceived without the aid of male seed. And his mother took care to have him brought up by another snake: Python. Even the virgin Artemis was portrayed while emerging from the trunk of a tree (*theà éndendros*)—and together with her torso two snakes rose up. Hecate used snakes as a belt and her body terminated in serpentine coils. Ares was the father of the serpent that guarded his spring in Thebes. In the Eleusinian Mysteries snakes appear everywhere. No wonder the snake was considered "the most spiritual (*pneumatikótaton*) of animals." At times Demeter kept at her feet the mystic cist, from which a snake's head emerged.

The deeper you go into stories about snakes in ancient Greece, the more pointless—and inapplicable—becomes the usual division between *benign* and *malign*. The snake obviously transcends this—indeed it is the emblem of that which generally transcends this opposition. The serpent is power, in its undifferentiated and indistinct state. Or at least in that state that seems undifferentiated and indistinct to our eyes, when we draw near

it and discover it, in uncertainty and terror. As a permanent reminder of that state, the snake creeps into every story and over every body. The divine is that which has not lost contact with the serpent. Which may even kill it or condemn it, but recognizes it. And sometimes may use it as an ally or an accomplice. We catch a glimpse of the nature of a civilization from its ability to deal with serpents and its willingness to welcome them. On the high ground of the *Scherzi* we see the assembly of those snakes that elsewhere were driven out or ignored.

Those who enter the Basilica of Saint Ambrose in Milan, one of the most ancient seats of Christianity, instantly come across a surprise: on the left side of the central nave stands an isolated granite column, surmounted by a bronze serpent coiled up horizontally. According to Landolf the Elder, an eleventh-century chronicler, that serpent was given by the Eastern Roman Emperor Basil to Archbishop Arnulf, Otto III's ambassador to Constantinople in 1001 or 1002. Dom Jean Leclercq wrote: "The Greek gave that fine object in bronze saying that it was the brazen serpent raised by Moses in the desert. This fantasy met with great success among the people, who have not ceased to believe it, although learned men are of a different opinion."

In any event, for a thousand years this disconcerting metal animal, "rather elegant in form," has been wounding the powerful, Romanesque equilibrium of the basilica. Others must have already perceived it as an intrusive element, if from the thirteenth century an exactly symmetrical column was erected on the other side of the central nave, surmounted by a bronze cross, today replaced by a nineteenth-century cross, which fails to balance the power of the Byzantine serpent. But in one of his sermons on the Psalms, Saint Ambrose had touched on the theme of the parallels between the bronze serpent and Jesus on the Cross:

"*potest non timere serpentes, qui hunc novit adorare serpentem*" (who worships this serpent cannot fear serpents).

On looking at the bronze serpent in the Basilica of Saint Ambrose one thinks of the "*aureus coluber,*" the "golden serpent," which, according to Arnobius, was an actor and perhaps the protagonist of the pagan Mysteries. Athens and Jerusalem almost touch asymptotically in the simulacrum of a metallic serpent. Once the serpent was brandished in the hand of Moses, once it slipped across the belly of initiates, *theòs dià kólpou* (god across the belly), says an Orphic fragment. And in both cases it brings salvation.

The Orphic formula is the boldest and most sexual of those

handed down by the Mysteries. But fearlessly Saint Ambrose proved capable of adapting even that to the Christian mystery: "The good Serpent slips nimbly into the womb of its beloved and all the way inside the bosom of the most hidden thoughts and, without touching them, it introduces fire into the bones and grazes in the most recondite areas."

In Rome the serpent came from the sea. The plague had been raging for three years. The Romans consulted the Sibylline Books. Apollo had sent the plague; Apollo would cure it. He commanded the Romans to seek out the god's son Aesculapius. They were to transfer him to Rome. An embassy showed up at Epidaurus. The priests said that they would never give up their god, but they would allow the Romans to take away the serpent, which was the god in another form. As such the serpent appeared to them, when they saw it rise up, eyes flashing, hissing, as the temple trembled. "*En deus est, deus est!*" they cried. (Behold the god, behold the god.) And they obeyed. The serpent slithered down the steps of the temple. But it looked back. It said farewell to the altars and columns among which it had lived.

A ship took it as far as the mouth of the Tiber; then it made its way upstream. On landing at Tiber Island, the serpent left the ship for the island, which is shaped like a boat. It was met there by another god, Faunus, as is shown in a bronze medal of Antoninus Pius. Gods cannot but superimpose themselves on other gods. And so, around the year 1000, the church of Saint Bartholomew was probably built on the island. But, already since pagan times, on the wall that girds Tiber Island it was possible to see, in relief, a snake coiled around a rod ("*baculum qui nexibus ambit,*" as Ovid put it). The plague died down. It was the year 293 B.C.

·   ·   ·

All symbols are ambivalent, but the most ambivalent of all is the serpent. Because, for centuries and centuries, it has stood for damnation and salvation, according to both the Christian and the pagan traditions. Until at the height of the Renaissance we read, in Pierio Valeriano's *Hieroglyphica*—an encyclopedia of images for many years consulted by writers and painters wishing to acquire its learning—that the serpent not only saved the children of Israel in the desert "but also among the Egyptians and the Romans it was the symbol of bodily and spiritual health" ("*Verum etiam apud Egyptios et Romanos animae atque corporis salutare symbolum fuit*"). From Pierio Valeriano to Tiepolo, as from Veronese to Tiepolo, the step was an easy one.

The *question of serpents* is the most difficult one posed by Tiepolo. A theological more than a pictorial one. Suited to seekers of enigmas. An unspoken question, because neither Tiepolo nor his contemporaries have left us a single word to help us answer it. And it will remain unspoken, as is the case for any full under-

standing of painting. It must therefore be tackled with caution and humility, without presuming any certainty. And no help will be given.

The first thought is that snakes, since they are found so often in the *Capricci* and the *Scherzi,* are a question limited to that sphere. It would therefore be necessary first of all to identify the characters—the various Orientals, the erotic adolescents, the Satyrs and Satyresses, the soldiers, the owls, but also Punchinello and Death—who, among the bas-reliefs and altars on the high ground of the *Capricci* and the *Scherzi,* meet in broad daylight. And the second thought is that they come together as members of a cult, like some heterodox and perhaps illicit club. But another plate, today in Trieste, warns us immediately that the solution is not that simple. If we are dealing with a cult, it can't be a private, restricted one, but is potentially collective, because here we see a whole crowd—larger and more packed than anything found elsewhere in Tiepolo—that has assembled to contemplate (to worship?) something: a snake coiled around a broken tree trunk. And it is not the only snake: in the immediate surroundings there are another four. One is coiled around a staff; another is creeping among some amphorae; two others, on the left-hand side, are entwined. On the ground we also see two skulls, a sword, a quiver, perhaps a mirror. To one side, we see what is perhaps a shield, with a fascinating face in relief. They might be accessories brought from one of the scenes in the *Scherzi*. But the most striking thing is the crowd. Numerous heads, which lose themselves in the background. Mostly men, youths, and old people. Intent expressions. The faces are often noble, others inspire fear. There is also a young blond woman, seen in profile. And a little boy bending over to get a better look at a snake. The sky—deserted. We seem to be in open country-

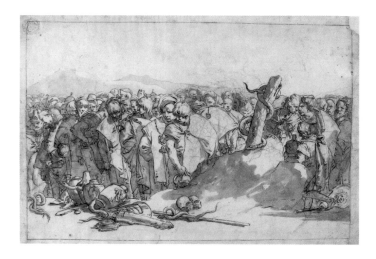

side, but there is no clue as to the landscape. Why have all these people assembled before the snakes? Who informed them about this? Who led them there? Or did each one arrive on his own? And why are those objects lying on that desolate plain, as well as the two skulls? And the tree trunk, bare and broken off, growing from a protuberance of the ground? Why is the snake coiling itself around it with so much determination, turning finally toward the crowd, which if we try to count the heads with the aid of a magnifying glass, numbers about forty? Various faces wear dignified, mysterious expressions. The title normally attributed to the drawing is *The Crowd and Serpents*. It might be a mystery scene, but that crowd whose end cannot be seen hints at a mystery without defenses, open to whoever passes by.

The primordial opposition, the one that stands out behind all the others when we find ourselves faced with the world, is between *eating* and *looking*. Its clearest formulation, insuperable, prior to any other we can read about, is found in a hymn in the Rig-Veda: "Two birds, inseparable companions, are perched in

the same tree. One is eating the sweet berries, the other looks on without eating." In the Bible this opposition never becomes explicit, but in implicit form it is present in the third chapter of Genesis. Here the words have such weight and such consequences that they are known even to those who have never read them, but have already come across them in everyday language. Yet one phrase has eluded us, perhaps because it is a redundancy in a context that ignores redundancies. With regard to the Tree of Good and Evil, we read: "And when the woman saw that the tree was good for food, and pleasant to the eyes, and that the tree was pleasant to look at." It is the first moment since the days of the Creation in which a creature finds something of the world "pleasant to look at." In fact, the observation is duplicated in the same sentence, as in a reflection. If we had to provide a fundamental passage that shields and defends painting, it would be this one. Now, the moment in which the woman—Eve—notices that the tree is "pleasant to the eyes" comes immediately after the words of the serpent. There is therefore a very close connection between the act of looking and the animal that is "more subtle than any beast of the field." Wherever we deal with images, we encounter the serpent. Or a trace of the serpent.

The serpent is the continuum: or a token of the continuum. The mark of its wisdom, superior to that of all the other animals according to Genesis (3:1), lies in its *not being articulated*. The snake is the only land animal that cannot be divided into segments. And it differs only in its eye and its bite, which is why that eye and that bite have such power. All the rest of its body is the continuum: that which all have lost, that with which all seek contact, that which inevitably reemerges and escapes. Just as small cats possess the features and expressions of the big cats, and thus in the cat we recognize the tiger, so in any snake, even

the tiniest, we recognize the power of Leviathan and Behemoth, of those beings that have no profile and that no gaze can comprehend, because the gaze itself is part of them.

Moses's gesture, when he brandished a bronze serpent and told the murmuring Jews to *look at it,* was a gesture that marked the discovery that evil can be cured by its image. Indeed that evil can be cured *only* by the contemplation of its image. Around, there is nothing else but sand and snakes hidden in the sand. Yet Moses ordered all to contemplate an object very similar to the amulets that proliferated in Egypt. But where did it spring from? There was no forge, no metals. Yet the command worked. It was one of the most crucial discoveries that can be made. A silent discovery this time. Not etched on a plate, nor found in a text. It was the discovery of the image, of its healing power. It is one of the supreme Jewish paradoxes that this discovery was made by he who would be remembered and celebrated as the enemy of images.

*The Crowd and Serpents* is the prelude and the background to the *Scherzi,* a hint at the fact that the eccentricity of a few could easily become the obsession of many. That we are dealing with a cult or a vision there is no doubt. Was not the paramount experience of Eleusis called *epopteía,* or "vision"? Why otherwise would those dozens of people crowd together—and with those grave expressions—if not to witness something that is not otherwise given to see?

But it is not in that pen-and-ink drawing that snakes make their first appearance in Tiepolo's work. Carefully concealed, but all the more evident and eloquent in the shadows of the background, we already came across them in a painting in which Tiepolo put himself on the scene in the guise of Apelles painting

Campaspe. Instead of showing himself enchanted by Alexander's concubine—who, later, Alexander was magnanimous enough to give to him—Apelles is none other than Tiepolo in his gawky mode, as he also appears in the Udine frescoes: wind-break nose, eyes round and wide open, amazed but not intimidated by the spectacle of the world. Before the painter, a portrait of Campaspe, she too a little gawky, taken from a portrait by Rosalba Carriera, without any particularly important alterations. But behind the canvas we glimpse two paintings hanging on the wall of the artist's studio. The first is shadowy, dramatic. What is its subject? The bronze serpent. We can recognize a twisted pole with a snake coiled around it and, in the foreground, the powerful back of one of the Jews attacked by the snakes in the desert. We are watching a sort of erotic game: the artist is painting Alexander's half-naked concubine, who is about to become his lover. The scene is clear, vivid, but it stands out against a greenish, nocturnal background, which seems to belong to another painter. The young Tiepolo (the picture is from the twenties, when the painter was in his twenties too) seems to be telling us: I am, I shall be the one and the other. I shall continue tirelessly to paint naked blond women, often sitting on clouds (and, in fact, the subject of the other painting we can just see on the wall was identified by Molmenti as *Aeneas Recognizes Venus Disappearing Among the Clouds*). But I shall also be the painter of serpents, the one who will never neglect, not even on the grand staircase of the residence of the prince-bishop of Würzburg, to make them appear, engraved on the sky, often coiled around a wooden staff. One detail should be added: in that youthful and disrespectful painting, which critics past and present all agree to mistreat (Molmenti judged it "slovenly in design," Alpers and Baxandall consider it "modest"), Tiepolo hints cryptically at something

premonitory and revealing: in fact both the subjects of the pictures in the background—*The Bronze Serpent* and *Venus Leaving Aeneas*—would be painted by Tiepolo, but only years later, in another form and using another technique: *The Bronze Serpent* in an extremely long decoration for the church of Saints Cosmas and Damian on the Giudecca (today in the Accademia, badly damaged, but overpowering in its violence), while there is also a *Venus Leaving Aeneas* in the Villa Valmarana: as if the vicissitudes and fortuitousness of his commissions did not have the power to make Tiepolo deviate from subjects he had *already painted,* even before someone asked him to do so.

Thirteen of the twenty-three plates of the *Scherzi* have as their subject the act of seeing. A tense, spasmodic seeing, focused on something that reveals itself. The tension is so strong that the other plates can easily be seen as pauses, interludes between the sudden kindling of those looks. Looks that are often directed toward something beyond the frame of the picture (*Scherzi* 6, 19, and 23). But even when we can see the point on which they are concentrated (as in *Scherzi* 2, 4, 7, 12, and 17) the meaning of those visions is neither univocal nor clear. We cannot say, first of all, whether we are dealing with something that the characters are seeking or fleeing from. And often serpents appear—burnt or coiled around rods, staffs, or poles. No matter how long you study the *Scherzi,* the question as to what has drawn the characters' attention eludes any conclusive answer. And a suspicion slowly begins to creep in: that the subject of the *Scherzi* is seeing—and observing oneself. And so a person who looks at the *Scherzi* would be none other than an ulterior, invisible character of those plates. We are in the presence of a case of protracted, Gödelian self-reflexiveness. More than any magic—white or

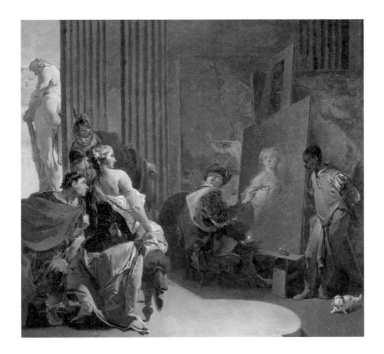

black—what is disquieting is the capacity, innate to anyone, to look at oneself and observe one's life as if it were a scene. And perhaps that *double gaze* is also a precondition of any magic. The *Scherzi* would be dedicated to that gaze. So the "joke" that the *Scherzi* conceal in their gravity would be this: they are images that look at themselves. In this way we could finally clarify why on the title page the nine owls stare fixedly—as if in defiance— at the viewer.

But Tiepolo also wanted the *act of looking* to be included in painting. And he entrusted this to a class of figures: the Orientals. They were to have a precise, very lofty function: to be the witnesses, to be the first gaze to fall on the scene that will later be observed by the viewer. It was a way of freeing painting from

that pure function of representation of the real to which it was being reduced. Sacred painting, profane painting. Churches, villas, palaces. Not much changed. But if an eye, if various eyes hid inside the picture and looked at it, even before anyone else looked at it, a new level, an invisible step, was added to every image.

In Tiepolo's metahistorical vision, according to which the same woman—wearing almost the same clothing—first saved Moses from the waters, then became Antony's lover, then married Frederick Barbarossa, and finally became the city of Venice, it was necessary to find a class of beings that could present themselves with equal naturalness in all epochs—and in their case too without changing dress too much. Such beings could be none other than the Orientals: simultaneously the three Magi, Jewish prophets, hermetic sages, Levantine merchants, and counselors of remote kingdoms. They had to be hieratic and worldly, authoritative and omnipresent. And they could permit themselves to have expressions that were more intelligent but also more insinuating, wiser but also more forbidding compared to those of the ranks of occasional costars in the episodes from history. Such episodes could be the sacrifice of Iphigenia or the flagellation of Christ, the meeting of Antony and Cleopatra or the flight into Egypt. In the Orientals, the pagan, Jewish, Islamic, or Christian past, as well as history, myth, and legend, are all blended into a single substance. Which was a mere look, from beneath bushy, knitted brows. The style of the headgear and the turbans changed constantly, but it is as if they all belonged to the same family. Venetian painting had already seen many Orientals, from Gentile Bellini to Carpaccio, down to Giorgione, Tintoretto, and Veronese. But on every occasion they were a panel

in the chromatic and gestural fan and their functions were fortu-
itous. With Tiepolo they became the axis of the painting, the pre-
condition of the representation. Without the Orientals all was
leveled out, all returned to the ranks. With them, the painting
was raised up, elevated, and floated in the light perhaps because
it was anchored to their impenetrable gaze, which permitted the
scene to palpitate, but also intimated an ulterior significance, to
be sought out before the image vanished from the retina.

In whatever situation they appear—festive or dramatic,
secret or public—the Orientals wear the same expression:
grave, absorbed, with something foreboding and sinister about
it. They never intervene, they observe. And we cannot even
understand if they approve or condemn what happens. But their
presence points to the fact that *something is happening,* something
that perhaps eludes the actors and the bystanders—and perhaps
even those who look at the picture. You can run right through all
painting at the height of the eighteenth century and find nothing
like Tiepolo's Orientals. It is as if they were a concentrate of
everything that the period attempted to expunge from itself.
What were they doing, first of all? Looking at something being
destroyed by fire—and becoming invisible. They were looking at
an invisible entity produced by a certain artfully conceived
destruction of the visible. By now, this might seem like the prac-
tice of witchcraft. But it was the foundation of ancient liturgies
in India and Persia—the places of origin of those Orientals who
now found themselves on the high ground, in countryside per-
haps not far from Venice.

III

GLORY
AND
SOLITUDE

If we include modelletti, canvases, and frescoes, Tiepolo tackled the theme of Antony and Cleopatra eleven times. All in the decade 1740–1750, culminating in the frescoes of Palazzo Labia. And always limiting himself to two scenes: the meeting and the banquet. Tiepolo did not intend to tell the story of two legendary lovers nor to show Antony reduced to "the bellows and the fan / to cool a gipsy's lust," as Shakespeare put it. What he did want to do was to stage a clash of emblems, a conflict between two opposing powers, fated to attract each other, but only to destroy themselves.

It all begins with a kiss on the hand. In two sketches of the meeting, Antony, having just disembarked in Alexandria, solicitously bends over to kiss the queen's hand. In one variant—in the canvas in the Metropolitan Museum—the queen follows the great captain's gesture with attentive, lowered eyes, while in the other—in the canvas in Edinburgh—she is looking straight at the viewer of the picture, as if to ensure that nothing escapes him. That kiss on the hand struck Giorgio Manganelli as exemplary of Tiepolo as a whole: a "diachronic refinement" to be considered "as enchanting, and of the same nature, as the gently rhymed little verses that Metastasio puts between the languid lips of the Phoenician queen Dido." But here the kiss had a far

broader implication, as if it were the tacit assumption underlying an entire method of painting: "Tiepolo's world, anachronistic not because eternal but because so totally theatrical as to be intolerant of comparisons with any presumed reality, is in complete agreement with that affected kiss on the hand, which is an idea no less 'false' than it is 'right.' "

In the crowded meeting scene, which eventually appeared on a wall in Palazzo Labia, the two dignitaries show up in their full dress uniforms: Antony is the imperial power ready to invade the world, convinced that the world itself is something that, albeit with some resistance, is waiting only to be devoured. He is a young, unfledged power, the parvenu of power. On the other side there is she whom Pliny calls, with the harshness of the Quirite, "*regina meretrix,*" the last queen of Egypt, whose figure celebrates a theocracy by now ripe for selling out, at the highest price. And it is above all a question of price, between Antony and Cleopatra, as we discover in the second fresco in Palazzo Labia, dedicated to their banquet. But it was to be a price in the metaphysical sense, far beyond the seductive arts of the *meretrix* queen.

At the moment of meeting, however, it is still a question of looks: Cleopatra's gaze is direct, cold, so confident as to be almost absent; Antony's pensive and vaguely melancholy look is directed only slightly upward, but just enough to force him into a subordinate position, while for the first time, from below, his hand is entwined in Cleopatra's, palm to palm. But, if it is a question of looks, those of the Orientals of the queen's escort weigh almost as heavily on the scene as those of the two protagonists. The Orientals are Tiepolo's *rishis,* those who know and keep silent, those who see what is looming. Their irises are hidden under their bushy eyebrows, but not enough to prevent us from glimpsing their ruthless light.

And one day we come to the banquet. The episode is narrated by Pliny, with regard to the pearls. The first image associated with them, he says, is that of Lollia Paulina, Caligula's wife, "covered in emeralds and pearls" for a "mediocre engagement dinner." And they were not the gifts of a profligate lover, but "ancestral riches, in other words booty from the provinces"; hence those jewels were "*rapinarum exitus*" (the fruits of rapine). The pearl and absolute, predatory power appear together. But there is an example that, in Pliny's view, towered over all others: that of the banquet for Antony and Cleopatra.

Antony is trapped. He is free to sit at table with his helmet and crest, he can also keep on telling himself that he is the conqueror. But, if he looked around, he would find himself watched by inscrutable—and certainly not benevolent—eyes. No trace of Rome, nor of deference to its empire. Munatius Plancus, who ought to be Antony's first ally and supporter, sits at his side like an Oriental dignitary, not overly reassuring. Perhaps, rather than helping him, he is controlling him. All this is fully evinced in the version of the banquet, now in Melbourne, which is more lighthearted and vibrant than the one in Palazzo Labia. In the Melbourne canvas, Cleopatra is younger and more insolent, svelte of figure and mordant of gesture, whereas in Palazzo Labia she has something of the courtesan who has seen it all—and now has to deal with this Roman warrior. One more. Her gaze does not meet that of her lover-adversary. It is suspended in emptiness. Instead, it is Antony who is staring at her, puzzled and enchanted—with the eyes of a romantic adolescent, even though he tries to affect composure by resting one hand on his hip and thrusting out his strong arm.

More than the historical anecdote, the scene illustrates some-

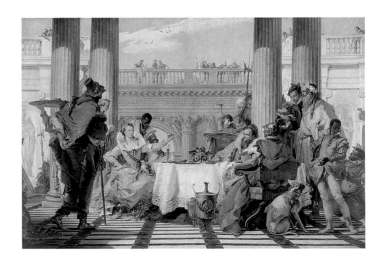

thing about Tiepolo's very method of painting. Antony is his spectator—and he could even be his patron, given his position of recognized power. Situated at the center of the vision and convinced that he dominates it, he is instead ensnared, enveloped, and bewitched by it. The Orientals are a sign that Roman sovereignty is inoperative in their realm, which is not geographical but mental. They produce the pearl, which a moment later Cleopatra will dissolve. Just as Tiepolo's vision, with all its various characters, dissolved as soon as the viewer set foot outside the Palazzo.

For the banquet with Antony, the Melbourne Cleopatra has chosen the same dress she wore when the baby Moses was found. Then she was the pharaoh's daughter. Now she finds herself playing the last queen of Egypt. The places have changed but little, the times by a few centuries, but the taste in dress remains constant. Even the lapdog is the same (but in the Moses painting it

had a red ribbon around its neck). In place of the bandolier-like belt studded with gems, there is a sash. It is lighter and softer, but she wears it in exactly the same way. The only variation worthy of note is the ruff, now white and pleated. She must have had it replaced by a court seamstress. The apricot hue of the fabric is unchanged. And above all the superb trimming on the lower hem of the dress is identical.

How to explain all this? Was Cleopatra's wardrobe perhaps so limited? Or maybe the queen yearned for her biblical youth? No other painter had shown such consistency with clothing nor such boldness in that consistency. Neither the dress nor the person wearing it was subjected to any more than the slightest variations. And this is the peculiar giddiness to which Tiepolo subjects his viewers. The stories are numberless, the times and places varied. But the actors and actresses authorized to stage them were less numerous. Through their faces the artist had already accomplished a notably marked reduction, as in Plato the multitude of *eídōla* (simulacra) is set and crystallized into the self-sufficient, autistic fixity of ideas. But here there is no trace of ideas: there are simulacra who replace other simulacra. As if the totality of the world were to be portrayed only by a well-defined quantity of simulacra, who acted as its messengers or ambassadors. The epochs, the places: indifferent. The meanings: secondary. What counted was the systematic occupation of the visible surfaces through the agency of a sect, whose members could also be chromatic tones, clouds, ferns, columns, headgear, poses—and not only Egyptian princesses and queens.

Some time has gone by since the first meeting. Antony and Cleopatra are lovers and doubly sovereign. Every day, Antony "gorged himself on exquisite dishes" (Pliny, scornful and

laconic). Macrobius notes: "Since Antony was convinced that all born of the sea, the land, or the sky existed to sate his voracity, he had it pass through his teeth and down his throat, and in the same way he wished to transform the Roman empire into the kingdom of Egypt." But, every day, something bothered Antony: Cleopatra, the *regina meretrix* who sat opposite him, did not seem impressed. Power is a question of recognition—and Antony did not feel recognized even in his "superb and provocative pomp." Exasperated, he asked his mistress what he might yet add to all that dissipation, as long as she did not mock him. Like a book-maker, Cleopatra replied saying that, at a single dinner, she would be capable of consuming ten million sesterces.

At this point the banqueting table is transformed into a gambling table. Antony accepts Cleopatra's challenge. Pliny adds that "Antony wished to learn how this might be possible, but he didn't believe it." A referee for the wager is appointed: the "extremely strict" Munatius Plancus.

The next evening, Cleopatra ordered the preparation of the usual sumptuous dinner ("so that no day would be lost," adds Pliny with pure Roman humor). Antony gorges himself as usual, but already he looks at Cleopatra, who has a mocking air: Is that it? she seems to be saying. Cleopatra observes that this dinner was merely a "corollary." So when does the theorem come along?

Then Cleopatra orders another dish, only for her. They set before her a goblet of very strong vinegar. Cleopatra takes a pearl from her ear. It is one of a pair unique in the world, which the queen had received "from the hands of the kings of the Orient." The acidity of the vinegar instantly dissolves the pearl. Cleopatra raises the goblet and drinks the dissolved pearl. Then she makes to take off the other earring. But Munatius Plancus stops her. The bet is already won: a single pearl was worth more

than ten million sesterces. Neither Pliny nor Macrobius specifies *what* the wager had been. Pliny says only that Antony was "beaten." And he adds: "The portent came to pass."

The wager between the two lovers was about power. And Cleopatra proved that Oriental power, by then enfeebled, nonetheless went far further than the new Roman power. It is not enough to consider any thing as an object of conquest. It is also necessary to be prepared to destroy it in a totally arbitrary manner. Only pure destruction makes it possible to reach a higher level, inaccessible to mere power. What was at work in that frivolous scene, through the *meretrix* queen, was the ancient metaphysics of sacrifice. Cleopatra gave her lover a lesson in the doctrine of power that was by then wholly inapplicable, because both she and Antony had thrown in their lot in pursuit of another power, that Roman power accustomed to devouring all for greed, and not for a challenge. And soon it was to devour them too.

Cleopatra's impudence: for the banquet with Antony she did not choose a dress similar to the one she wore when the baby Moses was found. She chose *the same dress.* What should we understand by this? Life is dotted with occasions that require us to conform with the ceremonial spirit. So that apricot-colored dress was taken out of the closet. That dress *is* history. There is no Cleopatra, there is no pharaoh's daughter, if they are not sheathed in that silk, grown together with their bodies. But this is also true of nudity. In Tiepolo, the glorious bosom of Venus as she hangs suspended in the sky is her stage costume. Neither Venus nor Cleopatra could exist otherwise. And they could not emigrate elsewhere, because they belong to no world if not to that stage, prisoners of their colored surfaces.

According to Plutarch, when Cleopatra met Antony "she

placed the greatest part of her hopes in herself, in her spells and her bewitching charm." And this is how she appears in the fresco in Palazzo Labia. Tiepolo's Cleopatra is sovereign in every possible sense, immune to any threat, except that of a still remote double chin. Steady of gaze, serene of gesture. Facing her, if only he would take off his helmet, which he even wears at table, to the detriment of good manners, Antony would be revealed as a magnificent, almost beardless adolescent with a lively gaze, but a man certainly unaware of many things (as he is portrayed in a preparatory drawing). This is the meeting of two powers, the Eastern and the Western. The last queen of Egypt received her unique pearls from the "kings of the Orient." It is not clear whether by inheritance, gift, or on the basis of some unspecified dealings: "*per manus orientis regum sibi traditos,*" writes Pliny (given to her by the hands of the Oriental kings).

Antony represents the power that invades the world, but he does not possess the two pearls. Only one of which is sufficient to vanquish him. What happened to the other? It was sawn in two—and the two halves were attached to the ears of the statue of Venus in the Pantheon. There is decidedly something paltry about that Western power, obliged to adorn one of its goddesses with two half pearls that the Oriental queen was prepared to swallow in a sip of vinegar.

Of all the possible moments in Cleopatra's life, Tiepolo decided to paint the one in which the queen is holding the incomparable pearl in her fingers, immediately before dissolving it in the vinegar. He was not the only one to choose that scene, which from the sixteenth century onward had been frescoed several times in the villas of the Veneto. But he was the only one to grasp all of its ramifications and consequences.

Cleopatra is seated at table, by now with the two bared breasts of the *meretrix,* while in the scene of the meeting with Antony a single breast is about to spill out of her soft dress, which struggles to contain it. Her gaze is still steady and direct, but perhaps already absent. And Antony? Even more melancholy, he is staring into space. Neither of the two lovers meets the other's gaze at the decisive moment. But the one observing them is the referee Munatius Plancus. In him we discover Tiepolo's profound, subtle factiousness. Munatius is not—as one might expect—an armed Quirite in Antony's entourage, but an Oriental, delegated by the other Orientals to act as a representative of destiny. His long, reddish robes and his priestly, conical headgear have nothing Roman about them. Even less so his face, with its sharp profile shown aslant. The judgment takes place in the East—and it comes from the East. But standing to the left, carefully observing the scene, there is a character with a Western look: an aquiline profile, high cheekbones, and a vaguely birdlike air. This is Tiepolo himself, who does not want to miss the chance to be an onlooker at an event that is also the mise-en-scène of his painting. Plutarch wrote that Antony and Cleopatra founded the "association [*sýnodos*] of Inimitable Lives." They were the first aesthetic couple. When they saw defeat looming, they dissolved it and founded an ulterior "association": that of "Those-who-die-together." Plutarch tells us this and moves on, adding only that this second association did not offer "delights" inferior to the first. Superb pithiness. The priest of Delphi did not think it necessary to explain further, whereas he continued to describe battles in scrupulous detail. All this trickled down as far as Shakespeare—and Tiepolo.

For Tiepolo too, as for Plutarch, the story of Antony and Cleopatra is the tale of a particularly tenacious and enduring

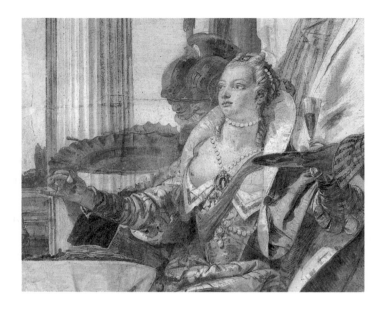

enchantment. To describe it, Plutarch frequently uses the technical terms of magic. More than by Cleopatra's beauty (which Plutarch does not hesitate to insinuate was doubtful), Antony was ensnared by her "witchcraft," *goēteías,* which forced him to keep "his eyes always trained on hers" (*paptaínonta pròs ekeínēn aeí*). For Tiepolo, Cleopatra's power is revealed by the pearl suspended in the air, about to be dissolved. It is the ultimate power of appearance (and thus also of painting), which remains sovereign as long as it obeys the terms of a secret alliance with that which destroys it. Antony knew little of all this, like the Quirites in general, provincials with a vocation for domination, while Cleopatra could speak—still according to Plutarch—the tongue of the "Ethiopians, the Troglodytes, the Jews, the Arabs, the Syrians, the Medes and the Parthians." And, when she decided to flee, she did not turn toward the cramped confines of Europe,

but came up with a plan to have her ships transported along the strip of land that one day would become the Suez Canal. Thus her intention was to lose herself in a boundless Asiatic homeland.

If we observe the composition, we note that it is based on four elements: the three central characters (Cleopatra, Antony, and Munatius Plancus) and a geometrical figure that stands out in the background, behind the loggia: a sharp, slender, pointed obelisk, like a pure white spearpoint directed straight at the sky. Its presence is so disconcerting that many commentators have ignored it, as if they didn't see it. In general, a construction of this kind is not to be found anywhere, if not in treatises on solids. A bird is flying in front of that incongruous whiteness.

Yet, in order to understand what that singular obelisk is, we need only look up at the ceiling, where a blond girl—among the most bewitching ever painted by Tiepolo—is floating among the clouds with her clothes bellying out in the wind. Her left hand is pointing at another obelisk, the twin of the first and suspended in the sky. And we discover that this is the "Glory of the Princes," according to the precepts of Ripa's *Iconology:* "A most beautiful woman . . . Her hair will be curly and blonde [and this was how Tiepolo faithfully portrayed her]. . . . In her left hand she will hold a pyramid, which stands for the manifest and high glory of the Princes, who with magnificence make sumptuous, grand constructions through which they display their glory."

In this way the enigma is revealed: in her palace gardens the queen of Egypt kept the Glory, as others might have kept a gazebo. And an allegory, when it is blended in with an everyday landscape, can easily become a hallucination, because it always falls short of or is in excess of the outside world. No other artist

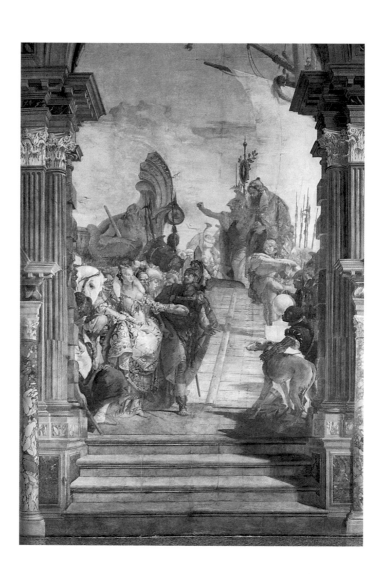

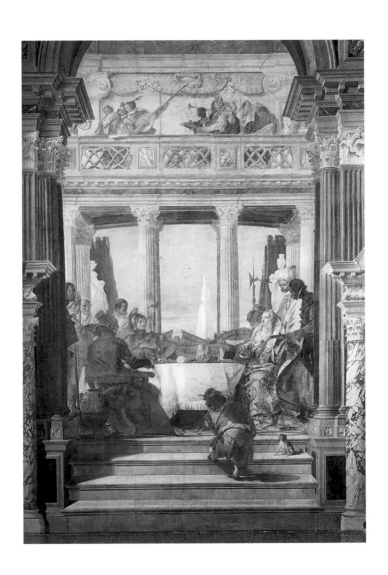

was more aware of this than Tiepolo, who every time he painted a Virtue or an Art transformed them into creatures so feminine as to show themselves forgetful of their duty to signify without ambiguity.

The match was therefore down to four players: Cleopatra and Antony at table, Munatius Plancus between them—and, diagonally across from him, the Glory, a silent witness. Tiepolo's genius also lay in this: for him it was equally easy to accommodate on the frescoed wall a hallucinatory allegory and the court dwarf coming up the stairs to observe the scene of the wager, not to mention Cleopatra's puppy, whose muzzle is pointed toward him. There is space and air for all. But those disparate elements are borne up by an occult center: the suspended pearl, which emanates a whitish light, identical to that of the obelisk piercing the bluish-gray sky.

Tiepolo's Cleopatra does not have the "tawny front" of Shakespeare's queen. On the contrary, she is rosy and golden like Venice receiving Neptune's homage. For Tiepolo, exoticism begins in the first street of his native city. At the center, there is always a blond or tawny blond woman. This holds for biblical or Ptolemaic Egypt (the pharaoh's daughter is Cleopatra) as it does for medieval Europe (Beatrice of Burgundy). They are all forerunners of allegorical Venice. Venice is the ecumenical point of balance, which is found in every epoch and in all climes. All around, the whispering and rustling of Orientals, always wearing the most enchanting fabrics. Not cicisbei, but—perhaps—slave traders or sages. It's hard to tell one from the other. But this is the court that befits such a queen.

Sovereignty, in Tiepolo, is feminine. His Alexander, Scipio, Frederick Barbarossa, and Henry III are unsure of what pose to strike, swinging between awkwardness and pomposity. And in

any event they are never memorable. As for Antony, he is the vanquished rather than the victor. Sovereignty lies in Cleopatra, Armida, and Beatrice of Burgundy, even in the obscure African girl who awaits the judgment of Scipio. Sovereignty rests in itself; it has something pensive, almost absent, about it. It is never linked to the immediate exercise of power. On the male side, it is not noticeable in the kings and emperors; if anything, it may be perceived in certain vigorous old men—namely Time and Hades—closely embraced by voluptuous maidens. This was a requirement of Tiepolo's metaphysics, based on the hidden complicity between the splendor of appearance and that which induces appearance to dissolve.

Four years after Palazzo Labia, Tiepolo's Cleopatra moved to Würzburg. She became Beatrice of Burgundy and she had to marry Frederick Barbarossa. She did not change her hairdo, with large pearls braided into her hair, worn drawn back at the forehead and gathered up into a sumptuous bun. She knew perfectly well what suited her best. As for colors, she stuck to the golden yellow she had already used in various rehearsals for the meeting with Antony. And above all she couldn't forgo the tall ribbed ruff, which encircled her neck so well and plunged down as far as her bosom. Even though this time, kneeling before the altar, she could not leave her breasts bare, as happened at the banquet with Antony. As for the rest, she knows she is the very same woman who had been Cleopatra and one day would be Venice— and, centuries before, she had been the pharaoh's daughter who saved Moses from the waters. All those appearances suit her equally well and are simultaneous, all refer to the same full and opulent phase of her beauty. There is only one detail she cannot do without: she always wears a choker around her neck, a single string of large pearls. But she does change her earrings: at her

wedding with Barbarossa there reappear two large baroque pearls, which she had not used since Antony's day. Who knew if someone would notice? By then, a lot of time had gone by.

The Residenz at Würzburg, with its grandiose staircase that gave Tiepolo the perfect opportunity, in relation to light and space, to spread out his painting, is basically attributable to a swindling administrator. If Prince-Bishop Johann Philipp Franz von Schönborn had not asked to see the accounts kept by Gallus Jakob, in charge of the treasury in that little state of about two hundred and fifty thousand inhabitants, if he had not discovered the constant larceny that Jakob had been committing for years in his lands, if he had not threatened to expose him publicly, and if Gallus Jakob, to block the investigations, had not immediately paid the prince-bishop the enormous sum of six hundred thousand florins, the project for the Würzburg Residenz would not have been conceived, nor would a start have been made on the work, which was financed for a long time by that sum. Finally, thirty-one years later, when Karl Philipp von Greiffenklau had become prince-bishop, Giambattista Tiepolo, accompanied by his sons Giandomenico and Lorenzo, arrived from Venice in the fall of 1750 to fresco the ceiling of the staircase, as well as the Emperor's Hall of the palace. The fact that the Residenz was part of a wholly inconsistent and illusory political power, in a Germany dominated solely by Frederick the Great's Prussia, created the most favorable conditions for Tiepolo's work, as he always needed the vanity, the pomp, and the megalomania of his patrons to unleash the energy of his painting. The more unreal the power he was celebrating, the more nimble his hand became. But it would be ridiculous to think that Tiepolo shared in the vainglory of his patrons. On the contrary, he sometimes allowed a subtle

sarcasm to emerge. Otherwise how can we explain the way he portrayed his patron in Würzburg? In the cloudy sky above Europe and alongside the superb torso of an angelic trumpeter, a propagator of glory, there stands out the oval with its portrayal, against an olive green background, of Prince-Bishop von Greiffenklau in his white wig. But what is his dynastic griffin doing (Greiffenklau means "griffin claw")? Clinging to the frame, the wild animal has abandoned all heraldic fixity. Maw agape, it seems on the verge of using its beak to tear at the dignified image of the prince-bishop above him. The animal possesses an immense compressed energy and its talons are perhaps already damaging the noble wreath of the oval, made of laurel leaves, as if the glory of the prince-bishop could be easily defaced by one of the numerous animals that Tiepolo had marshaled in the fresco of the Four Continents and that now seemed to let themselves be led across the sky by the griffin, the true lord of the place, far older, and far more fearsome than any representative of human lineage.

The eighteenth century teems with ceilings that become skies in which figures wheel and circle, every time we come across a sufficiently magnificent and ambitious palace. But they are never as airy and intoxicating as those by Tiepolo. And, among Tiepolo's skies, none can compare with that of Würzburg. Even his historic enemy, Roberto Longhi, had to admit—through gritted teeth and by proxy (that is, by attributing the words to the artist himself)—that Tiepolo's "fables" moved "in the purest and most luminous air that ever blew." And it is precisely this, in the end, that makes Tiepolo stand out from all his contemporaries: the sweeping range, the invincible sense of lightness, a coefficient of antigravity, with which his figures are imbued. Nothing else is

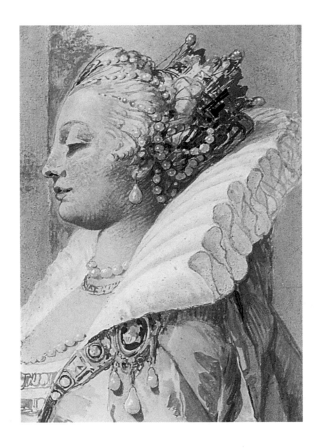

needed to get over the palisades of that period. In the presence
of that air, the ecclesiastics and the aristocratic families, the
courts and the dynasties all move away. They become so many
pretexts. So what is left, then? The pure exhibition of the world,
with all its apparatus of ceremonies and fatuousness. Tiepolo
intended to be its chronicler, without explaining it in any way.
Far less commenting upon it. But none of this makes the image
devoid of intelligence, which is a subcutaneous, physiological
presence, unscathed by the word, in all that his hand touched. In

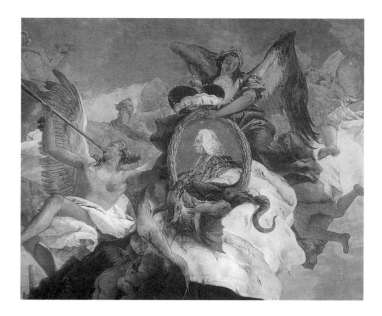

a short story of genius, "The Tale of the Good Old Man and the Lovely Young Girl," shying like a skittish horse, Italo Svevo unexpectedly writes: "Beautiful women always seem intelligent at first. A fine color or line are in fact the expression of the most absolute intelligence." Two sentences that might leave one puzzled, if Tiepolo's entire oeuvre were not here to demonstrate their validity.

The program for the frescoes in the Emperor's Hall, drawn up in the prince-bishop's chancellery, was full of exasperatingly meticulous detail. After fifteen years of laborious study, the fourth draft included all the possible supporting documents—historic, juridical, geographical, and dynastic—required to illustrate the wedding of Frederick Barbarossa and Beatrice of Burgundy and the consequent investiture of Bishop Harold of

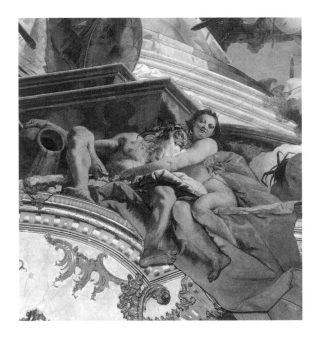

Würzburg. And, with apprehensive concern, all this material was consigned to the talents of the artist who was to translate it into figures that "his brush would have to express in a poetic manner."

As always, Tiepolo bowed and obeyed, even though we may reasonably surmise that he was unfamiliar with events in twelfth-century Franconia. *Wedding, princess, coats of arms,* Genius imperii, *solemn homage, retinue,* Phoebus orientalis: these words, however, which are scattered throughout the program, should have reassured him. This was his chosen ground. The program also allowed for the possibility that, "in the event of there remaining some space at the edges of the arch, the gods could show their grateful wonder at the Emperor's munificence." The last of their number would be the river god Main together with

a Nymph: an opportunity that Tiepolo could not let slip. So, immediately beneath the throne of the *Genius imperii,* he went back to painting his favorite erotic combination: the vigorous old man and the maiden, clinging together tenderly but firmly. This time the river god is covered only by a few ivy leaves and the Nymph is completely nude, apart from a slender golden belt around her waist, while her left hand is slipped familiarly between her companion's open legs. While the prince-bishop's court set store by its details, Tiepolo did the same for his own. And, more than the way these two bodies are intertwined, the viewer's eye—when not taken up with some ceremonial task—would have noted the cataract of turquoise silk that flows around the river god and the Nymph, certainly not to cover them but to exalt them.

The least attractive subject that Tiepolo found himself painting at Würzburg was that in which Emperor Frederick Barbarossa invests Bishop Harold as Duke of Franconia. It is one of those scenes where painting was bound to joyless functionality: the pure confirmation and celebration of power. Moreover, it was a wholly masculine scene—and thus already threatened by tedium. Tiepolo tried to avoid this by falling back on his strategic allies: the graceful page boy (as in *The Finding of Moses*), the Orientals who look on (two here, entirely unjustified according to the program and shamelessly more fascinating than the Western dignitaries), the dog (a St. Bernard that turns its back to the scene and whose majesty contrasts with the nondescript emperor and the bishop awaiting his investiture).

But it can be said that this time the frame was more important than the fresco. When he arrived in Würzburg, Tiepolo found a ready-made space that seemed to suit the requirements of his

painting: a happy convergence of the stars, because the decoration of the room had been conceived before Tiepolo's patron chose him to fresco it. Balthasar Neumann, an army engineer by trade and a prodigious stage designer, had planned for the two frescoes on the walls to be revealed as if by the raising of a curtain of blue and gold stucco, studded with mirrors and supported by winged putti. The challenge, for Tiepolo, was almost too perfect. This time he did not have to create the illusion of a stage, but merely to populate it with his characters. But, as always, he needed a queen. Here it could not have been anyone other than Beatrice of Burgundy. And Tiepolo's Beatrice became the point of delicate equilibrium between the insolent Cleopatra in Melbourne and the mature Cleopatra in Palazzo Labia. Her complexion was imperceptibly paler, barely touched by the frosts of the north. She is not looking at the groom, and she is not looking at the bishop holding the service. She is totally solitary in her sovereignty. Around her, as if in superimposed orbits, rotate the authorities of the Church and the Empire, amid the crowd of dignitaries, soldiers, and clergy. But there lingers a vague sense of extraneousness, of a distance between Beatrice and all those taking part in the ceremony. Her only accomplices could have been the Orientals, who—by an extraordinary chance—are wholly absent here. As is a *kórē* of the Acropolis with respect to Athens, so is Beatrice with respect to Europe: not eighteenth-century, or medieval, or Renaissance, or Venetian, or Germanic, but a pure essence, long distilled and soon dispersed.

In Baroque festivals and in the Gobelins works, in Meissen china and in the Triumphs, in Ripa's *Iconology,* and in the travel books with etchings by the De Bry brothers we find an infinity of vari-

ations of the image of the Four Continents. And Tiepolo had already used it, in Palazzo Clerici and Villa Cordellina. Now it was the turn of the Würzburg Residenz. Tiepolo could have stuck to the numerous precedents, adding a few new touches. But a multiplicity of signs authorizes us to suspect that this time he had another plan in mind: nothing less than to make radical yet subtle changes to a predictable and canonical order of images, making them take on meanings that might have even proved disconcerting. Yet Tiepolo was certainly not inclined to scandalize. And so he had to count on the fact that most of his risky maneuvers would elude the scrutiny of those who, in haste or concerned about their dignity, were about to go up or down the grand staircase of Würzburg. In this way the most conspicuous work could also be the most secret. At bottom, what better place to hide than on a vast ceiling above a monumental staircase? At the same time, those constant infractions of conventional codes, even though not perceived one by one, would have created an overall impression of singularity, indeed of uniqueness. Which was, after all, for different and perhaps opposite reasons, the result desired by both artist and patron.

Of the Four Continents, Europe is the only one granted a throne. But it is also the one to flaunt a bored, lackluster expression. This would be impossible for the others, sovereign but unstable on their mounts: Asia on an elephant, America on an alligator, and Africa on a camel. But their gazes also betray a completely different liveliness and pride. Europe instead is wearily resting the scepter in her arm between the horns of the bull that one day in the remote past had carried her off, but now looks like a pensioner among bovines. Meek, sad, pensive. As for Painting, who stands beside it decorating a globe—without much conviction—she is perhaps the only female figure in the

entire Würzburg ceiling who is not only devoid of charm, but is also stolid of expression and awkward of gesture. How to explain this? In such an admirably calibrated whole, it cannot be other than a hint at something. Of all the continents, Europe is the only one shown orthogonally, squared, the only one with a wall as a background. Apart from this, a right angle appears only in Asia, but in a parallelepiped on which mysterious signs are engraved. Some letters are Greek, others Armenian. There is something asphyxial about Europe, who lacks the unlimited, adventurous air of the other continents. It is as if culture, which only here is claimed and flaunted, were combined with a diminution of the vital force. All inversely proportional to the bales of merchandise, the striped tent, and the wild animals else-where. Perhaps this was one of the coded announcements that, unbeknownst to his patrons and admirers, Tiepolo wished to send out from the sky of Würzburg.

If we observe the Würzburg ceiling at length, what might remain a suspicion on other occasions inevitably becomes a certainty: Tiepolo is playing, playing constantly and extremely boldly with his viewers. And the higher his figures fly, the more daring and complex the game gets.

Asia appears on the back of an elephant with an immense ear, like a tropical plant. Around her: figures and banners. Then there is a patch of empty sky and a barren hill, on which stand out two crosses. Commentators agree in recognizing this as Golgotha. But among the figures that accompany Asia and the hill we see another two humps, which at first sight might seem a part of the landscape. Instead they are two men, almost completely covered by voluminous robes, from which three skinny legs emerge. Who are they? Are they prostrating themselves? Or looking for

something on the ground? The Würzburg catalog says that these figures and a preparatory sketch "were drawn from life, to examine the way in which light falls on heavy robes." No doubt Tiepolo was, here and as ever, concerned with light. But who are these characters? Why are they shown in a pose of the deepest devotion, the *proskýnēsis* of Oriental ritual? And why did Tiepolo paint them in such a way as to camouflage them against the background, so that only after long and attentive looking do we discover their presence, as if they were stowaways? The robes covering them are in dense, dark colors, like drapes or blankets. But the legs and the feet that protrude from them seem to be shod in a European style. Are they unknown Westerners who prostrate themselves before Asia's elephant, which might even trample them? No answer has been given to this. Indeed, Tiepolo ensured that the question would not even be asked. But it is inevitable to think that those two figures, in such awkward and improbable positions, correspond to the single European hanging on to a cornice who can be seen alongside America. These intruders are all Europeans: curious, intrusive, they clash with their surroundings. But they are us, Tiepolo seems to be saying: our insuppressible vocation. And so those figures stand between the viewer and the distant continents, like an outpost of those who look, while they are lightly brushed by a subtle, affectionate mockery. And it is very likely that they do not even notice this.

On moving around the populations of the Four Continents of Würzburg, we cannot fail to notice something that is reflected in all of Tiepolo's most felicitous work: we are in the midst of a sample of humanity that is not yet exotic, but *not provincial*. The difference is enormous. The exotic presupposes a nonexotic normality to be measured against, with respect to which it offers a

surplus of the picturesque or the marvelous or the deformed. But this is a sentiment unknown to Tiepolo. The non-provincial, instead, is everything likely to establish a relationship of familiarity, on the same level and without batting an eye, with every imaginable figure, human or semidivine, such as the Nymphs or other denizens of rivers and springs. For Tiepolo, the plumed Indian woman riding an alligator is no more singular than the European musicians who played at court. If we compare the Four Continents of Würzburg with contemporary French or English painting, unfailingly confined within rigid boundaries of class and manner, the gap appears evident. Whether the occasion is devotional or secular, Tiepolo uses it as an excuse for shuffling the social cards. To what class would his Orientals belong? And certain youths—are they scions of the aristocracy, flowers of the commonalty, or river spirits? If the princesses and the queens are hard to distinguish from the courtesans, it is because the courtesans participated in sovereignty. Precisely in the works of a painter who always painted to commission, and in compliance with strict functionality, the figures seem on the verge of detaching themselves, with a slightly mocking effect, from all social servitude. They are hothouse plants moved into the open air of all crossroads, pure morphological varieties. And if their features, their gestures, and the cut and color of their clothes imply the entire course of history, it is by now like an atavistic memory.

Asia, Africa, and America are very beautiful women riding on animals (an elephant, a camel, and an alligator). Europe needs an architectonic frame (stone pedestal, columns, pediments, scaffolding). Asia, Africa, and America live in a space without borders, where the only half-closed structure is the long, gypsy-style tent with its light blue and white stripes, behind Africa's back.

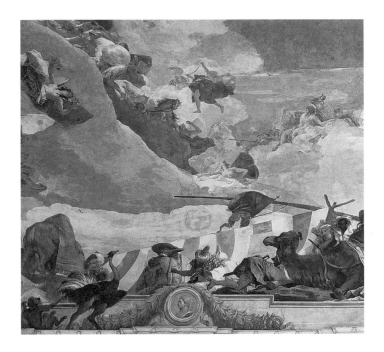

Compared to the others, Europe's scene—and we must repeat this—is the only one that might risk being boring. The general tone of what is happening has a hint of pomposity, a certain stiffness induced by dignity: both in the dominant female figure—an opulent Venetian beauty—and in the characters that surround her. Together with his son Giandomenico—wearing a wig, while his father has a craftsman's beret—Tiepolo dutifully portrays himself close to Europe, but to one side, in the position of the attentive observer, separated from the center of the scene and almost in the shadow of a voluptuous figure made of stucco. In the center we recognize Balthasar Neumann dressed in the exquisite purple uniform of an artillery colonel, leaning limply against the barrel of a cannon. Neumann is probably contemplat-

ing the magnificent staircase of his own design. Or perhaps he is lost in other thoughts about which we know nothing. And so we do not even notice that one of Tiepolo's dogs—his heralds who always show up in strategic positions—is sniffing at him, as if he were a rag doll. But Tiepolo's ubiquitous irony does not stop here. Its point of greatest irreverence is a dig at the Catholic Church. On Europe's right-hand side stands the bull to which she owes her original transfer to the continent she gave her name to—and which in the meantime has been worn down by history to the point of forgetting that it is Zeus. On its forehead, with absent familiarity, rests the hand of the queen holding the scepter. On her left there is a miter, a cross, and a crosier. Even though he was at the court of a prince-bishop, Tiepolo did not grant the high prelate the honor of a personal appearance. The regalia are sufficient, whereas the handsome blond page boy holding the crosier is well in the foreground. As for the globe, which in previous times, together with the cross, designated imperial power, it is now a simple and cumbersome map of the earth, beneath Europe's pedestal. And a woman is painting it. Her arms are too thick and she wears a rather obtuse expression, accentuated by her half-open mouth. In her we recognize Madame Painting, with palette and brush in hand. It is not very clear where she is looking: perhaps toward the medallion with the portrait of the prince-bishop, which is moving across the sky among the clouds, accompanied by a trumpet fanfare. But looking at von Greiffenklau's wig cannot be of much use to Madame Painting in her work of depicting a map of the world. In the air there lingers a hint of a joke that painting is making about itself.

Tiepolo unfailingly applied one rule to all his works: in order to grasp the meaning and the tone of an image, he makes sure that

you need to look immediately at what appears in the middle ground or even in the background. From there you must work your way forward toward the rest. This holds all the more for the ceilings, where the middle grounds and backgrounds tend to blend together and disappear, for purely optical reasons.

In Würzburg we can begin with America, the newest, least known, most primitive continent. Who is America? A magnificent young woman with bared bosom, wearing necklaces and medallions and a feathered headdress that one day would inspire the Folies Bergère. She is riding leisurely on the back of an imposing alligator whose open jaws await a victim. A page who might have come from a banquet by Veronese is gazing raptly at her and is about to pour her a cup of hot chocolate from an exquisite porcelain jug, whose style cannot be ascertained. Perhaps the redskins are the true dandies. Tiepolo had already intuited this a century before Baudelaire came to the same conclusion on observing George Catlin's portrayals of Indian chiefs, in which he recognized "the gravity and the aristocratic dandyism that characterize the chiefs of the powerful tribes." Besides, was it not Chateaubriand, the model of every modern dandy, who found his peers "in the forests and along the lake shores of the New World"? In the Würzburg Four Continents all historical and ethnic distinctions collapse. This gives free rein to dandyism, that "institution beyond the law," which "has strict laws that inflexibly bind all its subjects, which are moreover the ardor and independence of their character."

America's torso is vigorous, with wrestler's shoulder muscles well in evidence. The leg astride the alligator is slender and elegant, the foot shod with a golden sandal, like the one worn by Armida in Villa Valmarana. On the alligator's back there is a sumptuous dark red floral-patterned brocade. America is sitting

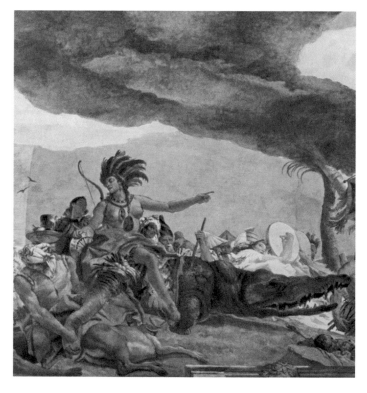

on this as if it were a decorated saddle and is pointing toward a
decidedly Western banner on which there is an embroidered
griffin (an allusion to the house of the von Greiffenklau family?).
But beside that we see military colors surmounted by a Turkish
crescent moon. On the ground, near a boulder, four severed
heads, one pierced by an arrow. Heads of Europeans? Of Orien-
tals? Of natives? It is not clear. Around, the presence of turbaned
Orientals, and other Indians wearing feathered headdress. In the
middle ground walks a stunning young woman with bared
breasts and an amphora on her head. From her features, com-
plexion, and gait she could be Italian—she is certainly a

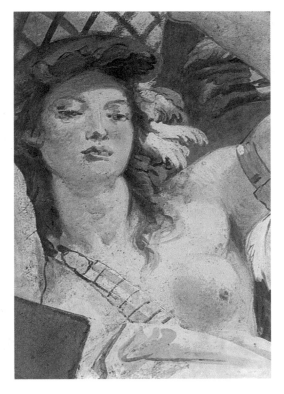

Mediterranean European. This is borne out all the more if we look toward the background immediately behind her, where we see an umbrella pine, typical of the Roman countryside, and the outlines of hills with cypresses, which resemble the hills around Villa Valmarana in the Veneto. The characters stand out against one another with bold nonchalance, incorporated in a scene they must have played out on many other occasions. We do not get the impression that we are on a remote continent, with unique and perhaps aberrant characteristics, but in a place of radical fusion and hybridization, where the bewitching page and the severed heads—a few meters farther on—quietly coexist just as

the Indian woman in the feathered headdress rides along on her alligator together with the girl from the Mediterranean country-side with the amphora on her head. Nothing excludes anything else, above all in terms of clothing and manner. And the only dominant rule seems to be aesthetic, similar to the one that imposes or prohibits certain color combinations.

But the judgment implicit to this vision without frontiers is not only aesthetic. Cultures are equated and mixed, as if each one needed the others in order to stand out. And as if all were members of a single caravanserai, which is history. While there is no trace of Enlightenment condescension—on the contrary, of all the continents, Europe emerges as the only one threatened by a certain lassitude and a hint of torpor—there is an immense curiosity about forms (the same curiosity that must have prompted a European wearing a delicate pomace-colored tail-coat to hang on to the cornice under the America of Würzburg to see what was happening there, while in his other hand he is clutching a portfolio—perhaps—of etchings), and a willingness to submit to the appeal of the most diverse figures, without obliging them to accept her own laws. In short, it is the attitude that the West—and *only* the West—managed to crystallize after many centuries and that the West itself often mistrusted (as it was to mistrust Tiepolo, by forgetting him for a long time). Per-haps the West does not consider such an attitude serious enough. Yet it is an improbable and precious form, attained after long and bloody training. It is that peculiarly Western skillfulness in handling the totality of appearance with a clear mind, putting itself in doubt, even dissolving itself before getting the explo-ration under way, without being bound to untouchable beliefs, but keeping the gift of recognizing the power of that which is.

·  ·  ·

The Europe of Würzburg is the same leading lady who was to play the role of Venice receiving gifts from Neptune, in the Palazzo Ducale. In fact, what was Europe if not an extension of Venice, with the addition of a few complexities (the centralized state, vast territories, and so on)? But for the Venetians it was enough for Neptune to arise from the sea and—devoted, obedient—to pour from a cornucopia onto the hem of Venice's dress a mass of golden coins and jewels, among which emerge a few branches of coral. And in the shadow behind old Neptune we glimpse an intensely erotic and very young companion of his, holding the trident. But apart from the marine details, Venice and Europe correspond. The same features, the same coiffure, the same skilled arrangement of the crown and the pearls in the tawny blond hair (a crown used as a precious hairgrip rather than a symbol of power). Despite this, Venice was to have a more imperious and vigilant gaze, whereas Europe is absent, almost feeble. Her arms hang down limply. Her left arm seems to be resting on the shoulder of a bishop, whose miter is the only thing we can see of him. The bishop is accompanied by two enchanting youths (one dark and one fair, because the Church welcomes all). Europe's right arm, which is holding the scepter, rests slackly on the bull that carried her off from Sidon and now looks like a meek creature better suited to pasture. How many centuries since it last knew the intoxicating thrill of adventure!

Unlike the other continents, one might say that Europe's scene is enveloped in a film of vagueness and melancholy, while from the sky erupts the blare of a trumpet and—standing out in midair—we see Prince-Bishop von Greiffenklau's medallion with its griffin. This last is by far the liveliest creature, darting and fearsome amid the noble and pensive assembly surrounding Europe. This crowd is too dense, as if at an official ceremony. We

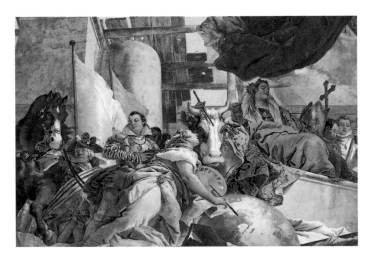

sense the oppression of history, which has mixed up too many elements. By now there is a pressing need to forget or demolish something.

In Mengs's *Parnassus* everything is insipid—both the extraordinarily dull Muses and the doltish Apollo. A place from which one is immediately tempted to flee. In Tiepolo's Four Continents in Würzburg, on the other hand, we always feel a desire to venture further in, as if into some boundless bazaar, even though there are many perils. In America they are cooking what might be human flesh on a spit. To one side, a few severed heads lie on the ground. Nor do the Orientals look particularly trustworthy. And, in the presence of Asia, an athletic young man is writhing on the ground with one wrist locked in an iron ring with a (broken) chain. Something worrying must have happened.

Then there are all those animals: a monstrous alligator that serves as a docile mount for an Indian woman with a voluptuous bared bosom; an elegant deer; another alligator, smaller, carried

like a sack on the shoulders of a vigorous young man; a pensive
camel; an ostrich alongside a monkey; marsh birds and a parrot;
a sumptuously caparisoned elephant. There's no way you can get
bored. And you have to watch out at every step, even though all
seem to be concentrating on what they are doing and little
inclined to pay attention to any intruders.

But can there be an intruder? Yes. It is the most comical fig-
ure, in precarious balance on the cornice of the fresco, clinging
desperately to a large portfolio, his only handhold. What can the
portfolio contain? Drawings, etchings? Something to sell? The
man is clearly an artist. And while at any second he risks plung-
ing down onto the stairway below, he finds himself hemmed in
between his cumbersome portfolio and the bundles of firewood
that the American savages have already prepared in order to
cook the flesh of some other human being (there are four sev-
ered heads arranged neatly on the left—and they might be the
heads of *whites*).

With his impeccable pomace-colored tailcoat and high-
fashion shoes, the painter has got himself into the most danger-
ous point of the Four Continents. But who is he? This individual's
name is unimportant. Because he is the West, the only entity
curious and foolhardy enough to get into trouble in such a far-
away place—and always convinced that there are good business
deals to be done. No one else saw this with Tiepolo's prophetic
irony. So prophetic indeed that it went unnoticed. That artist
hanging from a cornice, like Hitchcock's gentleman thief on the
Côte d'Azur, was considered to be the pretext for another
example of Tiepolo's virtuoso mastery of perspective, a chance
for a boldly foreshortened view. And instead it was the most reli-
able portrait of a civilization.

·   ·   ·

As well as a stunning pictorial epiphany, the Würzburg ceiling is an anthropological experiment. For the first and—until today—the only time, we find assembled here a literally ecumenical humanity, idiosyncratic and in reciprocal contact. If ever the word *cosmopolitanism* had a meaning, it is on that ceiling. Where it is clear that all the characters, including the animals, would be able to understand one another, talking a lingua franca made up of facial features, fabrics, and colors. But without any of this implying a conciliatory attitude. All would cling to their own nature, which can also make them enemies, traitors, or indifferent. Here the word *humanity,* usually irksome and devoid of any capacity to translate itself into images, suddenly becomes tangible, but thanks only to the powerful authority of Tiepolo's hand, his indifference to history and geography, and his rapacity in seizing all that was congenial to his vision. The Four Continents link up to form one single continent, where you breathe in the sea air, but where the characters can easily move from one part

of the ceiling to another. The page offering the chocolate to America and the one proffering the crown to Europe could very easily exchange roles the next morning, like bellhops at work on different floors of the same Grand Hotel. Just as the snake coiled around a shaft that—for no evident reason—is suspended in the sky above Asia, also looms over the first characters of America and belongs equally to them. Whereas its place of origin is the high ground of the *Scherzi,* which lies in some European countryside. Wherever we turn, we find that snake. And it is the only kind of verifiable universality: aesthetic and enigmatic.

"A myth is the 'mesh' of a 'spider's web,' and not a dictionary entry," Marcel Mauss once said. Tiepolo treated the stories his patrons asked him to translate into images in the same way. Christian or pagan—it was indifferent. Real or fictitious, at a certain point all events had to be transformed into the threads of that spider's web, hanging between the branches of a slanted tree trunk and swaying gently at every puff of wind. Never had it been possible to move around in the past with such agility, as if distances in time and space were rhetorical arguments that facilitated contact rather than hindered it. The exotic, as such, no longer existed. All was exotic—or nothing. When Tiepolo found himself frescoing the ceiling of the Würzburg Residenz staircase, he summoned the men, women, and animals that had always accompanied him. It is hard not to suspect that on that occasion painting had called up, for a last parade, the phantasmagoria of history, still imbued with an alarming vivacity, shortly before an insurmountable caesura reduced it to a subject fit for schoolbooks, popular encyclopedias, and civic monuments. This was to happen after 1789. If we wish to understand Tiepolo it would be advisable to run through, by way of contrast, the historical paint-

ing of the nineteenth century: awkward, solemn, stiff, and cumbersome in its Neoclassical versions as well as in the *style troubadour,* or in academic pomposity. They had irrevocably lost the knack for dealing with the past. Only Degas could have found the way again, if he had followed up three works of genius (*Scene of War in the Middle Ages, Semiramis Building Babylon,* and *Spartan Girls Challenging Boys*). But those paintings existed for decades amid a dense silence. Until the last, Degas kept them in his studio, turned toward the wall. Better to wander through the wings and the dressing rooms of the Opéra.

In early 1881, on arriving in Venice, the unsophisticated but perceptive traveler Camillo Boito observed: "Tiepolo is all the rage today: Tiepolo and Carpaccio."

Thus the two heads of Venetian painting reemerged, both permeated by the *magic of the extreme.* Carpaccio is the one who "narrates, tirelessly narrates"—and it almost seems that with these three words of Longhi's we have said the indispensable. Especially if we add a note of his: "Carpaccio, a clear-sighted onlooker who shows no emotion, does not take sides, but simply portrays: but his is a preordained world, already parceled up." A definition that also fits Tiepolo, were it not for the fact that Carpaccio is distinguishable because he always divides the space with a few "extremely sharp triangles of shadow," while Tiepolo allows himself to be dazzled by the light. Apart from this, in terms of the profiles and the rhythm of their figures, Carpaccio and Tiepolo could not be more unalike. But as soon as we say this once more we notice that something unites them in an ironclad complicity: pleasure.

Anton Maria Zanetti was certainly no fan of Carpaccio, whose work he implausibly labeled as being devoid of any "savor of

color." And he found fault with other points too ("the forms of his figures were not noble"). Yet Zanetti did not fail to observe a curious phenomenon, regularly connected to Carpaccio's painting: "Nonetheless, I believe that one of the greatest virtues of these works consists of their effects, and the effect each one has on the sensibilities, and in the hearts of people with little understanding of art. Occasionally, unobserved, I spend some time in this chapel, and I see certain good persons enter, who after a brief prayer, indeed often during prayer itself, turn their eyes to these pictures, their eyes and minds suspended. . . . They betray an easy understanding of every portrayal; they reason in their hearts; and they cannot conceal the inner stirrings they experience." We can instantly imagine certain devout people who, in the Chapel of St. Ursula near the Basilica of Saints John and Paul, could not avoid mixing their prayers with a few furtive glances at the painted walls, perhaps pausing to "admire the saint asleep in her virginal bed, portrayed with such pure grace and innocence; whose expression reveals that in dream she sees true images of Paradise." And we can also believe that those glances stolen from prayer did not hinder it; on the contrary they acted by occupying the mind like a wordless, overflowing background to prayer. In exactly the same way we can imagine another scene, in Würzburg, in an inevitably more secular context: certain dignitaries slowly climb the steps of the grand staircase in the prince-bishop's Residenz, weighed down by uniforms and robes, in preparation for some exhausting ceremony. But, as soon as decorum permits, they cannot avoid a few lightning-fast, voracious glances at the frescoed ceiling, instantly losing themselves among the forests, the tents, and the bales of merchandise of the Four Continents, clinging with their psyches to the cornice in an attempt to carry on being a part of worlds that were

so much more adventurous, vaster, and spicier in comparison with the prince-bishop's realm, already with a hint of Ruritania about it.

The imperative that underpins this *flight of glances,* both in Carpaccio and Tiepolo, is pure pleasure. One day Debussy was to claim that *faire plaisir* is the first of music's aspirations. But he was preceded by those painted surfaces, where there unfolded what Leibniz had called "pleasure accompanied by light," aimed with impartial benevolence at the forms that manifest themselves, whatever they may be.

Of all the greats of painting, Tiepolo was the last one who knew how to keep silent. No one managed to wring from him any declarations of faithfulness to nature or the sanctity of drawing. It was neither the time nor the place—nor was Tiepolo the right character: he executed the work, delivered it to his patron, taking care to please him, and then he moved on. He proceeded in this way for fifty years, without a break, without changing. So, in the end, it is all the more meaningful and symbolic that Tiepolo's *only* statement about art is the one reported—indirectly, as if by a journalist who had caught it on the fly, but sounding wholly authentic—in the *Nuova Veneta Gazzetta* when the paper announced his departure for Madrid, where he had been appointed to fresco the Throne Room in the Royal Palace. Words that, given the circumstances and the way in which they were conveyed, as well as their being surrounded by the artist's stubborn silence on the motives of art itself, seem like a disagreeable, impudent, and sarcastic response to all his future detractors. But, in order to understand the *fin fond* (as Sainte-Beuve would have put it) of that statement, it would be a good idea to examine the setting. The article appeared on March 20, 1762, in the

*Nuova Veneta Gazzetta,* a paper that, beneath its title, stated that it contained "what there is to sell, buy, rent out, and things sought after, lost and found in Venice, or outside Venice, the price of goods, exchange rates, and other news, in part for enjoyment, and in part of public utility." And, among the "things lost" on that day there was the case of "A bitch puppy of a brownish yellow color with 4 white patches," with a plea to inform a Mr. Marcuzzi. Anyone finding the dog, it was added, "will be given by courtesy of the Lady owner of the pup, three Filippi [silver coins worth 100 scudi], one silver ducat from the Lady's maid, and from a relative of the said Lady a basket of doughnuts immediately, a basket of almonds on the following Easter, and macaroni on St. Michael's Day."

The news of the day, on this Saturday in March, was that "Signor Gio: Battista Tiepolo our citizen and famous painter, whose name already is recorded in the annals of the illustrious men of our century, is to leave together with his son, signor Gio: Domenico." And immediately it was added, with a certain arch slyness: "More than any doctrinal debate, this news ought certainly to prove more capable of promoting emulation on the part of those who profess both the Sciences and the Arts. On many occasions signor Tiepolo has been summoned from his homeland to practice his talents, which he has employed to such good effect that he has become recognized as an excellent painter; and he has earned a great deal." After this last observation— separated from the rest by an eloquent semicolon and certainly a juicier tidbit for the readers of the *Nuova Veneta Gazzetta*—the reporter goes on to quote some words of the celebrated painter: "I have heard signor Tiepolo himself say that many young men, when they believe they know something, no longer wish to study, and thus bring to a standstill that progress, for which they

have sufficient talent. He added that painters must try to succeed in great works, that is to say in those that may please wealthy noblemen, because such men make the fortunes of practitioners, and not other people, who cannot buy paintings of much value. Hence the mind of the painter must always strive for the Sublime, the Heroic, and the Perfect, and when—with his gifts—he has gone beyond those steps that at first struck him as the limits of his talents, then fortune will come of its own accord; since by spreading the fame of his skill he will be summoned from his country, or commissions will arrive from within it, which can make him wealthy."

Since the days of Pseudo-Longinus there had never been such a stringent and irreverent case for the Sublime. Which is embodied in this: the Sublime is necessary because it is paid for—and paid well. A thesis that made it possible to ascertain the artist's position in a debate rekindled by Edmund Burke barely six years before.

We have only scant information about Tiepolo's last years, in Madrid. Not a single world from him about the welcome he received, or about everyday life. But had he perhaps done any different in Würzburg? He simply was not in the habit of doing such things. Tiepolo took up his pen when he had to deal with some commission, writing mostly about delivery dates and problems. As for the rest, he did not exist. He was like the skies of his ceilings, on whose margins he cultivated a crowded, animated human vegetation. But he remained intact in the center and benevolently looked on at the passage of clouds, angels, and Hours with butterfly wings.

These huge lacunae should be respected, contemplated. Posterity's pretensions to reconstruct, to weave something out of

nothing, are a sorry affair. The works remain—and their elo-
quence may suffice. First of all the ceiling in the Royal Palace,
which cannot stand comparison with the one in Würzburg and
not even with those of Palazzo Clerici or Villa Pisani. It is as if, by
working for the first time in the locus of an imposing and indu-
bitable power, Tiepolo's creativity diminished, lost some of its
intrepid daring. The marvels of the Royal Palace are concen-
trated in details, for example, the vigilant lynx resting its paws
on the bales of merchandise piled up on the deck of Columbus's
caravel, as if observing the ocean from a balcony. Or the splen-
did flag, flapping from a mast (slanted, naturally) on the same
caravel.

But the allegorical women—Spain enthroned, the Glory near

the obelisk—no longer emanate the fragrance that Tiepolo otherwise distilled. The room had low, insufficient windows. The light: inert. And Tiepolo could make the most of any idea, but not with inert light. Spain itself, all around, knew nothing of taste. It was heavy, irritating, like its machine-gun bursts of consonants. As incompatible as you can get with the softness of Venetian diction. Tiepolo found himself in the part of Europe least congenial to him, amid people who knew nothing of *sprezzatura,* a word that probably was not even translatable into their lexicon. The Spanish were people concerned with honor and dignity, while all Tiepolo cared about was the modality of appearance, its capacity for constant expansion, from the minimal to the enormous.

Apart from the frescoes in the Royal Palace, in his last years Tiepolo composed on another two registers, the first of these being the religious and the public, namely the paintings for San Pascual Baylon, doomed to an unhappy fate: an attempt to comply with local tastes, they were misunderstood, scorned, and mistreated. The second register is that of the private paintings, of whose origins we know nothing, all in small format, unusual for Tiepolo. And all of a high, extremely pure intensity, divergent from any other paintings of the period—and anomalous even in Tiepolo's oeuvre, like a solitary, uninhabited little island. The frescoes in the Royal Palace, the canvases for San Pascual Baylon, the small-format paintings (probably kept until the last in the artist's studio): works perhaps attributable to three different painters, who painted angels the same way. It is difficult to shake off the feeling that these small pictures were Tiepolo's last signature—a finale in a minor key, transparent and melancholy.

What little we know about Tiepolo's private life is subject to the most serious doubts. Yet, just as the gossip collected by Diogenes

Laertius is a precious aid to understanding the Greek philosophers, so is the Venetian street chitchat of value in this case. Tiepolo's wife and the mother of his nine children, Cecilia, sister of Francesco Guardi (and of Francesco's ever mistreated elder brother Giovanni Antonio, thought to be too frivolous), is said to have developed a passion for gambling. Protected by her mask, she apparently went regularly to the Ridotto and, when her money ran out, she allegedly wagered Giambattista's sketches— as well as, once, the house in Zianigo, which her relatives then had to buy back.

On December 22, 1883, after bidding farewell to the De Nittis family on their departure for Italy, Edmond de Goncourt went to dinner, after a long interval, with Gavarni. Among the other guests he found Rogier l'Égyptien, "a friend of Gavarni and Gautier, and a collector of small Italian rarities," who at a certain point during the evening started talking about Tiepolo: "Rogier said, with regard to a portrait of Giambattista Tiepolo's wife, which he had seen in Venice, that an old collector of that place, who had known her husband, had told him: 'She was a bad woman.' One night she lost a large sum of money. The other player said to her: 'I'll wager what you have lost against the sketches by your husband you keep in the house.' She gambled and lost. Then the winner said: 'I'll wager all you have lost against your house on the mainland and the frescoes it contains.' Tiepolo had covered the walls of his country house with amusing paintings, which featured an interminable triumph of Punchinello. Tiepolo's wife gambled again and lost. This happened while Giambattista Tiepolo was in Madrid, summoned by the Spanish court."

Like all the stories recorded by Goncourt, this one has been described as dubious. But in the case in question the source was highly reliable. Rogier l'Égyptien, a Romantic illustrator and a

friend of Nerval in the days of rue du Doyenné, which he had also decorated with his frescoes, had retired to Venice after quitting his job as director of the Postal Service in Beirut. He told the same story to a Tiepolo scholar, Henry de Chennevières, adding that he had heard it told by the old count Algarotti-Corniani. Now, that same count had sold the most important albums of Tiepolo's drawings to Edward Cheney in 1852. Among these albums two had remained intact, titled *Various Studies and Thoughts* and *Single Clothed Figures,* both of which are today in the Victoria and Albert Museum.

Chennevières ended the story this way: "By wholly fortuitous and rather undeserved chance, Domenico arrived from Spain a few days later and was able to sort out the matter, but not without having to give a large quantity of drawings to the collector . . . satisfied with having believed for a day that he was the owner of Tiepolo's studio and villa." According to George Knox, "We [ . . . ] have no alternative, but to accept this as the correct story of how the drawings passed from the Tiepolo studio to the Algarotti-Corniani family."

The symbolic clash that ushered in the long period of obscurity—and above all of moral condemnation—which Giambattista Tiepolo was to undergo occurred in Madrid, where at the court of Charles III two incompatible painters found themselves working at the same time: on the one hand Tiepolo, accompanied by his sons; on the other Raphael Mengs, whom Robert Hughes had the gracious impertinence to define as "one of the supreme bores of European civilization."

From the heights of the praise accorded him by Johann Joachim Winckelmann ("almost like a phoenix he has been called forth from the ashes of the first Raphael to teach the world the

beauty of art"), Mengs probably saw Tiepolo as a relic of an age that had already expired. And there is no need to wonder about the insane haste with which, after Tiepolo's death, the Spanish court rushed to remove his altarpieces in Aranjuez. The match between the stuffy Mengs and the mercurial Tiepolo ended in favor of the former. And obviously it was Mengs who was appointed the king's *pintor de cámara*.

But the consequences of the clash projected their shadow much further forward. One century later, Charles Blanc was to dramatize it with words that would sound comical if they did not correspond faithfully to a collective judgment that was repeated, another century later and certainly in better prose, in the caustic lines of Roberto Longhi's *Viatico*. But Blanc is to be listened to for the psychological background, laden with flavor, of his dramaturgy: "They say that Mengs had the weakness to show his jealousy for Tiepolo: we do not believe this at all. What they must have taken for jealousy was without a doubt the legitimate intolerance of a sober and dignified painter, who saw himself, precisely he who was faithful to the great traditions and wholly devoted to the philosophy of his art, put on the same level as an unhealthy and bizarre talent, a neglected and unprofessional improviser, a decorator without restraint, without measure, and without a sense of the proprieties, in short an artist that must have struck him as extravagant. What, I wonder, must a man as sober as Mengs have thought of a painter capable of putting on a ceiling, in the middle of saints and angels, an owl perched on a branch wrapped in a fluttering drape, or a parrot whose natural colors form a splotch that Tiepolo finds enchanting in the optical harmonies of his orchestra?"

Whether it was the most conservative courts or the most subversive Enlightenment minds to demand it, everything con-

spired to found a new realm of Virtue, wherein Tiepolo could not be well received, if for no other reason than the incurable frivolity that obliged him to take as much care—even with the Virgin—over the soft folds of her silk dress as he did with the rueful expression on her face. One year before Tiepolo's death it was his friend and admirer Saverio Bettinelli, a man of letters who, like a first Nikolai Bukharin, summed up the shortsighted rules that were being imposed on the arts: "The marvelous aspect of mythology has become suspect to the fine arts of our times, which are more austere out of sound or vain philosophy, thinking to open people's eyes to reason, criticism, and truth, almost leaving youth behind, and hence there is no longer a taste for marvels, enchantments, and paintings of fantasy." As a sober chronicler, Bettinelli was explaining the reasons *why* an opaque curtain was about to cover up the glitter that was Tiepolo. This was to leave an insipid Apollo to hold the key to ideal Beauty from the observatory that is Mengs's *Parnassus,* on the ceiling of the gallery in Villa Albani, in Rome.

In Madrid, Giacomo Casanova was Mengs's guest. At a certain point Mengs kicked him out, because he feared for his own reputation. Wherever he went, Casanova made waves—and not only because of women. His revenge was to take form in a few lines, which say more about Mengs than any history of art: "Mengs was greedy for glory, fame, a great worker, jealous, and an enemy to all contemporary painters of any merit. He was wrong, because although he was a great painter in terms of color and design, he lacked imagination, as essential for the painter as it is for the poet." Mengs was par excellence the exportable painter of the day. He knew four languages, all badly. Casanova, who was fussy about languages, pointed out to him one day that the artist was about to send off to the Spanish court a missive

signed *el más ínclito* (the most illustrious). Mengs thought that *ínclito* meant "humble" (*humilde*). Instead of being grateful, Mengs was furious with Casanova and then "despaired when a dictionary proved him wrong."

And Tiepolo, who was in Madrid in those very days? Casanova does not mention him. Only in one sentence, later expunged from the *Mémoires,* he talks of a certain court bookseller who had made him a generous loan, never returned: "He [the bookseller] had only one daughter, but an enchanting one and the heir to all his fortune, who married the son of the Venetian painter Tiepoletto, an artist of mediocre talent, but a good sort of fellow." The son was Lorenzo.

When Tiepolo arrived in Madrid to fresco the ceiling of the Throne Room of the Royal Palace he was no longer young. He was supported by two sons who had a share of his talent and served as extensions of his hand. It does not appear that this glorious commission was particularly close to Tiepolo's heart. But this was not the case for the governor of Venice, who wanted to please the Spanish king. Foscari, the chief inquisitor, also stepped in to free Tiepolo from other commitments. So Madrid was forced upon him by an iron hand in a velvet glove. But the Throne Room did not have the right light for frescoes—the light of Würzburg. And this, more than the pomp of the court, must have counted for the "universal painter" who had introduced "with marvelous art in his works, a beauty, a sun that perhaps has no equal" (as Anton Maria Zanetti wrote of Tiepolo at the time).

Despite the fact that we have no direct testimony, from various signs we can deduce that the favor of the court tended ever more steadily toward Mengs. The two artists worked one beside the other—and Mengs's arrogance could feed on a few insane words penned by Winckelmann and published a few months

after Tiepolo's arrival in Madrid: "Tiepolo does more in one day than Mengs does in a week, but as soon as his [Tiepolo's] work is seen it is forgotten, while the other's remains immortal." As laughable as this may seem today, Mengs stood for the new times while Tiepolo seemed to belong to a period ready to founder among its own clouds.

The fact remains that, after four and a half years living in Madrid (and not two as he had foreseen) working on the frescoes in the Royal Palace, Tiepolo wrote to the king's secretary, Miguel de Muzquiz, to solicit other commissions—offering himself also as a painter working with canvas. So Tiepolo must have felt no pressing desire to return to Venice, even though by then he was over seventy. Evidently he was more attracted by the prospect of a commission for the seven altarpieces in the church of San Pascual Baylon at Aranjuez, another royal residence. "*Está bien,*" wrote Charles III in the margin of a note informing him about the painter's intentions. A few weeks later Tiepolo was awarded the commission. And, when the lengthy work in San Pascual Baylon was finished, he wrote another letter to Muzquiz. Once more he had heard that an important royal commission was in the air: to fresco the church of San Ildefonso at La Granja. Again Tiepolo stepped forward. At seventy-three, he had no fear of putting himself to the test in the laborious art of fresco painting, at which he had no rival. The commission was granted him a few days after his letter was received. Tiepolo welcomed the news with joy. His last letter was one of thanks—and he assured his patron that he would devote himself to the new work with "*toda la atencion y cuidado,*" "with all my attention and care." Basically, Tiepolo had nothing else to say—nor did he have anything else to say during his entire lifetime.

·  ·  ·

The world, which Tiepolo had been affably mocking and avoiding for many years, using it above all as a pretext for composing figures, decided to take its revenge on him at the end of his life, in Madrid—and it entrusted this task to two opposing and converging archons: the layman Raphael Mengs and the Franciscan Joaquín de Eleta, the king's confessor. Two men made specially to hate him: theirs was an alliance of secular conformism and long-standing bigotry. Just as Tiepolo had been unbiased toward the sacred and the profane, placing himself at the service of both and using them for his own ends, so did these two powers conspire to punish the man no one had managed to punish before. To Mengs, the moderate neoclassicist, Tiepolo must have seemed a living outrage. As for Eleta, uncultivated and truculent, he knew well how a father confessor could make life difficult for a foreign artist at the court of Spain. Amid an ominous silence, as if his presence in Madrid—being responsible for an imposing task like the fresco in the Throne Room—were something not to be mentioned, Tiepolo worked in the city without interruption until his death. He also completed the altarpieces for San Pascual Baylon, which he was never to see installed in the church. In a letter that was for once sober and poignant, he explained to the king's secretary that he had not succeeded in "*obtener el honor*" of speaking to the father confessor—and this led him to suppose something that hurt him: "*no haber dado cumplimiento a mi encargo, a su cabal satisfaccion, que seria para mi la major mortificacion.*" (Not having finished my task, to your complete satisfaction, would be most mortifying for me.)

Being obliged to write a letter of this tone, after having used far different terms with his past patrons, came as a perfidious, retaliatory punishment to Tiepolo. Two months after his death, the canvases were hung in the church, for the saint's day. But

they were not to stay there long. In that same year it was decided—again on the advice of the father confessor—to replace them with the works of Mengs and his disciples, inspired by the same subjects used by Tiepolo. This was the ultimate insult, as if Tiepolo had to be expunged from history, centimeter by centimeter. And so his canvases were dispersed and mistreated in various parts of the monastery. One painting—the one on which Tiepolo was working at the end—was cut in two. The angel showing the Eucharist to San Pascual Baylon was separated from the saint. It can still be seen today in the Prado, a solitary angel.

Tiepolo had no Vasari or Bellori to bear witness to his life. Not even Algarotti, who kept his company and got on well with him, ever wrote about him, if not en passant. For his contemporaries he was "the illustrious Tiepoletto" and "the follower of Paolo Veronese." This was enough to satisfy them.

What stands out even more, as a funeral oration of an inverted rhetoric, is the note in the Libro de Enterramientos, the register of burials in the parish of San Martín, dated March 27, 1770, the very day of the painter's death:

"Don Giambattista Domenico Tiepolo, court painter to our lord the king, deceased husband to donna Cecilia Guardi, and a native of the city of Venice, a parishioner of this church, in Saint Martin's square, and home of don Antonio Muriel, was granted a declaration of indigency before Manuel de Robles, the royal scribe, on 12 August 1762, and named as his heirs don Domenico, don Giuseppe, don Lorenzo, donna Anna, donna Elena, donna Angela, and donna Orsola di Tiepolo, his seven legitimate children and his abovementioned wife. He was unable to receive the Holy Sacraments. He died on 27 March 1770. Buried in Saint

Martin's in secret, by license of the lord Vicar, in one of the
niches in the vault of the Santíssimo Christo de los Milagros."

These are words from which we may deduce some facts, men-
tioned only in this document. First and foremost: Giambattista
Tiepolo, *pintor de cámara* to the king, two months after arriving
in Madrid to fresco the Throne Room of the Royal Palace, had
presented a declaration of indigency before the royal notary
Manuel de Robles. Why did he feel it necessary to do this? Cer-
tainly in order to obtain some practical benefit, which we are
unable to ascertain. And without this implying an effective state
of need. But the point remains that as soon as the renowned *pic-
tor Venetus* Tiepolo arrived in the capital—armed with the most

prestigious commission conceivable for a painter—he decided to declare himself *poor,* the same man who immediately before leaving Venice had specified that a painter should work for "wealthy noblemen, because such men make the fortunes of practitioners."

Moreover Tiepolo died without the comforts of religion, presumably because of the suddenness of the event. But why was he buried in secret? The painter of glory took his leave in secret. A leave-taking that was not inappropriate.

The king took note of Tiepolo's death (in a communication from Muzquiz dated March 28) and gave commands for the canvases for San Pascual Baylon kept in his studio to be installed in the church, where he attended the first Mass on May 17. The following November orders were issued for Tiepolo's paintings to be removed and replaced with works by Maella, Bayeu—and Mengs, on the main altar. Even though we do not know much more about the attitude of the Spanish court toward Tiepolo, this act of profound incomprehension is sufficiently eloquent. *Exit Tiepolus*—and let his memory be wiped out. But another thing overloads that moment with significance. The removal of the altarpieces in San Pascual Baylon marked the beginning of the removal of Tiepolo in toto from the European psyche. This process was to last roughly one century, during which a strange phenomenon occurred: people continued to swarm beneath Tiepolo's skies, in Venice and in Würzburg, in Milan and Madrid, but they ignored them, having no intention to look up toward those clouds, animals, and angels. Something incompatible with those skies prevented them from being perceived. And when people once more began to see them, these images had become remote and inaccessible for they spoke of a vanished, irresponsi-

ble realm, one made up of gestures and hues forever in desuetude. Or perhaps one hue remained, which might be conjured up among fabric merchants: *Tiepolo pink.*

What might be defined as Tiepolo's *late style* is manifested by nine small easel paintings, in an unusual format for him, ranging between 40 and 60 centimeters. Eight of these have religious subjects, one pagan. It does not appear that these paintings were made to commission. On the contrary, it may be said that we know nothing about them. Not a word has come down to us in their regard. The canvases themselves came to light very slowly and to this day some of them are still in private collections. Compared to the altarpieces made for San Pascual, in these nine small canvases we breathe another air. The space is finally uncluttered. In the San Pascual altarpieces the painter's hand is forever burdened by the malevolent eye of the king's confessor, like some evil spell. And Tiepolo's efforts to find an honorable compromise were pathetic. Nothing reveals this like Tiepolo's San Carlo Borromeo in meditation, with that intrusive nose of his. Despite all possible goodwill, that saint could never have become one of the repertoire of Tiepolo's characters, because of a sort of physiognomic incompatibility. But in the small canvases of the late period, all persecution has vanished. The game becomes secret and intimate. Here, the *Christian elegy,* dear to Sainte-Beuve, reaches its supreme intensity, which painting was never to attain again.

If all that remained of Tiepolo were those nine pictures, what might we say of him? Something very different with respect to what is suggested by the rest of his oeuvre, yet this something is—by secret ways—concordant, like a resonance that was implicit previously but only now lets itself be heard. No less than

the *Scherzi* and the *Capricci,* these nine small canvases are a *templum,* a clearly circumscribed and protected area, set within the vast stretches of Tiepolo's painting. Here what spread out elsewhere to overcome all obstacles is condensed into smallness, almost as if it were the only possible dimension.

These canvases have no precedent in Tiepolo's work, far less in the painting of his century. It is as if the word *religious* had suddenly gone back to being natural and implicit, as in Giovanni Bellini's day. There is no trace of eighteenth-century aridity, nor of the obligatory devotion of the high rhetorical school, which Tiepolo too had practiced like a master—and was still practicing in the altarpieces for San Pascual Baylon. In these small canvases Tiepolo turns his back on his own times. By now seventy, after having spent a lifetime complying with the will of all kinds of patrons, for the first time Tiepolo chose to ignore his surroundings. With regard to European painting of those years Tiepolo's nine canvases are perfectly, happily extraneous. But they also move away from his previous work. While they may seem reminiscent of the vibrant incisiveness of the modelletti for the frescoes, after a second look they are detached from them. Here there is no allusion to a greater dimension and to a greater definition of the features of the figures. Here the vibration of the light is the ultimate state, nor can the figures be more greatly defined. A certain pensive austerity reigns over all, which gives the tone to the image.

In the *Deposition from the Cross* and in the *Deposition at the Sepulcher* Tiepolo discovers the pure sound of desolation and suffering, which until then he had not succeeded in isolating: in *Abraham and the Angels* and in *The Annunciation* he rediscovers the miracle of revelation, which had been the trumpet blast of his youth, in Udine's Palazzo Patriarcale. Finally, in the four scenes

of the flight into Egypt, charged with silence, suspended, intact, he attains a definitive point of sentiment, as happens at times in Schubert. The elements are reduced to a minimum. There remain certain looming cliffs; a few slanted tree trunks; still, glassy water. And above all a silvery quality that permeates the light. It is invincible Christianity at its most meditative, sober, and abandoned.

And the gods, where are they—those gods with whom Tiepolo had been so familiar? They are still there, still intact. Sufficient proof of this lies in a single canvas, ignored for a long time because it was closed up in the Pinto Basto collection and never shown at the great retrospectives. It portrays an old man on his

knees, with large wings and a newborn baby in his arms: before
him, a little higher up, resting on a fluffy cloud, there is a nude
blond woman who seems to be offering the child a plaything. She
is accompanied by a handmaiden, also nude, and two winged
putti. An eagle is observing the scene. Who are they? Before
answering, we know we are in the presence of familiar figures,
for Tiepolo. How many times have we come across that vigor-
ous, hirsute old man with the huge wings of a bird of prey? And
that young blond woman, who flaunts her magnificent bosom
and divergent breasts? In a similar situation—and still with a
baby between them—they had been painted together on the
ceiling of Ca' Contarini, in Venice, about ten years before. Gian-

domenico Tiepolo, who had made an etching from that painting of his father's, titled it *Birth of Venus* in an invoice he sent to Mariette. But what did that scene represent, that scene now repeated—no longer in the sky but in some mysterious and bewitching place on the earth—in the small painting of the Madrid years? Was it Venus entrusting her son to Time, as plausibly maintained by Michael Levey? Or was it *Chronos Entrusting Cupid to Venus,* as we read in the Morassi catalog? Who was entrusting to whom? And did the picture perhaps conceal dynastic allusions? Perhaps it hinted at the birth of Francis II, who was to become the last heir to the Holy Roman Empire? Why is it that the little Eros or Cupid has no trace of wings? The catalog of the National Gallery of London, which now houses the Ca' Contarini canvas, has no intention of compromising itself and titles the work *An Allegory with Venus and Time.*

Whatever the answer, for Tiepolo the small Madrid painting marked the last appearance of the two figures who most faithfully and tenaciously had accompanied him throughout his life as a painter: the old man and the maiden. Whether they were Pluto and Proserpine or Neptune and Venice or a river god and a Nymph or Time and Truth or Time and Venus, in any event they were always those two characters who met and embraced. Something indomitable and recurrent binds them together. Were they enemies, lovers, father and daughter, allies? Every possibility flows into the other, in an uninterrupted circular motion. In the same way it is not sure if Time, on unveiling Truth, was introducing her to glory or to ruin. Yet it seems unlikely that Tiepolo himself attached any importance to answering this. What interested him above all was to paint those beings as the two supreme powers that underpinned his art, which consumed it and exalted it at one and the same time.

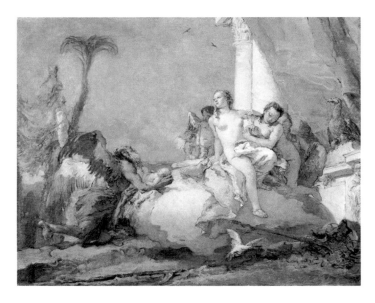

Hence the complicity between Venus and Time, which was never as evident and penetrating as it is in the small Madrid canvas. Tiepolo wished to take his leave of them too.

Truth as a young woman—blond, naked, and shapely—was not a novelty in Venice. Nor was Time as the winged old man who seizes her. They had appeared on the device of Franco Marcolini, publisher, watchmaker, and engraver, who made his debut in 1534 when he published Pietro Aretino's *Passion of Christ,* followed in 1536 by *The School of Whoredom,* also by Aretino and whose original title would translate as: *A dialogue, in which Nanna on the first day teaches her daughter Pippa to be a whore.* Great publishing.

*Veritas filia Temporis:* those ominous words can be read on the oval frame of Marcolini's device. And they were words that had already echoed down the centuries for the most diverse doc-

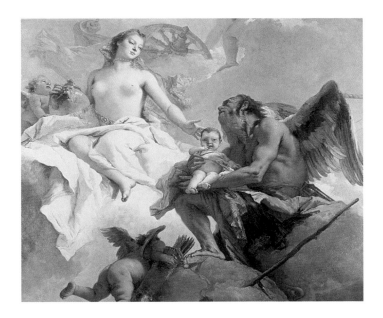

trines. Their first mention dates back to Aulus Gellius, who—
and this was truly strange for such an erudite man—attributed
them to "another one of the old poets, whose name has escaped
my memory at present." First, a salutary warning about the
ambiguity of that kinship. If Time engenders Truth, it also en-
genders obscurity, which conceals Truth.

Suddenly, starting from the third decade of the sixteenth cen-
tury, Truth as a naked woman, sometimes lashed with serpents
by another woman, sometimes seized by the firm hand of a
winged old man, began to circulate in Europe: not only in
Aretino's Venice, but in Germany and England, where it had an
influence on religious struggles.

Plunging into the debate and the allusions of the period, Fritz
Saxl has shown how this image erupted into the light and was
used for the most different ends. By Mary Tudor to celebrate the

Roman Catholic Church, but a few years later by Elizabeth I to oppose it. Saxl observed soberly: "In less than twenty-five years it has reversed its meaning twice, and has been made the vehicle three times of strong emotion." In the end, the image of Truth as the daughter of Time was to extend within the following century into versions by Rubens, Poussin, and Bernini.

When they reached Tiepolo, therefore, Time and Truth were a seasoned couple, one that in other periods had been destined to embody incompatible meanings. Now they were no longer any different from many other stock characters, who might prove useful according to circumstances. And thus they found them-

selves on the verge of winning back a condition of sovereign indifference, which allowed them to return to their primordial nature as enigma: visually expressed as the complicity between a winged old man, equipped with a fearsome scythe, and a naked young woman, who in certain cases was portrayed as she emerged from a dark recess. But for Tiepolo, as in Marcolini's device, the most appropriate place for their evolutions, like dancers, would be the sky, with its retinue of clouds.

Erwin Panofsky carried out a memorable study of Father Time, working back to his Persian origins and then up through Hellenic antiquity, the medieval centuries, and the Renaissance before finally coming to Poussin and his *A Dance to the Music of Time,* where Father Time—bald, muscular, and with a white beard—plays the lyre for the four symbolic maidens joined in the dance. After Poussin, Panosfsky implies, without saying so directly, the story of the symbol crumbles and burns itself out. Yet, almost like a palinode, Panofsky put on the facing title page of *Studies in Iconology* a drawing by Tiepolo with a figure of Father Time. And he remarked that the Metropolitan possessed "more than half a dozen" of those drawings, with various themes: "Time and Fortune. Time and Truth, Time on a chariot drawn by Dragons, Venus handing Cupid over to Time, etc." Behind that "etc." there unfolds a complex story, which cannot be explained even with iconological means: that of the relationship between Tiepolo and Father Time.

For much of his life Tiepolo continued drawing and painting a vigorous old man and a voluptuous woman: side by side, often embracing, at times one facing the other. To explain this, it is not enough to talk of his patrons' tendency to welcome the simultaneous appearance on their ceilings of a seductive naked woman

and a moral lesson. We need to understand what pushed Tiepolo, with such frequency and with loving tenacity, in the direction of those characters, to the point of making them a dominant feature of his repertoire—and often the fulcrum of his scenes. As always with Tiepolo, it is pointless to seek in the nooks and crannies of iconology. Like few other painters, Tiepolo worked out a private, encoded iconology that he superimposed, just as much as was indispensable, over the official iconology required by his patrons. Moreover, those same patrons certainly were not as scrupulous as Isabella d'Este had once been—and by then they were satisfied with vague generalities, allegorical or mythological as they might be. In astrological terms, we might say that Tiepolo's aim was to link up and tie in an erotic knot Saturnine abysses and Aphroditic luster, as if those two signs each existed as a function of the other and thanks to the complicity of the other. This helps to explain the confusion that has led critics to differ in their definitions of the scene Tiepolo painted in Ca' Contarini. While uncertainty continues to linger over which of the two divine beings is the subject, there was no doubt about the attitude: a trusting dependence between united powers. But shouldn't Venus be the greatest enemy of Time? And shouldn't Time attack the sovereignty of Venus? There is no myth to help us on this point. Only Tiepolo's images. Whereas Antony and Cleopatra are lovers solely because they are fundamentally enemies, Time and Venus are enemies solely insofar as they are eternal lovers. In their physical and metaphysical sky, Time and Venus do not clash; on the contrary they glory in each other. In Tiepolo's view, Venus was like the noetic substance, which the Chaldean Oracles often defined as "flower," because it expanded in the flux of manifestation. And her son Eros, already in the first Greek bas-reliefs, appears with a flower

in his right hand. Or otherwise as a tiny figure standing on his mother's forearm as she offers a flower to Hermes, the presumptive father. In Venus's view, old Father Time was the only lover able to measure and foster the challenge of appearance, because Eros was also another name for Phanes, He-who-appears.

If these themes found no outlet in words in the years in which Tiepolo was painting them, it was because the period had no new Marsilio Ficino or Pico della Mirandola at its disposal. And by then mythic images were becoming accustomed to surviving as stateless persons to whom painting had granted one last, temporary pass. But in their refulgent muteness they did not even fret about that sudden silence, which fortified them after so many centuries of human chatter—and perhaps prepared and goaded them into new metamorphoses still to come, for them and us.

Right from the start there has been a debate regarding Eros's parentage. The generally accepted mother was Aphrodite. But the father? This is a case of *pater incertus* like none other. According to some, it was Hermes, according to others, Ares. Sappho went as far as to say it was Uranus. Until, in the late Alexandrine period, Meleager dared to define that father: "No one, son of No one." And he described Aphrodite, who, exasperated, pointed out the disappearance of her son from her bed, exclaiming: "I don't know who the father may be."

Meleager was an artful rascal, but the matter could reveal serious grounds for concern. Even Pausanias was puzzled when they told him of the many fathers attributed to Eros. In his wanderings throughout Greece he came to Thespiae in Boeotia, the only place with a cult devoted to Eros, but one that was "superior to

that of all the other gods." The god was worshipped in the form of a "rough-hewn stone." But a legendary statue, the Eros of Praxiteles, had been kept for a long time in the sanctuary of Eros. The renowned courtesan Phryne had donated it, after having received it as a "lover's gift" from Praxiteles himself. That statue was a case of inspiring self-referentiality: "Eros as the price of eros." Tullius Geminus celebrated Praxiteles in an epigram, because on that occasion the sculptor had given to all, as the "fruit of two arts," his and that of Phryne, "the even more perfect god he kept in his bowels." But one day the grasping Nero stole the statue of Eros from Thespiae, bringing disaster upon himself. Sheer formlessness and the purest form, what Winckelmann was to evoke like a hallucination in his writings and was never to see, because Praxiteles' statue was destroyed by fire in Rome: all this was the Eros of Thespiae. Pausanias wanted to question one of the priests of the god. And so he heard talk of certain Orphic poems that went together with the ritual and revealed the identity of Eros's real father. But at that point he realized he was stepping over the threshold of the secret. And he wrote: "Of these things I will make no further mention." In point of fact there was another story whose echoes had resounded and ramified since remote times. Not only was Eros not the son of Aphrodite, but apparently he had helped her to be born, lifting her gently from the waves. The scene can still be recognized in an enchanting silver medallion from Galaxidis, today in the Louvre. Adolf Furtwängler provided some sound reasons why that medallion perhaps portrayed a scene sculpted by Phidias on the base of the statue of Zeus at Olympia: "Eros greeting Aphrodite as she emerges from the sea," to use Pausanias's words. But before being a winged young man who helped his mother into the world, who had Eros been and how was he born?

"Tyrant of the gods and of men," according to Euripides, Eros came long before both. Under the name of Phanes, he had appeared with appearance itself. Winged, androgynous, made up of many animals, first among which the serpent, he concealed in his body "the seed of the gods." And it was he who saw to it that the gods had "a habitation and a common seat." But who was his father? Time-without-old-age had generated him in coitus with Ananke, serpent with serpent. "In the immensity of his coils, Time begot Aether and glorious Eros, of the dual nature and the all-seeing gaze." This doctrine was formulated in the *Orphic Argonautics,* which circulated in a Latin translation from the midfifteenth century onward and came out in an Aldine edition in 1517.

Hence there were two traditions, by no means opposites. Eros could have a mother—Aphrodite—and an uncertain father: or otherwise he could have a father—Time—and, as a mother, a serpent that girded the world. But, if we let ourselves slip down the precipice of the centuries, until we reach the rooms of a Venetian palazzo and a small canvas painted by Tiepolo in Madrid, Eros will return to claim his dual lineage: son of Venus, but also the son of Time. And perhaps this will help us to grasp the secret pathos of the two images. The mother, who perhaps is not the mother, offers her son to an old man, who perhaps is the real father. In both pictures the protective, maternal gesture toward little Eros is that of Time, who holds him in his arms. Venus merely shows herself, with bared bosom. She is appearance itself, as in a remote epoch Eros had been, insofar as he was also Phanes. And Time is *almost* kneeling before her in the Madrid canvas. Little Eros, whom Time has just taken into his arms, seems about to be offered to Venus once more. The perfect duality of giving and receiving. Meanwhile Venus looks into the

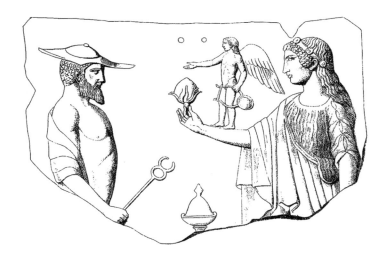

far distance, holding a jewel in her hand. Time's scythe lies abandoned on the ground. In the background—and Gottfried Benn was to spot this immediately—an "impious blue."

In the small canvas showing Venus and Time there is a feature that we discover only at the end. Dazzlingly white, like Venus's body, behind the goddess there arises a column with a Corinthian capital, which looks like part of a temple. And, as elsewhere in Tiepolo, Venus is resting on a frothy mass, both cloud and rock at one and the same time. But interposed obliquely between her body and the column there is a yellowish curtain. More than an ordinary curtain, it is a stage curtain. We cannot see from where it hangs. But it could be hung only from the sky. If closed, the curtain would cover the temple and the landscape we glimpse behind it. It would separate the world from the divine characters. So those who observe the scene realize that, perhaps for the last time, they find themselves on the

side of the gods. The curtain that was to make them invisible to the world had yet to come down.

If the curtain were closed, what objects would remain on the gods' side? The ground is bare and rugged. But something is recognizable—and it's no surprise: Time's scythe, left lying carelessly on the ground, not far from its owner, who for the time being has something else on his mind. But this is not all. Between Venus's white foot and the white dove with open wings there is a dark, slanting line, like an old scar, hanging in precarious balance. What is it? As if meeting up once more with an old friend, a regular visitor of all blind alleys but also of the sky, we recognize the staff with the serpent coiled around it. Who does it belong to? Who has left it there, alongside Venus's frothy, stony cloud? Perhaps Venus herself—or otherwise any of the gods. And certainly that staff with the serpent, like the scythe too, is in its place of origin. Both are part of the landscape. Even before coming to the temple, which already belongs to the world of men, those two rectilinear segments meet, united with a curved element: the blade of the scythe, the coils of the serpent. The gods need nothing else.

Like so many *egrégoroi,* the invisible watchers who direct the course of the world without appearing in it, the nine small canvases in Madrid survived for a long time in complete obscurity. Their existence was ignored throughout the nineteenth century. Only at the beginning of the twentieth century did they receive scattered mention in writings on Tiepolo. Some of these mentions are to be found in Pompeo Molmenti (1909) and Eduard Sack (1910). Others in Giuseppe Fiocco (1940). And with *The Flight into Egypt* in New York we come to 1962 (Morassi). Nor

have the nine small canvases ever been seen all together. Even at the great tricentenary exhibition (1996) only four of them were on show, two on loan from the museums of Stuttgart and Lisbon, and two from the Villahermosa family. Yet this is a set that seems to suggest an internal order. If you look at these canvases one alongside the other, they reveal even more their extraneousness to the painting surrounding them. The paintings correspond thematically, even though there is no certainty that they were the only ones in that format painted by Tiepolo in his last years. Two are dedicated to the moment of vision: the angels who appear to Abraham and the angel who appears to Mary. Four refer to an event—the flight into Egypt—that recurs throughout the history of Giambattista and Giandomenico's family. Finally, the *Deposition from the Cross* and the *Deposition in the Sepulcher* show two moments of pure desperation in the story of Christ—and in their desolate, mute anguish they may stand as a late palinode for *The Ascent to Calvary* and *Christ in the Garden of Gethsemane,* where Tiepolo failed to avoid a certain mannered pathos. This leaves *Venus Entrusting Cupid to Time,* whose only public appearance dates from 1976, when it was sold at auction by Christie's. After that, all trace of the picture was lost until it recently resurfaced in the entry of the Museum of Montserrat, like a glorious pagan prelude in the mountain sacred to the Virgin. Yet that little painting is the epitome of all the gods who had crossed Tiepolo's skies and earth with the familiarity of those who find themselves in their native element. For the transitive law of gesture, the Abraham who prostrates himself before the angels, the angel who prostrates himself before Mary, and Time who kneels before Venus are fundamentally—with regard to all of Tiepolo's life and work—the same figure.

.  .  .

The flight into Egypt is recounted in a few words in the Gospel according to Matthew: "Behold an angel of the Lord appeared in sleep to Joseph, saying: Arise, and take the child and his mother, and fly into Egypt: and be there until I shall tell thee." A great number of painters chose that flight as a subject, on a par with the Annunciation and the Presentation in the Temple. But no one reached the point of Giandomenico Tiepolo, who transformed it into an account in twenty-four episodes. At that time he was living in Würzburg, together with his father. And there he engraved and published his *Idée Pittoresche Sopra La Fugga in Egitto di Giesu, Maria e Gioseppe* (spelling was not the Tiepolo family's forte), dedicated to Prince-Bishop von Greiffenklau.

Giandomenico's idea—a grandiose one—was to split up into twenty-four segments this event in which nothing happens if not the slow, cautious, arduous journey of a woman with a newborn baby in her arms, as she travels along on the back of a donkey led by a bald, wrinkled man. Yet those scenes, which could be so many details of genre paintings, are followed by cohorts of angels, by the eyes of malevolent or indifferent men, and even by the gaze of God the Father. Nothing more humble or insignificant, nothing more decisive for history. The heir of those who fled into Egypt attains salvation by returning to Egypt. This is a singular closure of the circle. And then: on that lonely road there occurs the first of the miracles that accompany the life of Jesus, even though it is recounted only in the Apocrypha. Having arrived almost at the end of the journey, while making their way along a tree-lined road in deep shadow, the Holy Family passes by the statue of a goddess, elegant and erotic in a peplum that leaves her shoulders and bosom uncovered. Mary with Jesus proceeds on the donkey's back, looking ahead. Her head is veiled; perhaps she has not even seen the statue. But Joseph, who

is leaning on a staff, looks to one side. He has realized that some-
thing is happening. In the very moment in which the Holy Fam-
ily passes the statue, the goddess's head falls off and crashes to
the ground. Giandomenico shows us, as in a photograph by
Muybridge, the instant in which the head of the statue is about to
smash to pieces. He even clearly etched the shadow projected by
the falling head. It may be said that this moment marks the end
of the pagan era and the beginning of something that at first is
only a young woman with a baby on a lonely road. Many were
tempted, in words or in images, to portray that mysterious
moment starting from which the pagan and the Christian worlds
found themselves coexisting, one as a landscape of ruins and
mutilated simulacra, and the other as a feeble, obscure pulsating
life. But only Giandomenico dared to fix that landscape in an
instantaneous event that no one notices except Joseph, who
probably did not grasp its significance. This is how history hap-
pens, the image tells us: by way of scoring and fractures that can
easily pass unnoticed. But they are irreversible.

Fifteen years after Giandomenico's twenty-four etchings, Giam-
battista was to paint in Madrid four small canvases on the same
theme: a countermelody, an antiphonal response, which would
create a perfect equilibrium.

Here, with supreme elegance, it was the father who conspicu-
ously borrowed elements from the son. Above all the insistence
on the river. In Giandomenico's sequence a good five etchings
had to do with the crossing of a river, where an angel acts as
ferryman. This river is not mentioned in the Gospel according
to Matthew. But Giambattista too considered it an essential
episode, devoting three of his four canvases to it. And this was
not the only way in which father followed son. In the scene out-

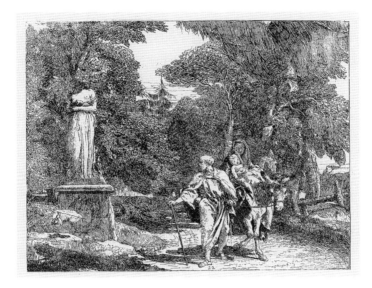

lined by Giandomenico clouds and mountains are blended and superimposed one upon the other. Giambattista picks up the barely sketched-in outlines and uses color to produce one of the most memorable landscapes in painting. The water is greenish blue, very still, solid. On both sides of the riverbank, spurs of jagged chalky rock. It is not clear where the mountains end and the clouds begin, in the background. In one of the pictures, the ferryman angel strikes a pose identical to that of one of Giandomenico's etchings (the fourteenth). Even more than in Giandomenico, where he is sometimes bald and other times has a thick head of hair, Joseph's appearance changes every time. In the canvas in which the Holy Family is nearing a city, he is a young, vigorous man with a beard. On the boat the angel is pushing across the river he is an old man with white hair and a beard. When the Holy Family is waiting and the angel has yet to appear, he is a small dark blotch on the landscape. Finally, when

the angel arrives with the boat and prostrates himself, Joseph is shown with a white beard and dark hair. But now his features have changed and it is not hard to recognize him: he is one of the Orientals.

The four canvases of the flight into Egypt mark the discreet beginning of a final monologue, a subdued performance in which only Giandomenico and Lorenzo could have understood all the allusions and details. Giambattista is hinting at his own arrival at the greenish blue river, which is death. For one last time, on the banks of that river, he painted a few slanted tree trunks, his oldest and most faithful companions: above all a pine resting against and almost embraced by those light, friable rocks, which belong to neither Spain nor Italy. Contrary to what occurs in nature, the branches of that tree begin far up the trunk, already near the top of the rocks. The main thing is the bare trunk, those two slanted lines that run across the picture and are the picture itself, thrusting toward the edge of the frozen waters.

The painter who for decades had devoted himself to filling vast ceilings with figures and in any case had always favored large surfaces was now working on the easel with canvases measuring an ideal 57 × 44 centimeters—those of the two scenes of the flight into Egypt. The light is clear, with unexpected splashes of sky blue and silver. All tumult has ceased. There remains a landscape, which is repeated. A spur of white rock, looming, a pine with a slanted trunk (how could it be otherwise?), the glassy water of a river that cannot be crossed. An immense feeling of solitude. A few birds furrow the sky. You can hear the silence. Until the angel appears and prostrates himself before Mary, the child, and an old Joseph—in no way dissimilar to one of those many Ori-

entals bent on magical operations—and a donkey. In the end it seems that these were fixed points for Tiepolo: the figure of the angel and the gesture of prostration, the submission to a vision. And it is the vision that prostrates itself before the vision. Abraham had prostrated himself before the angel. Now the same angel prostrates himself before Mary in flight, just as he had prostrated himself before her for the Annunciation. This chain of visions bears up the world. Then everything moves away. The supreme picture—also in the sense of the last picture—in this

*late style* might be *The Rest on the Flight into Egypt,* now in Stuttgart. Here there is almost only the landscape: the white rock, the pine tree, the birds, and the glassy river. Mary, Joseph, the child, and the donkey can barely be seen, in a corner. They are anonymous extras, absorbed in the landscape. The vision is still to come. There is an intact stasis—and the wonderful silence of the world.

# SOURCES

*The first number refers to the page in the text, the second to the line on which the quotation begins.*

PART I

4, 10 "steer clear of as far as possible": B. Castiglione, *Il Libro del Corte-giano,* I, xxvi.

4, 12 "affectation": Ibid.

4, 12 "bane of affectation": Ibid.

4, 13 "using in all things": Ibid.

4, 16 "From this, I believe": Ibid.

4, 17 "It can be said that true art": Ibid.

5, 13 "Tiepolo was a happy painter": A. M. Zanetti, *Della Pittura Veneziana* (Venice: Giacomo Storti, 1792), vol. 2, p. 600.

5, 15 "But this didn't stop him": Ibid.

5, 20 "His fire is mere artifice": Ch. Blanc, *Histoire des peintres de toutes les écoles. École vénitienne* (Paris: Renouard, 1868), p. 1.

5, 25 "stern critics": Zanetti, *Della Pittura Veneziana,* vol. 2, p. 600.

5, 27 "the dormant, happy": Ibid.

5, 30 "the forms of the heads": Zanetti, *Della Pittura Veneziana.*

6, 7 "he breaks out like a fanfare": G. Fiocco, in *Enciclopedia italiana* (Rome, 1949), vol. 33, *s.v.* "Tiepolo, Giambattista," p. 829.

6, 21 "the prophetic tribe": Ch. Baudelaire, *Bohémiens en voyage,* v. 1, in *Les Fleurs du mal.*

8, 3 "Tiepolo is not only a painter of angels": G. Manganelli, "Il soffitto come un palcoscenico," in *L'espresso a colori,* September 26, 1971.

8, 9 "He is an idolater of light": Ibid.

8, 16 "that kind of tedious article": Ch. Baudelaire, *Salon de 1859,* in *Œuvres complètes* (Paris: Gallimard, 1976), 2:608.

8, 19 "No explosions": Ibid.

8, 27 "those clouds with fantastic, luminous forms": Ibid., p. 666.

11, 4 "the most acclaimed": P. Gradenigo, *Notizie d'arte tratte dai notatori e dagli annali del N. H. Pietro Gradenigo* (Venice: La reale deputazione editrice, 1942), p. 64.

11, 7 "Court of Muscovy": G. Tiepolo to F. Algarotti, 16 March 1761, in G. Fogolari, "Lettere inedite di G. B. Tiepolo," in *Nuova Antologia* 1 (September 1942): 37.

11, 11 "*amatore*": C. Ricci, *I rapporti di G. B. Tiepolo con Parma* (Parma: Battei, 1896), p. 14.

11, 13 "Honorary Academician": Ibid., p. 16.

11, 21 "the man's personality": S. Alpers and M. Baxandall, *Tiepolo and the Pictorial Intelligence* (New Haven and London: Yale University Press, 1994), p. 164.

11, 30 "the sculptor born dead": R. Longhi, *Viatico per cinque secoli di pittura veneziana* (Florence: Sansoni, 1946), p. 43.

12, 12 "craving for truth": R. Longhi, "Dialogo fra il Caravaggio e il Tiepolo," in *Da Cimabue a Morandi* (Milan: Mondadori, 1973), p. 1028.

12, 15 "brawl among swarthy gondoliers": Ibid., p. 1030.

12, 16 "lethal thrust": Ibid., p. 1034.

13, 4 "Tiepolo was frequently the target": Manganelli, "Il soffitto come un palcoscenico," p. 39.

14, 15 "at all of life": R. Longhi, "Caravaggio," in *Da Cimabue a Morandi,* p. 813.

14, 21 "Even if Bacchus": Ibid., p. 818.

15, 5 "revolutionary impetus": R. Longhi, "Il Caravaggio e la sua cerchia a Milano," in *Da Cimabue a Morandi,* p. 879.

15, 6 "permanent revolution": Ibid., p. 877.

15, 8 "human more than humanist": Ibid., p. 893.

15, 20 "I deeply despised northern painting": R. Longhi, "Keine Malerei. Arte Boreale?," in *Il palazzo non finito* (Milan: Electa, 1995), p. 75.

15, 21   "In a mind that wishes": Ibid., p. 76.

16, 4   "acute and waspish phobia": C. Garboli, Introduction to Longhi, *Il palazzo non finito,* p. xiv.

16, 6   "perverse and providential Italianness": Ibid., p. xvi.

16, 21   "the most intelligent critics": R. Longhi, "Carlo Saraceni," in *Il palazzo non finito,* p. 114.

16, 23   "a really odd thing": Ibid.

17, 7   "Do me the favor": E. Degas, *Lettres* (Paris: Grasset, 1945), p. 72.

17, 15   "artists . . . all hold one another": R. Longhi, *Breve ma veridica storia della pittura italiana* (Florence: Sansoni, 1980), p. 178.

17, 29   "Tiepolo's genius": Longhi, *Viatico per cinque secoli di pittura veneziana,* p. 40.

18, 10   "haughty skepticism": Ibid., p. 42.

18, 15   "No effort [was required]": Ibid.

19, 1   "Instead of being the last painter of the Renaissance": R. Longhi, "Il Caravaggio e la sua cerchia a Milano," p. 893.

19, 4   "a kind of 'night porter' ": Ibid., p. 892.

19, 9   "workaday": Longhi, "Caravaggio," p. 813.

19, 24   "simple sentiments": Ibid.

20, 10   "Fields without light": Longhi, "Dialogo," p. 1026.

20, 13   "What was flashing through his mind": Longhi, "Caravaggio," p. 829.

20, 20   "flux of mythologies": Longhi, "Dialogo," p. 1027.

20, 29   "trace of truth": Ibid.

20, 30   "moment of truth": Ibid., p. 1030.

20, 30   "everyday truth": Ibid., p. 1032.

21, 2   "What do you do?": Ibid., p. 1030.

21, 3   "Was I wrong if, on watching festive plays": Ibid.

24, 9   "marvelous robe in crêpe de Chine": M. Proust, *À la recherche du temps perdu* (Paris: Gallimard, 1987), 1:531.

24, 14   "would laugh, to make fun of his ignorance": Ibid.

24, 18   "Tiepolo pink": Proust, *À la recherche du temps perdu,* 3:61.

24, 25   "Erect, isolated, with her husband": Ibid., p. 117.

25, 7   "changed into malleable gold": Ibid., p. 896.

25, 10   "sleeves lined with a cherry pink": Ibid.

26, 14   "a Veronese after a downpour": Longhi, *Breve ma veridica,* p. 170.

26, 15   "My companion, my true self": M. Barrès, *Un homme libre* (Paris: Perrin, 1889), p. 231.

26, 22   "an analyst who plays": Ibid.

26, 27 "[Tiepolo takes] all the people": Ibid., p. 233.

27, 6 "oeuvre brimming with fragmentary memories": Ibid.

27, 16 "virtually the beginner of Modernism": J. Ruskin, *St. Mark's Rest* (London: George Allen, 1908), p. 190.

27, 28 "in one of the wonderful faded back rooms": H. James, Preface to *The London Life,* in *Literary Criticism* (New York: The Library of America, 1984), p. 1152.

28, 8 "chariot of fire": L. Edel, *Henry James: 1901–1916* (London: Rupert Hart-Davis, 1972), 5:347.

28, 12 "But Tiepolo is *my* artist": M. Twain, *Notebooks & Journals* (Berkeley–Los Angeles–London: University of California Press, 1975), 2:205.

28, 22 "I have loved splendor": Coluthus, *The Rape of Helen,* 172.

30, 10 "hilarizing": L. Lanzi, *Storia pittorica della Italia,* vol. 2 (Florence: Sansoni, 1970), p. 168.

30, 13 "will never end up": G. Manganelli, *Il soffitto come un palcoscenico,* p. 39.

30, 29 "There is no concealing the fact": F. Algarotti, *Saggi* (Bari: Laterza, 1963), p. 79.

31, 16 "young man who knows languages": Letter from Voltaire to N.-C. Thieriot dated November 3, 1735, in *Correspondance* (Paris: Gallimard, 1977), 1:651.

32, 8 "assurance of brushstroke": Algarotti, *Saggi,* p. 22.

34, 12 "the variegated image of equivocal beauty": Ch. Baudelaire, *Le Peintre de la vie moderne,* in *Œuvres complètes,* 2:719–20.

34, 21 "In Veronese's women": P. Molmenti, *G. B. Tiepolo* (Milan: Hoepli, 1909), p. 299.

35, 8 "His Venuses, and his Divinities": C. Boito, *Gite di un artista* (Rome: De Luca, 1990), pp. 30–31.

35, 18 "*ad formam Cratinae meretricis*": Arnobius, *The Case against the Pagans,* VI, 13.

35, 23 "patient and meticulous": Baudelaire, *Le Peintre de la vie moderne,* p. 696.

35, 24 "courtesan of the present day": Ibid.

35, 25 "the pose, the gaze": Ibid.

38, 1 "*l'élégance sans nom de l'humaine armature*": Ch. Baudelaire, *Danse macabre,* v. 19, in *Les Fleurs du mal.*

38, 3 "Imagine a tall female skeleton": Baudelaire, *Salon de 1859,* p. 679.

38, 19 "*À travers le treillis recourbé*": Baudelaire, *Danse macabre,* vv. 31–32.

38, 26 *"chère indolente"*: Ch. Baudelaire, *Le serpent qui danse,* v. 1, in *Les Fleurs du mal.*

38, 26 "a serpent dancing around a stick": Ibid., vv. 19—20.

40, 28 "lived his life like a calm lake": P. Molmenti, *G. B. Tiepolo,* p. 21.

41, 12 "Unexpectedly summoned": G. Tiepolo to T. G. Farsetti, 12 December 1761, Biblioteca del Museo Correr, Venice, Epistolario Moschini.

42, 8 "he was not a robust man": E. Battisti, "Postille documentarie su artisti italiani a Madrid e sulla collezione Maratta," in *Arte Antica e Moderna* 9 (1960): 80.

42, 10 "marry off his numerous family": Ibid.

42, 12 "panic terrors": Ibid.

42, 25 "In his pictures all are richly dressed": Count C. G. Tessin to C. Hårleman, 16 June 1736, in O. Sirén, *Dessins et tableaux de la Renaissance Italienne dans les collections de Suède* (Stockholm: Hasse and W. Tullberg, 1902), p. 108.

43, 5 "I pray you news of Signor Tiepolo": Count C. G. Tessin to A. M. Zanetti di Girolamo, 12 March 1737, Biblioteca Nazionale Marciana, Venice, Mss. Italiani, Cl. XI, Cod. CXVI, 7356.

44, 3 "I' the east my pleasure lies": Shakespeare, *Antony and Cleopatra* 3.3.39.

46, 12 "follower of Paolo Veronese": Count C. G. Tessin to C. Hårleman, 16 June 1736, in Sirén, *Dessins et tableaux de la Renaissance Italienne,* p. 108.

46, 14 "manner of Veronese": Algarotti, *Saggi,* p. 22.

50, 12 "Veronese was Painting": S. Alpers and M. Baxandall, *Tiepolo and the Pictorial Intelligence,* p. 27.

51, 12 "dress, it seems": M. Levey, *Giambattista Tiepolo* (New Haven and London: Yale University Press, 1994), p. 80.

53, 27 "[He] might be modelled": Ibid., p. 81.

58, 28 "at no other time": M. Levey, "Tiepolo's Treatment of Classical Story at Villa Valmarana," in *Journal of the Warburg and Courtauld Institute* 20 (1957): 307.

59, 3 "the figure of Iphigenia": Molmenti, *G. B. Tiepolo,* p. 94.

60, 24 "parcenevole": Ibid., p. 21.

61, 8 "My Most Excellent": G. Tiepolo to F. Algarotti, 16 March 1761, in Fogolari, *Lettere inedite di G. B. Tiepolo,* p. 36.

62, 16 "Here I am": G. Tiepolo to F. Algarotti, 26 October 1743, ibid., pp. 34—35.

62, 25 "all the sagacity": F. Algarotti to Abbot G. Patriarchi, 7 April 1761, in *Lettere sopra la pittura*, in *Opere* (Livorno: Marco Coltellini, 1765), 6:127.

63, 22 "fricassee of children": E. and J. de Goncourt, *L'Art du dix-huitième siècle*, 3rd ed., vol. 1 (Paris: Quantin, 1880), p. 320.

66, 1 "Tiepolo has a wealth of talent": Ch.-N. Cochin letter circa 1750–1751, in *Archives de l'Art Français* 1 (1852): 175.

66, 6 "Even the illustrious Tiepoletto": D. Michelessi, *Memorie intorno alla vita e agli scritti del conte Francesco Algarotti*, in *Opere del conte Francesco Algarotti*, vol. 1 (Venice: Palese, 1791–1794), 1:lxii.

68, 31 "René Guénon does not exist": X. Accart, *Guénon ou le renversement des clartés* (Paris-Milan: Edidit-Archè, 2005), p. 83.

75, 10 "freemasonry of pleasure": A. Cajumi, *Il passaggio di Venere* (Turin: De Silva, 1948), p. 141.

75, 28 *"petit pan de mur jaune"*: Proust, *À la recherche du temps perdu*, 3:692.

79, 9 "to do absolutely what they wish": J.-C.R. de Saint-Non, *Journal*, in Saint-Non and Fragonard, *Panopticon italiano*, edited by P. Rosenberg (Rome: Edizioni dell'Elefante, 2000), p. 213.

PART II

84, 21 "the last three etchings": L. C. Frerichs, "Mariette et les eaux-fortes des Tiepolo," in *Gazette des Beaux Arts* 78 (1971): 249.

85, 11 "the artist's *sentimental escapism*": T. Pignatti, Introduction to *Le acqueforti dei Tiepolo*, edited by T. Pignatti (Florence: La Nuova Italia, 1965), p. 11.

85, 12 "the escapism of a roving imagination": A. Pallucchini, "Per una lettura iconologica delle acqueforti di Giambattista Tiepolo e per la loro cronologia," in *Atti dell'Istituto Veneto di Scienze, Lettere ed Arti* 131 (1972–1973): 518.

85, 14 "have considered them subjects": H. D. Russell, *Rare Etchings by Giovanni Battista and Giovanni Domenico Tiepolo* (Washington, D.C.: National Gallery of Art, 1972), p. 24.

85, 22 "amusement for the quiet hours": B. Passamani, "Giambattista Tiepolo," in *Giambattista Tiepolo (1696–1770). Acqueforti disegni e lettere*, edited by B. Passamani (Bassano: Vicenzi, 1970), p. 16.

85, 29 "in that witty, licentious and languid": H. Focillon, "Les eaux-fortes de Tiepolo," in *La Revue de l'Art Ancien et Moderne* (December 1912): 412.

86, 4   "Europe's print warehouse": Ibid., p. 414.

86, 16   "Tiepolo's etchings, however": Russell, *Rare Etchings,* p. 26.

86, 29   "These medleys of satyrs and nymphs": A. M. Hind, *A Short History of Engraving & Etching* (New York: Dover, 1963), p. 226.

87, 17   "Twenty-one *Capricci*": T. Pignatti, "In margine alla mostra delle acqueforti dei Tiepolo a Udine," in *Arte veneta* 24 (1970): 309.

88, 18   *"nodus et copula mundi"*: Marsilio Ficino, *Theologia Platonica* 3.2.

88, 25   "they are among each other": M. Kozloff, "The Caricatures of Giambattista Tiepolo," in *Marsyas* X (1961): 23.

90, 4   "strangeness of thoughts": V. da Canal, *Vita di Gregorio Lazzarini* (Venice: Palese, 1809), p. 32.

92, 8   "he could say: conceiving": G. A. Moschini, *Dell'incisione in Venezia,* (Venice: Zanetti, 1924), p. 162.

94, 9   "this series of *Capricci*": Blanc, *Histoire des peintres,* p. 10.

94, 13   "obscure allegories": Ibid.

94, 15   "inventions of the kind dreamed of": Ibid.

94, 21   "What an odd thing!": Ibid., p. 9.

94, 24   "a certain glittering of light": Ibid., p. 8.

94, 25   "vibrant, light and fragmented": Ibid.

94, 28   "But while he lets the point": Ibid., p. 10.

97, 11   "by the green trees upon the high ground": Jeremiah 17:2.

98, 1   "Burn their Asherah": Deuteronomy 12:3.

98, 2   "Cut down their Asherah": Deuteronomy 7:5.

99, 2   "the objects that had been made for Baal": 2 Kings 23:4.

99, 6   "made his son pass through the fire": 2 Kings 21:6.

106, 3   "enigmatic instability": G. Manganelli, *Salons* (Milan: Adelphi, 2000), p. 18.

125, 18   "Thinking is more interesting than knowing": J. W. Goethe, *Maximen und Reflexionen,* in *Werke* (Zürich-Stuttgart: Artemis, 1949), 9:645.

127, 5   "Tiepolo's *Capricci* are heroic collections": Barrès, *Un homme libre,* p. 235.

127, 14   "sky, flags, marbles": Ibid., p. 234.

127, 18   "Now the light that one sees": Giamblico, *Sui misteri,* 1, 9.

127, 24   "theurgical communion": Ibid., 1, 8.

128, 8   "A vigorous, athletic torso": M. Santifaller, "Il Continente 'Asia' degli affreschi del Tiepolo a Würzburg e alcuni fogli degli 'Scherzi di fantasia,' " in *Arte veneta* 25 (1971): 205.

128, 17   "in a relaxed pose": Ibid.

128, 23   "A shawl or a garment": Ibid.

130, 6   "absurd rites": H.-Th. Schulze Altcappenberg, *Giovanni Battista*

*Tiepolo (1696–1770) und sein Atelier* (Berlin: Staatliche Museen zu Berlin-Preussischer Kulturbesitz, 1996), p. 100.

130, 13 "themes relating to magic": G. Knox, *Catalogue of the Tiepolo Drawings in the Victoria and Albert Museum* (London: H. M. Stationery Office, 1960), p. 26.

130, 14 "satirical surface": Ibid., p. 25.

131, 2 "This sect . . . appears": C. Thiem, "Lorenzo Tiepolo as a Draftsman," in *Master Drawings* 32 (1994): 322.

131, 12 "a very obscure sect": Origen, *Contro Celso* 6.24.

132, 17 "in Erbipoli": G. Tartarotti, *Del Congresso Notturno delle Lammie* (Rovereto: Giambatista Pasquali, 1749), p. 48.

132, 25 "convinced since childhood": F. Venturi, *Settecento riformatore* (Turin: Einaudi, 1998), 1:366.

133, 1 "hapless sixteen-year-old girl": G. Tartarotti, *Apologia del Congresso Notturno delle Lammie* (Venice: Simone Occhi, 1751), p. 8.

133, 16 "Does not denying the existence of devils": B. Bonelli, *Animavversioni critiche sopra il notturno congresso delle lammie* (Venice: Simone Occhi, 1751), p. 92.

133, 24 "the nothing that deceives the world": Ibid., p. 386.

134, 3 "to burn an infinite number of witches": Tartarotti, *Del Congresso Notturno delle Lammie,* p. 40.

134, 4 "great slaughter of those hapless women": Ibid., p. 47.

134, 5 "the more you burn them": Ibid., p. 42.

134, 9 "such a crime was no more than a trick of the fancy": Ibid., p. xviii.

134, 17 "with fire, and with the executioner": Ibid., p. 36.

134, 19 "Bartolo decided that she must be burned": Ibid., p. 39.

134, 27 "Fraudulent more than any other art": Pliny the Elder, *Natural History* 30.1.1.

134, 28 "more than any other and for a greater number": Ibid.

134, 31 "greatest authority": Ibid.

135, 8 "the fog of humankind": Ibid.

135, 9 "triple bond": Ibid., 30.1, 2.

135, 10 "even today it is predominant": Ibid.

135, 18 "Without a doubt [magic] arose in Persia": Ibid., 30.2, 3.

135, 20 "six thousand years before Plato's death": Ibid.

135, 24 "*Mirum hoc in primis*": Ibid., 30.2, 4–5.

136, 2 "disseminated in every place": Ibid., 30.2, 8.

136, 26 "I have read millions of witticisms": J. de Maistre, *Les Soirées de Saint-Petersbourg* (Paris: Librairie Grecque, Latine et Française, 1821), 1:364.

137, 17 "means etymologically and in fact": Th. Hopfner, in *Realencyclopädie der Classischen Altertumswissenschaft* [Pauly-Wissowa], vol. 6A, tome i (Munich: Druckenmüller, 1987), s.v. "Theurgie," p. 258.

137, 29 "Magic or *goëtia,* its more detestable name": Saint Augustine, *The City of God* 10.9.

138, 3 "The foundation of all magic": Hopfner, in Pauly-Wissowa, s.v. "Theurgie," p. 258.

138, 12 "in the end, by abandoning nature": Proclus, *On Sacrifice and Magic,* pp. 151, 21–23 Bidez.

138, 16 "remaining in the divine": Plotinus, *Enneads* 4.8.1.

138, 17 "an indescribable act": Porphyry, *Life of Plotinus* 23.

139, 30 "having awakened to himself": Plotinus, *Enneads* 4.8.1.

139, 2 "several times": Ibid.

139, 5 "It is said that the rose": A. Momigliano, *Saggezza straniera* (Turin: Einaudi, 1980), p. 128.

139, 19 "still children": Plato, *Timeus* 22 b.

140, 4 "if there was a time": Momigliano, *Saggezza straniera,* p. 131.

140, 17 "magi who chanced to be in Athens": Seneca, *Letters to Lucilius* 6.58.31.

140, 23 "having gained the renowned land of Kekrops": Olympiodorus, *Commentary on Gorgias,* p. 395 Jahn (fr. 673 Rose).

141, 4 "having attempted to summon Jupiter": Pliny the Elder, *Natural History* 28.4.14.

141, 19 "every god is formless": Proclus, *Commentary on Plato's Republic,* vol. I, p. 40, 1 Kroll.

141, 23 "which tell the theurgist": Ibid., p. 39, 17–22 Kroll.

141, 29 "creeps upon the ground, like a slave": Heliodorus, *Ethiopics* 3.16.3.

142, 1 "true wisdom, of which the other [form]": Ibid., 3.16.4.

143, 26 "Someone might say that in this way": Porphyry, *On Abstinence* 2.51.1.

145, 14 "The etchings of the *Capricci*": Russell, *Rare Etchings,* p. 24.

145, 18 "claustrophobic": Levey, *Giambattista Tiepolo,* p. 216.

146, 3 "a highly personal dream-world": Ibid., p. 215.

146, 4 "exude a wisdom": Ibid., p. 217.

146, 8 "ulterior significance": Ibid.

146, 11 "could be claimed": Ibid.

146, 16 "start from the basis of diverting their creator": Ibid.

151, 16 "rock so admirably simulated": M. Michiel, *Notizia d'opere di disegno nella prima metà del secolo XVI* (Bassano: Iacopo Morelli, 1800), p. 64.

153, 12 "those things that are mistaken": G. Pico della Mirandola, *Opera omnia* (Basileae: ex officina Henricpetrina, 1572), p. 367.

154, 12 "staff with snake": Pallucchini, *Per una lettura*, p. 511.

155, 9 "purely ornamental": Pauly-Wissowa, vol. 6, tome i, 1985, s.v. "Kerykeion," p. 339.

155, 17 "Sophia herself had become a serpent": Irenaeus, *Against Heresies* 1.30.15.

155, 21 "And I will put enmity between thee and the woman": *Genesis* 3:15.

156, 1 "I will send thee unto Pharaoh": Exodus 3:10.

156, 4 "Who am I, that I should go": Exodus 3:11.

156, 6 "I am that I am!": Exodus 3:14.

156, 7 "But, behold, they will not believe me": Exodus 4:1.

156, 10 "And the Lord said unto him": Exodus 4:2-4.

156, 18 "I will be with thy mouth": Exodus 4:15.

156, 21 "And thou shalt take this rod": Exodus 4:17.

156, 26 "And Moses and Aaron went in unto Pharaoh": Exodus 7:10-12.

157, 7 "Wherefore is this that thou": Numbers, 20:5.

157, 11 "against Elohim and against Moses": Numbers 21:5.

157, 13 "And the Lord sent fiery serpents": Numbers 21:6-9.

157, 30 "the story of the bronze serpent can be": G. Kittel, *Theologisches Wörterbuch zum Neuen Testament* (Stuttgart: Kohlhammer, 1954), 5:575.

158, 1 "The story of the bronze serpent perhaps": Ibid.

158, 27 "And he did that which was right": 2 Kings 18:3-4.

159, 22 "no one can see . . . the kingdom of God": John 3:3.

159, 24 "Flesh gives birth to flesh": John 3:6.

159, 26 "[t]he wind blows wherever it pleases": John 3:8.

159, 30 "You are Israel's teacher": John 3:10.

160, 1 "I have spoken to you of earthly things": John 3:12.

160, 4 "Just as Moses lifted up the snake": John 3:14.

160, 14 "In the Gospel of Saint John": G. Kittel, *Theologisches Wörterbuch zum Neuen Testament*, 8:608.

161, 5 "And I, once I am raised up": John 12:32.

161, 7 "He said this to indicate the kind of death": John 12:33.

162, 2 "Among the figures struggling": E. Wind, *The Religious Symbolism of Michelangelo* (New York: Oxford University Press, 2000), p. 38, n. 26.

163, 17 "He licked the maiden's limbs": Nonnus, *The Dionysiacs* 6.162-63.

164, 8  "black earth": Alcman, fr. 89.

164, 23  "the most spiritual . . . of animals": Phylo of Biblos, 790 F 4, 8–9 Jacoby.

165, 17  "The Greek gave that fine object": F. Cabrol and H. Leclercq, *Dictionnaire d'archéologie chrétienne et de liturgie*, vol. 1, part 1 (Paris: Letouzey et Ané, 1924), s.v. "Ambrosienne (basilique)," coll. 1453–54.

165, 23  "rather elegant in form": Ibid., col. 1453.

166, 1  "*potest non timere serpentes*": Ambrose, *Commentary on Psalm 118*, 6, 15 (*Patrologia Latina*, vol. 15, 1272 D).

166, 4  "*aureus coluber*": Arnobius, *The Case against the Pagans* 6.21.

166, 9  *theòs dià kólpou*: *Orphicorum fragmenta*, 31, 24 Kern.

167, 3  "The good Serpent slips nimbly": Ambrose, *Commentary on Psalm 118*, 6, 15 (*Patrologia Latina*, vol. 15, 1273 B).

167, 16  "*En deus est, deus est!*": Ovid, *Metamorphosis* 15.677.

167, 28  "*baculum qui nexibus ambit*": Ibid., 15.659.

168, 9  "*Verum etiam apud Egyptios*": Celio Augusto Curione, *Hieroglyphicorum commentariorum liber prior,* in Pierio Valeriano, *Hieroglyphica* (Basel: Thomam Gaurinum, 1567), p. 436.

170, 18  "Two birds, inseparable companions": Rig-Veda 1.164.20.

171, 9  "And when the woman saw that the tree": Genesis 3:6.

171, 19  "more subtle than any beast of the field": Genesis 3:1.

173, 30  "slovenly in design": Molmenti, *G. B. Tiepolo*, p. 272.

173, 31  "modest": Alpers and Baxandall, *Tiepolo and the Pictorial Intelligence*, p. 10.

## PART III

181, 6  "the bellows and the fan": Shakespeare, *Antony and Cleopatra* 1.1.9–10.

181, 19  "diachronic refinement": Manganelli, "Il soffitto come un palcoscenico," pp. 39–41.

182, 2  "Tiepolo's world, anachronistic": Ibid., p. 41.

182, 14  "*regina meretrix*": Pliny the Elder, *Natural History* 9.58.119.

183, 3  "covered in emeralds and pearls": Ibid., 9.58.117.

183, 7  "*rapinarum exitus*": Ibid., 9.58.118.

185, 30  "gorged himself on exquisite dishes": Ibid., 9.58.119.

186, 1  "Since Antony was convinced": Macrobius, *Saturnalia* 3.17.15.

186, 8     "superb and provocative pomp": Pliny the Elder, *Natural History* 9.58.119.

186, 15   "Antony wished to learn": Ibid., 9.58.120.

186, 17   "extremely strict": Macrobius, *Saturnalia* 3.17.17.

186, 19   "so that no day would be lost": Pliny the Elder, *Natural History* 9.58.120.

186, 23   "corollary": Ibid.

186, 27   "from the hands of the kings of the Orient": Ibid., 9.58.119.

187, 3    "beaten": Ibid., 9.58.121.

187, 30   "she placed the greatest part of her hopes": Plutarch, *Life of Antony* 25.6.

188, 12   "kings of the Orient": Pliny the Elder, *Natural History* 9.58.119.

188, 14   "*per manus orientis*": Ibid.

189, 21   "association [*sýnodos*] of Inimitable Lives": Plutarch, *Life of Antony* 28.2.

189, 23   "Those-who-die-together": Ibid., 71.4.

189, 25   "delights": Ibid.

190, 4    "witchcraft": Ibid., 37.6.

190, 5    "his eyes always trained on hers": Ibid.

190, 13   "Ethiopians, the Troglodytes": Ibid., 27.4.

191, 20   "A most beautiful woman": C. Ripa, *Nova iconologia* (Padua: Pietro Paolo Tozzi, 1618), p. 223.

194, 16   "tawny front": Shakespeare, *Antony and Cleopatra* 1.1.6.

197, 26   "fables": Longhi, "Dialogo," p. 1029.

197, 26   "in the purest and most luminous air": Ibid.

199, 3    "Beautiful women always seem intelligent": I. Svevo, *La novella del buon vecchio e della bella fanciulla* (Milan: Morreale, 1929), p. 22.

200, 3    "his brush would have to express": M. H. von Freeden and C. Lamb, *Das Meisterwerk des Giovanni Battista Tiepolo* (Munich: Hirmer, 1956), p. 108.

200, 11   "in the event of there remaining": Ibid., pp. 108–9.

205, 2    "were drawn from life": C. Whistler, in "Katalog," in *Tiepolo in Würzburg,* edited by P. Krückmann (Munich–New York: Prestel, 1996), 1:115.

209, 18   "the gravity and the aristocratic dandyism": Baudelaire, *Salon de 1859,* p. 650.

209, 21   "in the forests and along the lake shores": Baudelaire, *Le Peintre de la vie moderne,* p. 709.

209, 24   "institution beyond the law": Ibid.

209, 24 "has strict laws that inflexibly bind": Ibid.

217, 11 "A myth is the 'mesh' ": M. Mauss, Œuvres (Paris: Minuit, 1969), 2:165.

218, 12 "Tiepolo is all the rage today": Boito, Gite di un artista, p. 29.

218, 16 "narrates, tirelessly narrates": Longhi, Viatico per cinque secoli di pittura veneziana, p. 15.

218, 18 "Carpaccio, a clear-sighted onlooker": Ibid., p. 17.

218, 23 "extremely sharp triangles of shadow": Ibid.

218, 30 "savor of color": Zanetti, Della Pittura Veneziana, vol. 1, p. 46.

219, 1 "the forms of his figures were not noble": Ibid.

219, 4 "Nonetheless, I believe": Ibid., p. 49.

219, 16 "admire the saint asleep": Ibid., pp. 50–51.

220, 8 "pleasure accompanied by light": G. W. Leibniz, Nouveaux Essais sur l'entendement humain, in Die philosophischen Schriften (Hildesheim: Olms, 1965), 5:175.

221, 2 "what there is to sell": Nuova Veneta Gazzetta, 3, 20 March 1762 [p. 1].

221, 6 "A bitch puppy": Ibid. [p. 7].

221, 8 "will be given by courtesy of the Lady owner": Ibid.

221, 15 "Signor Gio: Battista Tiepolo": Ibid. [pp. 1–2].

221, 19 "More than any doctrinal debate": Ibid.

221, 29 "I have heard signor Tiepolo himself": Ibid. [p. 2].

225, 14 "a friend of Gavarni and Gautier": E. and J. de Goncourt, Journal (Paris: Robert Laffont, 1989), 2:1035–36.

226, 11 "By wholly fortuitous and rather undeserved chance": H. de Chennevières, Les Tiepolo (Paris: Librairie de l'Art, 1898), p. 105.

226, 17 "We [ . . . ] have no alternative": Knox, Catalogue of the Tiepolo Drawings, p. 9.

226, 26 "one of the supreme bores of European civilization": R. Hughes, Goya (New York: Knopf, 2003), p. 72.

226, 29 "almost like a phoenix": J. J. Winckelmann, Geschichte der Kunst des Alterthums (Dresden: Walther, 1764), p. 184.

227, 15 "They say that Mengs had the weakness": Blanc, Histoire des peintres de toutes les écoles, pp. 11–12.

228, 8 "The marvelous aspect of mythology": S. Bettinelli, L'entusiasmo, in Opere dell'abate Saverio Bettinelli (Venice: Zatta, 1780–82), 2:300.

228, 24 "Mengs was greedy for glory": Casanova, Mémoires (Paris: Gallimard, 1960), 3:663.

229, 3 "despaired when a dictionary proved him wrong": Ibid., p. 664.

229, 8  "He [the bookseller] had only one daughter": Ibid., p. 1238.

229, 24  "universal painter": G. A. Moschini, *Della letteratura veneziana del secolo XVIII* (Venice: Palese, 1806), 3:75.

229, 25  "with marvelous art in his works": Zanetti, *Della Pittura Veneziana*, 2:601.

230, 1  "Tiepolo does more in one day": J. J. Winckelmann, *Abhandlung von der Fähigkeit der Empfindung des Schönen in der Kunst, und dem Unterrichte in derselben*, in *Werke* (Donaueschingen: Deutscher Classiker Verlag, 1825), 1:267.

230, 16  *"Está bien"*: G. M. Urbani de Gelthof, "Tiepolo in Ispagna," in *Bullettino d'Arti, Industrie, Numismatica e curiosità veneziane* 3, nos. 3–4 (Venice, 1880): 178.

230, 28  *"toda la atencion y cuidado"*: Ibid., p. 183.

231, 22  *"obtener el honor"*: Ibid., p. 180.

231, 24  *"no haber dado cumplimiento"*: Ibid., p. 181.

232, 15  "the illustrious Tiepoletto": Michelessi, *Memorie intorno alla vita e agli scritti del conte Francesco Algarotti,* p. lxii.

232, 15  "the follower of Paolo Veronese": Count C. G. Tessin to C. Hårleman, 16 June 1736, in O. Sirén, *Dessins et tableaux de la Renaissance Italienne,* p. 108.

232, 21  "Don Giambattista Domenico Tiepolo": M. Agulló y Cobo, *Mas noticias sobre pintores madrileños de los siglos XVI al XVIII* (Madrid: Ayuntamiento de Madrid, 1981), pp. 191–92.

234, 4  "wealthy noblemen": *Nuova Veneta Gazzetta,* [p. 2].

241, 3  "another one of the old poets": Aulus Gellius, *Attic Nights* 12:11.7.

242, 2  "In less than twenty-five years": F. Saxl, "Veritas filia temporis," in *Philosophy and History,* edited by R. Klibansky and H. J. Paton (New York: Harper and Row, 1963), p. 209.

243, 19  "more than half a dozen": E. Panofsky, *Studies in Iconology* (New York: Harper and Row, 1967), p. 92.

243, 20  "Time and Fortune, Time and Truth": Ibid.

244, 29  "flower": H. Lewy, *Chaldaean Oracles and Theurgy* (Paris: Études Augustiniennes, 1978), p. 25.

245, 22  "No one, son of No one": Meleager, *The Palatine Anthology* 5.180.6.

245, 24  "I don't know who the father may be": Ibid., 5.177.5.

245, 30  "superior to that of all the other gods": Pausanias, *Description of Greece* 9.27.1.

246, 2  "rough-hewn stone": Ibid.

246, 6  "Eros as the price of eros": Tullius Geminus, *The Planudean Anthology* 205.1–2.

246, 9 "fruit of two arts": Tullius Geminus, *The Palatine Anthology* 6.260.5—6.

246, 9 "the even more perfect god": Ibid.

246, 19 "Of these things I will make no further mention": Pausanias, *Description of Greece* 9.27.2.

246, 28 "Eros greeting Aphrodite": Ibid., 5.11.8.

247, 1 "Tyrant of the gods and of men": Euripides, fr. 136, 1 Nauck-Snell.

247, 5 "the seed of the gods": *Orphicorum fragmenta,* 85 Kern.

247, 6 "a habitation and a common seat": Lattantius, *Istituzioni divine,* 1.5.4; *Orphicorum fragmenta,* 160 Kern.

247, 8 "In the immensity of his coils": *Orphic Argonautics* 13—14.

248, 3 "impious blue": G. Benn, *Englisches Café,* v. 17, in *Sämtliche Werke* (Stuttgart: Klett-Cotta, 1986), 1:25.

251, 2 "Behold an angel of the Lord": Matthew 2:13.

# IMAGES

240 Giambattista Tiepolo, *Venus Entrusting Cupid to Time,* oil on canvas. Museum of Montserrat.

241 Giambattista Tiepolo, *An Allegory with Venus and Time,* oil on canvas. National Gallery, London.

242 *Veritas filia temporis,* etching; in Adriaen Willaert, *Liber quinque missarum,* Francesco Marcolini, Venice, 1536.

248 *Hermes and Aphrodite with Eros,* bas-relief in terra-cotta, Southern Italy; in W. H. Roscher, *Ausführliches Lexikon der griechischen und römischen Mythologie,* Olms, Hildesheim, vol. 1, 1965, coll. 1351–52.

253 Giandomenico Tiepolo, *The Flight into Egypt,* etching. Kupferstichkabinett, Berlin.

255 Giambattista Tiepolo, *Rest on the Flight into Egypt,* oil on canvas. Staatsgalerie, Stuttgart.

# INDEX OF NAMES, PLACES,
AND WORKS

A NOTE ON THE TYPE

The text of this book was set in a typeface named Perpetua, designed by the British artist Eric Gill (1882–1940) and cut by the Monotype Corporation of London in 1928–30. Perpetua is a contemporary letter of original design, without any direct historical antecedents. The shapes of the roman letters basically derive from stonecutting, a form of lettering in which Gill was eminent. The general effect of the typeface in reading sizes is one of lightness and grace.

COMPOSED BY
North Market Street Graphics, Lancaster, Pennsylvania

PRINTED AND BOUND BY
Tien Wah Press, Singapore

DESIGNED BY
Iris Weinstein